KU-051-804

R46490

LEEDS COLLEGE OF ART & DESIGN
770.1
LRC
GRE
10/10/06.

First published in 2006
Published by Photoforum and Photoworks

Photoforum
c/o School of Historical and Critical Studies,
University of Brighton,
10/11 Pavilion Parade,
Brighton, BN2 1RA

Photoworks
The Depot
100 North Road,
Brighton, BN1 1YE
T: 01273 607500
E: info@photoworksuk.org
www.photoworksuk.org

Distributed by Cornerhouse Publications
70 Oxford Street,
Manchester, M1 5NH
T: 0161 200 1503
F: 0161 200 1504
E: publications@cornerhouse.org

British Library Cataloguing-in-Publication Data.
A catalogue record for this book is available from the British Library.
ISBN 1-903796-18-0

Copyright © Photoforum and Photoworks
While copyright in the volume as a whole is vested with Photoforum
and Photoworks, copyright in individual essays belongs to their
respective authors. No part of this publication may be reproduced,
stored or transmitted in any form or by any means, electrical, mechanical
or otherwise, without the express permission of both the author and
publishers. Every effort has been made to contact the copyright holders of
the images reproduced here. If, for any reason, copyright has been infringed,
the copyright holder should contact the publishers.

Edited by David Green and Joanna Lowry
Design by Dean Pavitt at LOUP
Printed by Dexter Graphics Ltd

university college
for the creative arts
at canterbury, epsom, farnham
maidstone and rochester

University of Brighton

Stillness and Time: Photography and the Moving Image

Edited by David Green and Joanna Lowry

LEEDS COL OF ART & DESIGN

R46490K0084

Contents

Foreword and Acknowledgements

The starting point for this book was a conference bearing the same title organised by Photoforum and held at the Kent Institute of Art and Design in Canterbury in 2004. The majority of the essays published here were presented there for the first time. The thinking behind that initiative had been to open up a space for reconsidering the relationship between photographic theory and the theory of the moving image as that has been articulated in the study of film. Each of these areas had developed a rich and sophisticated body of ideas and modes of analysis during the 1970s and early 1980s, influenced by semiotics, Marxism, psychoanalysis, post-structuralism and phenomenology. Yet whilst inevitably there had been some degree of interchange between photography theory and film theory each, nevertheless, remained fairly discrete from the other. Indeed, as the introductory essay in this book points out, the seminal writings by such figures as Walter Benjamin, Siegfried Kracauer, André Bazin, Roland Barthes and Christian Metz tended to focus upon what were seen as the essential differences between the two mediums of photography and film. Concepts of stillness, movement and time were articulated in a manner in which those differences could be both identified and maintained.

It seemed to us that this implicit understanding was in need of re-evaluation. The primary reason why such a re-evaluation was necessary – and perhaps even made possible – is undoubtedly the impact of new image technologies. Technological developments and the emergence of the digital interface have seen the progressive erosion of the boundaries between the still and moving image. We now have the capacity at the flick of a switch to slow or freeze the moving image, or to animate a still one. The equipment around us is programmed for a bewildering multiplicity of tasks that makes it progressively difficult to identify the photograph itself as a stable entity with a privileged existence. The photograph no longer seems to cut into the flow of time itself: instead it seems to present us with a moment selected from a temporality that has already been digitally encoded. Thus 'the photograph' now exists as only one option in an expanding menu of representational and performative operations presented by the technology.

Undoubtedly such technological developments demand new theoretical frameworks that are based on a dramatically different culture of the image. Yet they are also the spur to look back at the formation of a theoretical and cultural history that we had taken for granted, and explore elements of the relationship between photography and film (and by extension video) that might only now emerge as being significant. The essays in this book are largely concerned with this project of critical retrospection.

A number of themes stand out in the essays published here. On the one hand there is a sense, in all of the contributions, that if we are going to understand the impact of photographic and filmic images in contemporary culture we may have to loosen our assumptions about where the boundaries between these two mediums are to be found; whether that boundary be considered technologically, culturally or psychically. There is also a strong sense that we are searching for a terminology that might be more open to a phenomenology of the image, to the way in which the image is experienced: concepts like 'becoming' and 'the event' return in these essays again and again, signalling an approach to the image that is perhaps more hermeneutic than post-structuralist. Finally, it is also clear that what is at stake in our discussions about stillness and movement, and the different temporalities of photography and film, does not ultimately rest with the issue of technology per se. Thus it is not as if different technologies might simply be thought of as means of producing representations of time but as technological apparatuses through which time itself is constituted and experienced in all of its multiplicity.

The conference *Stillness and Time: Photography and the Moving Image*, and henceforth this publication, was made possible by the generous support of the Univeristy of Brighton, the Kent Institute of Art and Design and the Surrey Institute of Art and Design University College (the latter two institutions since almagamated into the University College of the Creative Arts). We would like to extend our gratitude to these institutions for their continued support of Photoforum. We are also extremely grateful to Photoworks, and in particular David Chandler and Rebecca Drew, for their commitment, time and energy that have made this publication possible.

Joanna Lowry
David Green

Marking Time: Photography, Film and Temporalities of the Image
David Green

Since 1976 Hiroshi Sugimoto has worked on an on-going series of
photographs entitled *Theatres* which have as their setting and immediate
subject matter the ornate architectural interiors of cinema auditoria.
Following a carefully prescribed formula Sugimoto sets up his large-format
camera in an elevated position on the theatre's balcony, placed centrally and
directly facing the screen. While the film is projected the camera's shutter
remains open and the duration of the film determines the exposure time of
the photograph. Acting as the only source of illumination, the light reflected
from the screen reveals the space that surrounds it, drawing out of the
darkness the theatre's cavernous interior and its decorative encrustations.
At the same time the concentration of light from the film projector on the
screen itself results in the over-exposure of the photograph leaving an
imageless void at its centre. (Figure 1) In some of the photographs from the
Theatres series the white rectangle of the cinema screen assumes a certain
denseness and solidity and thereby evokes comparison to that paradigmatic
form of modernist abstract painting, the monochrome. In others, however,
the outer edges of the screen are breached by the light emanating from it,
dissolving its rigid perimeters and threatening to engulf all matter caught
within its glare.

 As with Sugimoto's other work, the *Theatres* series runs counter to
prevailing conceptions of photography's relationship to instantaneity and
to the photographic image as the record of a brief and transitory moment in
time. Here the photograph is, in a literal way, the embodiment of temporal
duration – in a manner that has rarely been so since the infancy of the
medium – and equally it would seem to demand of the viewer a form
of attention that also takes time. This sense of the extension of time as
constitutive of both the means of production and mode of perception of
the photograph is all the more significant in these images since it is achieved
at the expense of cinema and the medium to which photography is often
directly contrasted. There is indeed a deep irony in the fact that each of
Sugimoto's *Theatres* photographs exists as a result of the expiry of a film;
each image born from the transient existence of thousands of other images

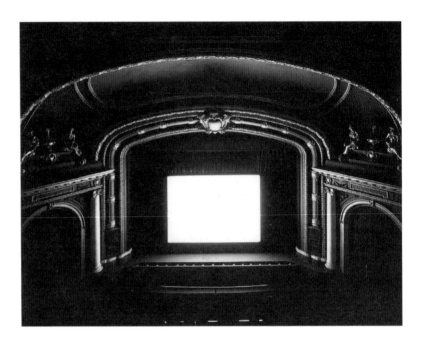

Figure 1
Hiroshi Sugimoto
Metropolitan, Los Angeles, 1993

that once briefly flickered across a cinema screen. Life is given to the photograph through the death of the film.

Anyone in the least familiar with writings on the history of cinema and with some of the abiding rudiments of film theory will immediately recognise the set of discursive terms that Sugimoto's *Theatres* photographs put into play and which my description of them is intended to evoke. Most conventional histories of the origins of cinema, for example, tend to privilege its relationship to photography. Whatever arguments may be mustered on behalf of cinema's debts to literature and theatre, the technological bases of film have guaranteed photography a primary role in any account of its early development and perhaps continue to inflect an understanding of film as being – first and foremost – a pre-eminently visual medium. But the fact that photography and film have always been seen as closely intertwined has also proved to be the spur to differentiate between them. That this process of the differentiation of photography and film has revolved around a polarisation between the still and the moving image, and the different temporalities associated with each, should come as no surprise.

One of the clearest examples in the realm of film theory in which photography and film are both seen as being intimately technologically and aesthetically connected yet ultimately ontologically distinct is Siegfried Kracauer's *Theory of Film: The Redemption of Physical Reality*. First published in 1960, though largely dependent upon his extensive body of writings on the cinema from the 1930s, Kracauer makes plain his commitment to the notion of unique and determinate properties of the medium early in the book. Significantly for my purposes here the opening chapter is devoted to, and simply entitled, 'Photography' and Kracauer uses it to lay out his own version of medium specificity. Mediums differ, according to Kracauer, in terms of 'the degree of the elusiveness of their properties'. Somewhat surprisingly he argues that painting demonstrates, through its historically varying modes of approach, 'to be least dependent upon fixed material and technical factors'.[1] The properties of photography, on the other hand, have proven to be 'fairly specific' and have therefore demanded compliance with a set of basic aesthetic principles, the single most important being its 'realistic tendency'. Within the parameters set by photography's 'realistic tendency' Kracauer goes on to identify four more particular properties that define the medium and which he calls its 'affinities'. The first of these is the capacity 'to render nature in the raw, nature as it exists independently of us'.[2] Through this intrinsic relationship to 'unstaged reality', photography comes to lay stress upon 'the fortuitous', further still 'to suggest endlessness' and finally to reveal a tendency towards the 'indeterminate' and all that is 'unorganised and diffuse'.

Whilst reading Kracauer it is difficult to ignore the insistent claims for the camera's unique abilities to 'record and reveal physical reality',[3] there is a need to counter the arguments of those who have dismissed his position as that of a 'naïve realist'. In the subtle shift, for example, from claiming the photograph's natural affinity to 'unstaged reality' to the description of its innate proclivity for the aleatory, 'for fragments rather than wholes', and for the fact of its inevitable incompleteness, there is the recognition that the photograph fundamentally transforms that which exists before the camera, and that in its inability – one might say its failure - to match reality the photograph is revealed in its difference: 'Its frame marks a provisional limit; its content refers to other contents outside the frame; and its structure denotes something that cannot be encompassed – physical existence.'[4] Thus if the photograph is – as Kracauer claims at one point – 'the text of nature', it is the potential ambivalence of that phrase that needs to be grasped.

This applies equally to how Kracauer develops these arguments with regard to film. Sharing with photography its technological basis in the optical and mechanical operations of the camera, film inherits from its historical

1 Siegfried Kracauer *Theory of Film: The Redemption of Physical Reality*, Oxford University Press, 1960, p.12.

2 Ibid., p.18

3 Ibid., p.28.

4 Ibid., p.19-20.

predecessor its 'affinities' with the 'unstaged', 'fortuitous', 'indeterminate' and sense of 'endlessness'. However, the single most important factor that distinguishes the two mediums is, of course, that film 'represent[s] reality as it evolves in time'[5] and this temporal dimension is indissociable from film's ability to capture movement.

5 Ibid., p.41.

There is a sense that for Kracauer film is able to achieve a higher synthesis of the features, that is the 'affinities', that photography itself possesses but that in the end the difference between the two mediums is not simply relative but absolute. What is denied to photography is seen as the defining characteristic of film and gives rise to a set of unique possibilities for representing 'physical reality' in all of its contingencies and transience. To this exclusively filmic mode of representation of the raw material of experience Kracauer gave the term – and, as we shall see, it is a significant one – 'the flow of life'. Indebted to the phenomenology of Bergson and Husserl, the notion of 'the flow of life' was intended to unite Kracauer's theory of what was specific to film as a medium with his belief in the cinema's natural propensity for the actual and the everyday. The motif that encapsulated this convergence of form and content was that of the street. In a passage that directly summons to mind the writing of his one-time friend and associate Walter Benjamin, Kracauer notes:

> The street in the extended sense of the word is not only the arena of fleeting impressions and chance encounters but a place where the flow of life is bound to assert itself. Again one will have to think mainly of the city street with its ever-moving crowds. The kaleidoscopic sights mingle with unidentified shapes and fragmentary visual complexes and cancel each other out, thereby preventing the onlooker from following up any of the innumerable suggestions they offer. What appeals to him are not so much sharp-contoured individuals engaged in this or that definable pursuit as loose throngs of sketchy, completely indeterminate figures. Each has a story, yet the story is not given. Instead, an incessant flow casts its spell over the flaneur or even creates him. The flaneur is intoxicated with life in the street – life eternally dissolving the patterns which it is about to form.[6]

6 Ibid., p.72.

As much as this might be read as a description of the kind of visual and sensory encounters of the urban milieu that are seen as synonymous with modernity it is also clearly intended to evoke something of our experience of film itself. The restlessness of the city street finds its direct analogy in the relentless movement of the film, in the fluidity of the camera and the rapid spatial transitions of montage. The 'flow of life' encompasses the flux of reality and its appearance on the screen. The question is where does this leave photography?

Apart from the opening chapter of *Theory of Film* the only other substantial text by Kracauer devoted to photography is an essay first published in 1927. Kracauer begins his essay by contrasting two photographs, one of a young film diva found on the cover of a current magazine, the other of a woman of similar age but taken sixty years before and whom he identifies now to be a grandmother. Possibly his own. The glamorous film star, like the illustrated publication on which her image appears and the profession to which she belongs, seems to embody the modern. She belongs to a contemporary consciousness, and the time of the image is lodged firmly in the present. By contrast the other photograph is 'essentially associated with the moment in time at which it came into existence'.[7] Whilst the woman that it pictures may still be known to those around her, the photograph itself can only testify to what once was. In the ever-widening gap between then and now meaning dissolves into 'particulars' such as the woman's costume that may appear to us in its anachronistic unfashionability as 'comical'. At the same time, however, those who gaze on such an image may also feel a 'shudder'. For what strikes the viewer is not only the inescapable fact that what has passed can never return but also the inevitability that the material contingencies of the present will similarly be engulfed by the flow of time and with it himself:

7 Siegfried Kracauer 'Photography', trans. Thomas Y. Levin, *Critical Inquiry*, 19, Spring 1993, p.428.

> *Those things once clung to us like our skin, and this is how property still clings to us today. We are contained in nothing and photography assembles fragments around a nothing. When Grandmother stood in front of the lens she was present for one second in the spatial continuum that presented itself to the lens. But it was this aspect and not the grandmother that was eternalised. A shudder runs through the beholder/viewer of old photographs. For they do not make visible the knowledge of the original but rather the spatial configuration of a moment; it is not the person who appears in his or her photograph, but the sum of what can be deducted from him or her. It annihilates the person by portraying him or her, and were person and portrayal to converge, the person would cease to exist.*[8]

8 Ibid., p.431.

Kracauer goes on, however, to suggest that the belief in the presentness of the images that fill the contemporary magazine is merely a veneer behind which we try to shelter from the inevitable:

> *That the world devours them is a sign of the fear of death. What the photo–graphs by their sheer accumulation attempt to banish is the recollection of death, which is part and parcel of ever memory-image. In the illustrated magazines the world has become a photographable-present, and the photographed present has been entirely externalised. Seemingly ripped from the clutch of death, in reality it has succumbed to it all the more.*[9]

9 Ibid., p.433.

10 Roland Barthes *Camera
Lucida: Reflections on
Photography*, trans. Richard
Howard, Hill and Wang, New
York, 1981, p.15.

11 Ibid., p.31-2.

These passages could have been written by Barthes who – fifty years later
– commenting on a photograph of himself noted that: 'Ultimately, what I am
seeking in the photograph taken of me...is Death: Death is the eidos of that
Photograph'.[10] Later in the same text, however, he extends the sentiment to
the photograph in general, noting that 'however lifelike we strive to make
it (and this frenzy to be lifelike can only be our mythic denial of an
apprehension of death), Photography is a kind of primitive theater, a kind
of Tableau Vivant, a figuration of the motionless and made up face beneath
which we see the dead.'[11] There is no need here to pursue in any detail the
complex and often enigmatic nature of Barthes' morbid reflections on
photography's intimate relationship to death which have given rise to
countless commentaries. What needs to be stressed, however, is that in the
course of writing about death as the eidos of photography, Barthes elaborates
an argument about the distinctive nature of the temporality of the photo-
graphic image, one which he describes as resulting from 'a perverse
confusion between two concepts: the Real and the Live'. He continues:

> ...by attesting that the object has been real, the photograph surreptitiously
> induces belief that it is alive, because of that delusion which makes us attribute
> to Reality an absolutely superior, somehow eternal value; but by shifting this
> reality to the past ("this has been"), the photograph suggests that it is
> already dead.[12]

12 Ibid., p.79.

This paradoxical coexistence within the photograph of the 'Real', the
authentication of a past-present, and the 'Live', the illusion of a present-
presence, Barthes later describes more simply as the simultaneity of the
'this will be' and the 'this has been' or, in more macabre fashion, as a state
of a future anterior 'of which death is the stake'. The latter provides the cue
for Barthes' response to a photograph of his mother with yet further and
more direct resonance with the words of Kracauer: 'I tell myself she is going
to die: I shudder, like Winnicott's psychotic patient, over a catastrophe which
has already occurred. Whether or not the subject is already dead, every
photograph is this catastrophe.'[13]

13 Ibid., p.96.

As I argue below, Barthes' attempt to account for the distinctive
phenomenology of the photographic image through such contortions of
grammatical tense as that of the notion of a future anterior has not always
led to discussions of photography with such equally complex analytical
ambitions. What needs to be stressed in the present context, however, is that
Barthes reflections on photography contained in *Camera Lucida* and which
in essence are concerned with time (as much as they are inseparable from
the subject of death) are conducted in direct dialogue with the medium of
film. Indeed, those passages of the text in which he tackles the issue of the

photograph's temporality contain repeated references to the cinema and it is clear that for Barthes it is only in the comparative distinction with the moving image that photography finds its inimitable identity. The terms of this argument had been laid out much earlier in writing on photography in *The Rhetoric of the Image* where he had described the unique temporal register of the photograph as being forged in 'an illogical conjunction between the *here-now* and the *there-then.*' From which he goes on to deduce that

> the photograph must be related to a pure spectatorial consciousness and not to the more projective, more magical fictional consciousness on which film by and large depends. This would lend authority to the view that the distinction between film and photograph is not a simple difference of degree but a radical opposition. Film can no longer be seen as animated photographs: the having-been-there *gives way before a* being-there *of the thing...*[14]

Barthes' own preferences fell sharply on one side of this divide. His dislike of narrative forms, which demand of the reader that he submit to the irreversible flow of linear time, is in stark contrast to his fascination with the stasis of the photograph that allows for an unrestrained mode of contemplation. Thus when Barthes chooses to write about film he directs his attention to the film-still, the individual photogram, that – once isolated from the flux of its apparent animation – 'scorns logical time'.[15]

Leaving aside these personal prejudices Barthes writing on photography needs to be understood in terms of what it takes from, and gives back, to film theory. As regards the former there is the unacknowledged debt to André Bazin. Like Kracauer's *Theory of Film,* Bazin's major work *What is Cinema?* opens with an essay devoted to photography. 'The Ontology of the Photographic Image' serves to lay the theoretical foundations for Bazin's particular theory of cinematic realism. Products of the same technical means of image production, photography and film partake in the unprecedented ability of the camera not only to reproduce the mere appearance of some-thing but to capture the thing itself: 'No matter how fuzzy, distorted, or discolored, no matter how lacking in documentary value the image may be, it shares, by virtue of the very process of its becoming, the being of the model of which it is the reproduction; it *is* the model.'[16] This said, however, photograph and film diverge as to realism's relationship to time. Photo-graphy's realism is one that assumes a particular spatio-temporal character, one that Bazin implies through opening his essay with reference to the origins of the visual arts in the primitive 'practice of embalming the dead'. Just as such funeral effigies attempted to preserve the appearance of life – 'to snatch it from the flow of time' – so the photographs in a family album testify to 'the disturbing presence of lives halted at a set moment in their

14 Roland Barthes 'The Rhetoric of the Image', trans. Stephen Heath, *Image-Music-Text*, Fontana, 1977, p.45.

15 Roland Barthes 'The Third Meaning', ibid., p.68.

16 André Bazin 'The Ontology of the Photographic Image', reprinted in *The Camera Viewed: Writings on Twentieth-Century Photography*, Volume 2, ed. Peninah R. Petruck, Dutton, New York, p.145.

17 Ibid., p.145

18 Ibid., p.145

19 Christian Metz
Film Language: A Semiotics of the Cinema,
Oxford University Press,
1974, p.8.

20 Ibid., p.9.

21 Ibid.

duration, freed from their destiny'.[17] 'Film', on the other hand, 'is no longer content to preserve the object, enshrouded as it were in an instant, as the bodies of insects are preserved intact, out of the distant past, in amber. The film delivers baroque art from its convulsive catalepsy.'[18]

If all of this foretells Barthes, his own formulation of the *having-been-there* of the photograph as opposed to the *being-there* of the film, was taken up by his one-time student Christian Metz. Seizing on Barthes' notion that the photograph can never testify to the presence of the object but only to the fact of its once having been present, Metz advances the argument that film overcomes this limitation and presents us with an impression of reality which is so much more 'vivid': 'The movie spectator is absorbed, not by a "has been there", but by a sense of "There it is"'. And the reason that film is able to convince us of the actual presence of something, Metz argues, is because of the appearance of movement. The reasons that Metz offers for this are mainly twofold. Firstly, by presenting us with successive images of objects existing within space, movement lends them a greater sense of corporeality (which for him is the measure of the real). In addition, however, Metz argues that whilst we might assume that, rather as the photograph can only offer a trace of what has been, so the film can only be 'the trace of a past motion', nonetheless 'the spectator always sees movement as being present'.[19] The reason for this, Metz agues, is that whilst the differentiation between material properties of an object and the form in which they appear within visual representation are easily proven to exist – the latter cannot for example be touched, and tactility for Metz is the most obvious means by which we can distinguish between the object and its image copy – such a distinction 'dissolves on the threshold of motion.'[20] Motion, as it were, can never be represented, it is always motion.

> Because movement is never material but is always *visual*, to reproduce its appearance is to duplicate its reality. In truth, one cannot even "reproduce" a movement: one can only re-produce it in a second production belonging to the same order of reality, for the spectator, as the first. It is not sufficient to say that film is more "living", more "animated" than still photography, or even that filmed objects are more "materialised". In the cinema the impression of reality is also the reality of impression, the real presence of motion.[21]

Whilst for Metz – as for Kracauer and Bazin – cinema is technologically and aesthetically dependent upon photography, ultimately it is seen as ontologically quite distinct. The differences between the two mediums appear as stark and absolute: on the one hand we have movement that not only is present but also lends to the image a 'presence' that is associated with life, and, on the other hand, we have a moment frozen in time and an

immobility that is lodged within an ever-receding past that can only testify to an absence that carries with it the spectre of death.

This perception is not limited to writers discussed here. Nor is it, I think, simply confined to the relatively rarefied domains of film and photographic theory. Yet clearly it is an orthodoxy that is open to being challenged, and perhaps necessarily so. In the case of the belief in the 'presentness' of film this is easily done. Film shares the same temporal properties of the index with the photograph and for all of its illusion of 'here and now' the filmic image is equally prey to the passage of time and the slow but inevitable recession from now to then. Consequently the spectre of death haunts the moving images of Greta Garbo (if not the screen characters she played) as much as it does the photograph of Barthes' mother.

The dominant perception of the 'pastness' of the photograph has proven more intractable, particularly in the shadow of the cloying melancholia of a post-Barthian era of photographic theory. Elsewhere I have argued that one of the possible ways of countering this tendency lies with understanding the photograph as a kind of performative utterance, a means by which things are not so much represented as simply designated.[22] The idea that the power of photography is as an act of ostentation, which bestows significance on something by pointing to it, has consequences for how we conceive of the temporality of the image. Ann Banfield has suggested that Barthes' attempt to account for the photograph in terms of 'an illogical conjunction between the *here-now* and the *there-then*' might better be reformulated as 'This was now here'.[23] However, thinking of the photograph's particular kind of referentiality as analogous to deixis anchors meaning to the immediate spatio-temporal context of the communicative act and to that which is immediately present. In other words 'This now here'. This might lead us to conjecture that it is possible to conceive of the photograph as occupying what has been referred to as an 'eternal present tense'. But perhaps better still we might abandon the notion of tense altogether and conclude that what the photograph offers us is purely and simply 'This'.

Another way of exploring the relationship between time and the photograph has been suggested by Peter Wollen, who is also dubious as to the exclusive association of the photograph with the past tense: 'Clearly there is no intrinsic 'tense' of the still image, any 'past' in contrast to the filmic 'present', as has often been averred. Still photography, like film... lacks any structure of tense, though it can order and demarcate time.'[24] In his short essay Wollen tentatively lays out a schema for the analysis of various kinds of photography using what linguistic theorists refer to as 'aspect'. What theories of 'aspect' allow for, according to Wollen, is the description and analysis of

22 See David Green and Joanna Lowry 'From Presence to the Performative: Rethinking Photographic Indexicality', in David Green ed. *Where is the Photograph?*, Photoworks/ Photoforum, 2003.

23 Ann Banfield 'L'Imparfait de l'Objectif: the Imperfect of the Object Glass', *Camera Obscura*, 24, 1990, pp.65-87.

24 Peter Wollen 'Fire and Ice', John X Berger and Olivier Richon (eds) *Other Than Itself: Writing Photography*, Cornerhouse Publications, Manchester, 1989.

photographs in terms of 'states', 'processes' or 'events' in which notions of change and duration, of the ordering and demarcation of time, of narrativity and so forth, are still available but without necessarily being enmeshed in the rigid polarisation of past and present tense. As Wollen implies, and what many of the essays in this volume also suggest, is that photography's relationship to time is a far more complex affair than is often granted.

Something of that complexity might be gleaned from the study of those phenomena in which one encounters the direct juxtaposition of the filmic and the photographic, of movement and stillness, as with Raymond Bellour's analysis of the occurrence of the image of the photograph in the certain examples of classical narrative cinema. Whilst Bellour grants that photographs represented as objects within a film are used to advance a story and that they are therefore caught up in the time of an unfolding narrative, their appearance nonetheless is problematic for the film's diegesis. In the examples he gives, the photograph is used as an emblematic motif around which the plot of the film might hinge (often at points in the narrative in which the passage of time is being marked through acts of remembrance), yet at precisely this moment the temporal flow of the film is arrested, its narrative momentum suspended, albeit briefly. At this point in which 'the film seems to freeze, to suspend itself', the viewer is made aware of two kinds of temporality, that which belongs to the film and the intrinsic forward movement of the narrative, and that which is the time of viewing the film and which carries the phenomenological force of the here and now. Thus paradoxically it is the photograph caught on film that directs our attention to the present – even as it functions within the narrative of the film in accordance with its predominant cultural forms to symbolize the past.

> The presence of the photograph, diverse, diffuse, ambiguous, thus has the effect of uncoupling the spectator from the image, even if only slightly, even if only by virtue of the extra fascination it holds. It pulls the spectator out of this imprecise, yet pregnant force: the ordinary imaginary of the cinema...[t]he photo thus becomes a stop within a stop, a freeze-frame within a freeze-frame; between it and the film from which it emerges, two kinds of time blend together, always and inextricable, but without becoming confused.[25]

25 Raymond Bellour 'The Pensive Spectator', *Wide Angle*, Vol.9, no. 1, 1987, p.10.

Extending this argument, Garrett Stewart notes that Bellour's analysis is constrained by the cinematic phenomena he uses. The placing of a photograph as an identifiable object within the illusory space of the film, even where that object may be co-extensive with the screen frame, whilst not without ramifications for film's narrative spatio-temporal diegesis, ultimately leaves it in place. What Stewart contrasts with this phenomenon of an image-within-an-image is the instance of the true freeze-frame, where

'the difference in question is between imaged motionlessness and the 'motionless' image.'[26] It is only in the case of the latter, when the elemental unit of film itself – a single photogram – is isolated and then multiplied and projected that the critical interrogation of 'the ordinary imaginary of the cinema' is truly engaged. Since the freeze-frame is actual stasis, and not merely its representation, its appearance on the screen is a moment of hiatus, not only in the temporal momentum of the film's narrative but also, potentially, in the illusion of reality to which it is bound. The freeze-frame, argues Stewart, allows the possibility of cinematic reflexivity; although interestingly this is achieved through something that might be deemed not to belong to the medium of film and one that may take us outside of the film. With the freeze-frame the film images itself: 'The film has become, so to speak, transparent to itself, but only in the moment, and at the price, of its cancelled succession, its negation as a moving picture.'[27]

The notion of reflexivity, whether one is concerned with film or photography or painting or whatever, has been central to theories of the medium, especially to ideas about medium specificity. Indeed, we can observe that it is only through reflexivity – or as Clement Greenberg called it a process of 'self criticism' – that it has been thought possible to identify those properties and characteristics that are peculiar and unique to it, in other words, to define its 'essence'. Yet, it would seem from Stewart's example of the freeze-frame that reflexivity in film is best, or perhaps only, possible through the deployment of a device that does not 'belong' to film, one that runs counter to common assumptions about the medium and the centrality of movement to it. Stasis or virtual stasis in various guises, ranging from the lack of movement of the camera to the fixity of objects placed before it, has always been regarded as uncinematic, as for example in the case of the appearance of the tableau in early cinema, as well as later films by Dreyer and Pasolini. But the sudden appearance of the freeze-frame is, according to Stewart, such a fundamental rupture in the filmic text, that it creates a kind of acinema. But if the freeze-frame of the film does not belong to cinema is it photography? Or is it neither?

I think that it would be fair to say both Bellour's and Stewart's arguments replicate the key assumptions concerning the differences between photography and film that I have outlined here. Both, however, also suggest a means of moving beyond the counter-posing of these two mediums by means of a manoeuvre through which each becomes open to critique and analysis by subjecting it to terms of reference drawn from the other. By proceeding on the basis of a dialectic rather than mere distinction the relationships between photography and film, between the still and the moving image, are revealed in a new light. Philippe Dubois makes the point succinctly:

26 Garrett Stewart, 'Photogravure: Death, Photography and Film Narrative', *Wide Angle*, Vol.9, no.6, 1987, p.17. Stewart expanded the issues first raised in this essay in his later book *Between Film and Screen: Modernism's Photo Synthesis*, University of Chicago Press, 1999. See also his essay in this volume.

27 Ibid., p.19.

I think we have never been in a better position to approach a given visual medium by imagining it in light of another, through another, in another, by another, or like another. Such an oblique, off-center vision can frequently offer a better opening onto what lies at the heart of the system... The thing is to practice this kind of oblique, sideways approach deliberately. We might begin with this simple idea: that the best lens on photography will be found outside photography. Thus, to grasp something of photography we must enter through the door of cinema (though it may end up being rather the opposite). In short, we must insert ourselves into the fold (in Deleuze's sense), the intersection that relates these two media so often deemed antagonistic. For example, is there anything that tells us more or in a better way about the fundamental stakes of the photographic imaginary than, say, Antonioni's Blow Up, *the hallmark film in this area? Or anything more central than Chris Marker's* La Jetée *for understanding photographically the nature of cinema (and vice versa?). And in theoretical and aesthetic terms, is the film frame (photogramme) not some— where near the heart of the fold, in other words before an "un-nameable" object that is simultaneously beyond photography and before the cinema, more than the one and less than the other, while being a little of both at the same time.'* [28]

28 Philippe Dubois, 'Photography Mise-en-Film: Autobiographical (Hi)stories and Psychic Apparatuses, trans. Lynne Kirby, in Patrice Pedro (ed.) *Fugitive Images: from photography to video*, Indiana University Press, 1995, pp.152-3.

What Dubois advocates here as critical method can I think be readily transposed to describe the practices of a number of contemporary artists whose work might be described as exploring what lies 'between' photography and film and the interstices of the still and moving image. Whilst the foundations for such an exploration were laid by a generation of artists working within the parameters of 'structuralist' or 'materialist' filmmaking in the early 1970s, the possibilities opened up by the technological development and greater accessibility of video in the 1980s proved crucial. As has often been noted the domestic VCR had a significant impact upon the premises and habits of cinema spectatorship and television viewing. As a recording device the VCR freed viewers to watch what they wanted, when they wanted. But in addition to this capacity to 'time-shift', video machines soon also offered the means to manipulate playback. The ability to fast-forward or reverse the flow of images, to vary the speed or freeze an individual 'frame', or simply to be able to easily and immediately re-view something, fundamentally altered our relationship to the screened image. In the hands of artists in particular the VCR became a tool with which to dismember the moving image and, through that process, produce new temporalities. It is not without significance that within the possibilities for the manipulation of time opened up by video it is exploration of the processes by which the cinematic image is slowed down or entirely stilled that seem to have been a primary focus of attention amongst contemporary artists. [29]

29 See my essay 'The Visibility of Time: The Work of David Claerbout, Photoworks, 2004, reprinted in *David Claerbout*, ed. Susanne Gaensheimer, Lenbachhaus Munich, 2004. Also see Joanna Lowry's essay in this volume.

More recently digital technologies have further eroded the boundaries between the still and moving image in terms of their production, distribution and reception. Whilst the same camera (and even most cell phones) is capable of recording moving *and* still images, perhaps the more far reaching consequence of such developments is that we are more likely to encounter both kinds of image through the 'interface' of an electronic screen. Since it is arguable that a conception of photography in terms of the atomisation of time, its freezing of a singular moment isolated and abstracted from the temporal flow and posited as past, is coincident with the form of the photographic print as a palpable object, we might ask what is the effect of this 'dematerialisation' of the photograph? Is it that stripped of its tangible material support and its 'objectness' as something that can be held in the hand, the photograph as it exists on the monitor screen appears to us perhaps as something more animate, more present?

It is clearly the case that the rapid and dramatic technological changes that have impacted upon both the means for the production and dissemination of the image have major implications for the way in which we experience and conceive of time. It also seems possible, perhaps likely, that the distinctions between the filmic and the photographic, between the moving and the still image, that have dominated the domains of both film and photography theory until recently, will wither in the face of these profound shifts in the complex technology of the visual. However, for the moment – and it is possibly both a brief and fragile moment – the notion of the 'photograph' and the 'film' remain with us and it would seem that within this space the concept of the medium remains necessary and useful.

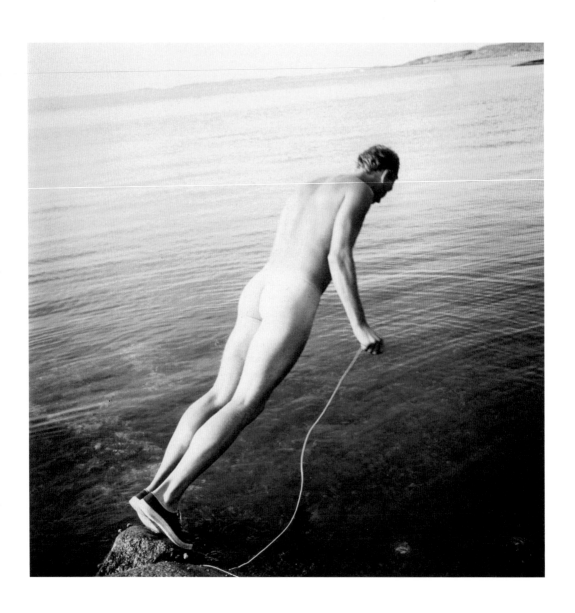

Real Time: Instantaneity and the Photographic Imaginary
Mary Ann Doane

In 1898 Henri Poincaré wrote, 'Whence comes the feeling that between any two instants there are others?' Ironically, this question, which takes for granted the reality of the concept of the instant, emerged in the course of an essay challenging the Bergsonian argument that we have an intuitive understanding of time, particularly of the notions of duration and simultaneity, that can act as the ground of a scientific epistemology.[1] But the instant, for Poincaré, along with our notion of time in general, was a thoroughly psychological concept and remained unproblematic only so long as it remained within subjectivity, within consciousness. An instant was a 'remembrance capable of classification in time.' It had nothing to do with the present but was instead steeped in memory, the antithesis of life and presence: 'It is only when they thus have lost all life that we can classify our memories in time as a botanist arranges dried flowers in his herbarium.'[2] Our strong sense of the continuity of time is based on a wager that our memories are finite and can never blanket the whole of time, that between our memories of any two instants, there will always exist more.

It is striking that Poincaré aligned the instant so intimately with memory, death, the inorganic, and the past at the moment when the cinema was transforming the past instant of photography into a form of scintillating presence, of fluid and life-like mobility. Until 1895 it was photography that was the privileged representational technology for the visualization of time, the indexical guarantee, as Roland Barthes would have it, of a 'that-has-been.'[3] But the cinema, with its celebrated ability to record movement, serialized photographic instants, imbuing them with an invisibility crucial to the maintenance of its illusion. The instant – embodied in the film frame – must disappear in order for movement to emerge. Nevertheless, I will argue that not only is the still image the material substrate of the film medium but its aspiration to instantaneity, its ideological investment in transforming time into a type of property, a tangible commodity, shadows the cinema and reaches out to inform a contemporary digitalized understanding of temporality as well.

1 Henri Poincaré, 'The Measure of Time,' in Stephen Jay Gould ed., *The Value of Science: Essential Writings of Henri Poincaré*, The Modern Library, New York, 2001, p.211.

2 Ibid., pp.210-211.

3 Roland Barthes, *Camera Lucida*, trans. Richard Howard, Hill and Wang, New York, 1981, p.77.

Figure 2
Dag Alveng, *The Photographer Shoots Himself*, 1981.

Instantaneity today seems most persistently and compellingly incarnated in the concept of 'real time', which is ubiquitous, used primarily to convey a sense of the capabilities of new media, of new computer technologies with specific and distinctive relations to temporality. The Oxford English Dictionary (Second Edition, 1989) defines real time as 'the actual time during which a process or event occurs, esp. one analyzed by a computer, incontrast to time subsequent to it when computer processing may be done, a recording replayed, or the like.' In other words, real time is the time of the now, of the 'taking place' of events – it is specifically opposed to the subsequent, the 'after.' Ideally, in real time, there would be no gap between the phenomenon and its analysis. Current definitions of real time tend to emphasize speed of response or reaction time, suggesting that interactivity, or the aspiration to interactivity, is what distinguishes computer real time from film or television real time e.g., 'real time operating systems are systems that respond to input immediately'[4]; '*Real time* is a level of computer responsiveness that a user senses as sufficiently immediate or that enables the computer to keep up with some external process...'.[5] However, these definitions of computer real time also expansively include those of film and television as well. Real time in digital terms would then include both continuity (the one to one relation between film time and everyday time promised by the cinema) and instantaneity (the speed of access, the simultaneity of event and reception promised by television). But in addition, digital real time, through the concept of interactivity, welds the user's time to the concept of real time. The lure of the internet is the lure of connectivity, of being in touch, of synchronicity, and of availability – 24/7/365: 24 hours a day, 7 days a week, 365 days a year. In this way, although the space of the internet may be superbly virtual, its time lays claim to the real.

The concept of real time is itself, of course, a denial of mediation, of the very presence of the technology. Indeed, it is arguable that the concept of the real, and hence of real time, only emerges with capitalism's historical insistence upon an intensified mediation. 'Real time' is compensatory – it makes up for a lack produced by representations at a distance, deracinated representations, which appear to circulate freely. 'Real time' allows the subject to experience the time of the event's own happening, any technical temporal difference being reduced to a bare minimum. The very idea of a time that is real presupposes an unreal time, a technologically produced and mediated time. 'Real time' suggests that represented time (whether mechanical, electronic, or digital) can be asymptotic to the instantaneous – with no delay, no distance, no deferral. And, as Jacques Derrida has pointed out, only technics can bring out the 'real time effect.'

4 'Real Time.' *PC Webopedia*. 28 March 2002. Jupitermedia Corporation. 2 June 2003. www.pcwebopaedia.com

5 'Real Time.' *Whatis?com*. 10 April 2003. TechTarget. 2 June 2003. http://whatis. techtarget.com.

An extraordinarily extended technical reproducibility serves to mimic living flux, the irreversible, spontaneity, that which carries singularity away in the movement of existence without return. When we watch television, we have the impression that something is happening *only once*: this is not going to happen again, we think, it is 'living,' live, real time, whereas we also know, on the other hand, it is being produced by the strongest, the most sophisticated repetition machines.[6]

6 Jacques Derrida and Bernard Stiegler, *Echographies of Television*, trans. Jennifer Bajorek, Polity Press, Cambridge, UK, 2002, pp.130, 89.

The difficulty for Derrida, of course, is that this effect of real time is only an intensification of that which always already characterizes our sense of the present moment or presence in general: the play of *différance* is the guarantee that this presence is always riven by delay and deferral. The question is, however, what constitutes the historical specificity of this technologically mediated real time, what is the lure of its promise of instantaneity, of its disavowal of repetition, its insistence that events happen 'only once'?

The historical predecessor of this desire for instantaneity is undoubtedly photography, but not photography in its earliest forms, with its emphasis upon the impressions and durability of tracings of light but photography as it strove for the registration of the smallest unit of time, the fastest possible shutter speed, and the fixing of movement in the constrained framework of the instant. Around 1880, the introduction of gelatin-silver bromide plates made possible snapshots with an exposure time of 1/25 of a second, re-orienting photography toward the instantaneous, those moments of time or of movement that were not necessarily available to the naked eye. For Walter Benjamin, the quintessential action of modernity was the snapping of the camera:

> *Of the countless movements of switching, inserting, pressing, and the like, the 'snapping' of the photographer has had the greatest consequences. A touch of the finger now sufficed to fix an event for an unlimited period of time. The camera gave the moment a posthumous shock, as it were.*[7]

7 Walter Benjamin, *Illuminations*, trans. Harry Zohn, Schocken, New York, 1969, pp.174-175.

Yet, for Benjamin, there was something obscene about the instantaneous, the contraction of time to a point, the speed and consequent oblivion associated with both urban space and modern technologies – hence his nostalgia for the daguerreotype with its relentless duration, as though the slowness of an etching were required to do justice to the peculiar qualities and texture of light. The daguerreotype was a lost object for modernity, always already historical and of another age; it not only *took time* but it endured in the midst of an era already committed to the ephemeral. Its value was a function of the slowness of its exposure, its status as a kind of work. For Benjamin there was something pre-modern about the sheer length of time required for a sitting: 'The procedure itself caused the subject to focus

his life in the moment rather than hurrying on past it; during the considerable period of the exposure, the subject as it were grew into the picture, in the sharpest contrast with appearances in a snap-shot...'. The daguerreotype could still be classed with that which lasts: 'the very creases in people's clothes have an air of permanence', he noted.[8] The technique itself of the snapshot, on the other hand, its slavish embrace of speed and the momentary, fits well with a throwaway culture and the reduced life span of its information.

Beyond the question of the speed of the apparatus, the power of instantaneous photography has always been aligned with the question of the representability of movement. More sensitive emulsions and faster shutter speeds enable the division of movement and gesture into their smallest possible increments. Perhaps this is why instantaneous photography has been consistently allied with a form of quasi-scientificity, a desire to analyze, dissect, and break down movement into its barely recognizable, alien components – Mach's bullet, Muybridge's horses, Marey's birds. Muybridge's photographs of horses in motion struck observers as ungainly, unaesthetic, the obverse of notions of the beautiful – their uninviting authenticity being their most salient feature. Marey's obsession with the legible instant led to the excision of any background detail and the reduction of the body to a skeletal framework in geometric chronophotography.

Yet the irony of instantaneous photography is that its celebrated capability of representing movement is attained at the expense of movement's petrification and paralysis. The perfect expression of movement becomes movement's own antithesis. Perhaps this paradox explains why instantaneous photography propelled mechanical reproduction into the era of the cinema, where movement looked like movement and any aspiration to scientificity was sacrificed. Instantaneous photography both reveals and hence corroborates the stillness of the photographic image *and* acts as the condition of possibility of the filmic illusion of movement.

In an attempt to unravel the complexity and the specificity of photo–graphic temporality, Thierry de Duve argues that there are two apparently separate categories of photographs that in reality merge and inform our experience of any photograph: the snapshot and the time exposure. The snapshot, in its punctual suddenness, is 'event-like.' The time exposure is most exemplarily the funerary portrait (but could be any portrait), in which 'the past tense freezes in a sort of infinitive.' The subject is dead, but forever there, present. The time exposure is always haunted by the past, by remembrance, by a work of mourning. The snapshot, on the other hand, embodies a form of trauma linked to the inaccessibility of the present – we

8 Walter Benjamin, 'A Small History of Photography,' in *One Way Street and Other Writings*, trans. Edmund Jephcott and Kingsley Shorter, Verso, London, 1985, p.245.

Figure 3
Julia Margaret Cameron, *Portrait of John Herschel*, 1867.

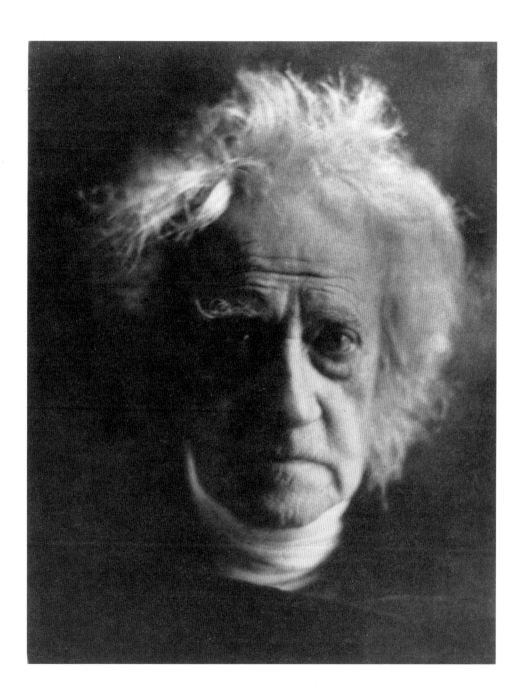

9 Thierry de Duve, 'Time Exposure and Snapshot: The Photograph as Paradox,' in October, no.5, Summer 1978, pp.117, 121. For a fascinating discussion of the epistemological fragility of the moment captured by instantaneous photography, see also Peter Geimar, 'Picturing the Black Box: On Blanks in Nineteenth Century Paintings and Photographs', Science in Context, vol. 17, no.4. 2004, pp.1-35.

10 Roland Barthes, Camera Lucida, trans. Richard Howard, Hill and Wang, New York, 1981, p.95.

view the event or movement represented before it is completed and simultaneously long after it has happened. The discus that is being thrown, frozen in the air, will never land, yet it has nevertheless already landed. The trauma of the snapshot is hence 'the sudden vanishing of the present tense, splitting into the contradiction of being simultaneously too late and too early,'[9] much like Barthes' reading of Alexander Gardner's 1865 Portrait of Lewis Payne: 'He is dead and he is going to die...'.[10]

Two pairs of photographs help to lay out these distinctions made by de Duve. In Dag Alveng's The Photographer Shoots Himself (1981), the photographer's nude body hovers precariously over a vast body of water, perched on a cliff and seemingly headed in a dive for the water, his hand grasping the remote shutter release that he has apparently just activated (Figure 2). The pose is, indeed, an impossible one: a body on the edge, defying gravity, in a position accessible only to instantaneous photography. Or perhaps more accurately, this is the antithesis of a pose, since it cannot be held for any length of time. Julia Margaret Cameron's 1867 Portrait of John Herschel (Figure 3), on the other hand, with its soft focus and attentiveness to the complex features, particularly the liquid eyes, of its subject, invites extended contemplation. Time is written into the image and it promises more to the studious gaze. It is as if there were a depth to which the stillness of the face gives access, but only through the expenditure of time. In Aaron Siskind's Terrors and Pleasures of Levitation (1961) there is nothing to be gained by prolonging the look. The photograph is grasped in an instant, its signification exhausted almost immediately (Figure 4). The body, like that in Dag Alveng's image, is suspended in mid-air, never to be grounded. Without background, it is further disengaged from any natural order – simply there. The shock of the instant lies in its implausibility. On the other hand, the woman in a mid-nineteenth century daguerreotype (Figure 5) exudes composure and stability, as though she had 'grown into the picture' in Benjamin's terms. This is a pose for a portrait and requires all the stillness the subject can muster. But in a sense this image, in its promise of permanence and endurance, anticipates and already instantiates her death.

While the snapshot takes movement as its referent but betrays it through its petrification, the time exposure has stillness or death as its referent but transforms it into a recurrent temporality of mourning or nostalgia. The instantaneity of the snapshot is like a blow: 'The snapshot steals the life outside and returns it as death. This is why it appears as abrupt, aggressive, and artificial, however convinced we might be of its realistic accuracy.'[11] The aesthetic of the snapshot is sharpness of focus – the faster the shutter speed, the crisper the outline of the body in movement, the more striking its

11 Thierry de Duve, op. cit., p.116.

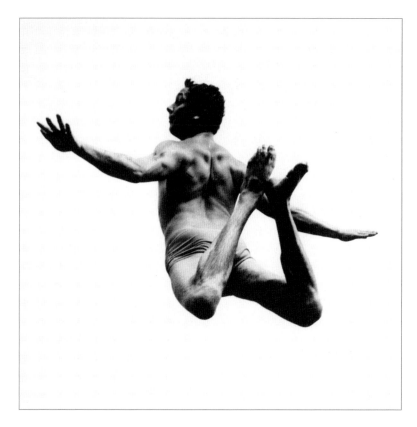

Figure 4
Aaron Siskind, *Terrors and Pleasures of Levitation*, 1961.

rupture of time's flow. The softer focus of the time exposure, on the other hand, is a signifier of time's duration, of the time of imprinting that supports the leisure of contemplation. According to de Duve, our experience of the photograph does not resolve this polar opposition between modes of looking but initiates an oscillation, more or less weighted as the photograph tends toward the snapshot or the time exposure. The aspiration of instantaneous photography, from this point of view, would be the draining of all traces of the past and the attainment of an impossible presence in the form of an uneasy, stuttering balance between the past and the future.

The cinema, however, rejects the petrification of the snapshot by concealing its own dependency upon the still image, the photogram. The rhetoric that greeted the cinema celebrated its inscription of movement, its life-like properties. It was life that was the obsessive concern of biology and

Figure 5
Anonymous portrait of a
woman. Daguerreotype c. 1850

12 E.J. Marey, *Animal
Mechanism: A Treatise
on Terrestrial and Aerial
Locomotion*, D. Appleton,
New York, 1874, p.27.

13 Michel Foucault, *The Order
of Things*, Vintage Books,
New York, 1973, p.273.

physiology in the nineteenth century and movement was its primary
signifier. Marey, whose work was foundational for the emergence of cinema,
maintained that 'motion is the most apparent characteristic of life; it
manifests itself in all the functions; it is even the essence of several of
them.'[12] The autopsy was therefore incompatible with the study of living
systems; and ultimately, the death-like pose of photographic portraiture
resisted the desire to represent life. Life is antithetical to classification –
taxonomy is predicated upon the loss of life, the dried-out flowers of
Poincaré's botanist. Life is always aligned with that somewhat cacophonous
present that resists the reduction of complexity. In cinematic projection, the
frameline that reveals the division of time into distinct instants must vanish.
The emergence of life as an epistemological category central to modernity
is opposed by Foucault to a Classical period in which being is knowable
through an immense table of categories:

> *Classical being was without flaw; life, on the other hand, is without edges or*
> *shading.... Being was posited in the perpetually analyzable space of*
> *representation; life withdraws into the enigma of a force inaccessible in its*
> *essence, apprehendable only in the efforts it makes here and there to manifest*
> *and maintain itself.*[13]

The irreversible temporal flow of film ensures that its grasp by the spectator is never sure, that it constitutes only a fleeting memory that never stabilizes. Much like life. The reified terms 'life-like', 'true-to-life', and the appeal to 'life itself' constitute the ultimate rebuttal, censoring all argument, appealing to a universal, undifferentiated, and undeniable experience shared by all.

Nevertheless, as has been provocatively argued by Garrett Stewart, the spectre of death embodied in the individual film frame does not cease to have its effects.[14] The haunting of film by photography is structural: as Deleuze points out, 'the cinema is the system which reproduces movement as a function of any-instant-whatever, that is, as a function of equidistant instants, selected so as to create an impression of continuity.'[15] Technically, the cinema was historically dependent upon the invention of instantaneous photography. And throughout its own history it has consistently returned to photography as a privileged generator of epistemological dilemmas that cannot fail to contaminate film as a form as well. We may consider here films as diverse as Antonioni's *Blow-Up*, Ridley Scott's *Blade Runner*, Hollis Frampton's *Nostalgia*, and Michael Snow's *Wavelength*, where the photograph constitutes the promise of a plumbable depth but while offering only the opacity of an impenetrable surface, reducible to increasingly unreadable units.

Yet, in these films, photography is theme, subject matter, or content. Safely ensconced within the image or narrative, photography is dealt with as an inferior discourse, the object of the film's more knowing analysis. Films that enact the inextricability of cinema and the photographic, on the other hand, reveal more explicitly what is at stake for the cinema's inscription of temporality. The best known example, perhaps, is Chris Marker's *La Jetée* (1962), whose narrative about time, memory, and a dystopic future is comprised of a series of mostly still images, each instantaneous, each implying a continuing action or event, yet only one of which contains any movement: when the woman of the protagonist's childhood memory, lying in bed, opens her eyes to behold the spectator. This moment of imagistic heterogeneity marks the event of movement as erotic in its presence and immediacy, somehow outside of time. The filming of individual frames of film in *La Jetée* risks an infinite mise-en-abyme, a vertiginous oscillation of movement and stillness. It is the cinematic imitation of stasis, the literalization of the cliché, 'time stands still.' This apparently avant-garde procedure, however, characterizes moments in even the most conventional of films, whenever the cinema mimics photography, sacrificing its trump card of movement to pay homage to stillness. It is arguable that this happens whenever there is a close-up, an enlargement and frequently a freezing of

14 Garrett Stewart, *Between Film and Screen: Modernism's Photo Synthesis*, The University of Chicago Press, Chicago, 1999.

15 Gilles Deleuze, *Cinema 1: The Movement Image*, trans. Hugh Tomlinson and Barbara Habberjam, University of Minnesota Press, Mineapolis, 1986, p.5.

space at the expense of the forward movement of the narrative. In Rouben Mamoulian's *Queen Christina* (1933), the final shot is a slow track in to an extremely tight close-up of Garbo who, having lost both lover and country, takes up her resolute position at the helm of the ship. All movement is marginalized, signaled only by the wisps of hair and collar blowing in the wind, but the face itself has the inertness of marble. (Figure 6) In its tightest position, the close-up reveals a face whose mobility is not compromised by the slightest tic, thwarting even the blink of an eye that signifies cinema in *La Jetée*. Here we are confronted with the cinema's mimicry of photography: in this case, of the time exposure discussed by de Duve. The close-up in this instance blocks the conventional access to interiority provided by the face while making that interiority more mysterious and desirable through its unreadability, its refusal to be written across the features.

More recently, some contemporary artists have directly confronted the dialectic of stasis and mobility that informs photography, cinema, and newer time based technologies such as video, television, and digital media. For example, Martin Arnold's *Cinemnesis* series, especially his *pièce touchée* (1989), directly engages with the radical tension between stillness and movement which subtends the cinema. Arnold uses a homemade optical printer to dissect motion into its smallest cinematic components and to experiment with varying speeds and with the repetition of frames so that movement seems to vibrate, to pulsate, to stutter. In *pièce touchée*, for instance, an 18 second shot from *The Human Jungle* (Joseph M. Newman, 1954) is stretched to fill the 15 minute duration of the film. Arnold deliberately chose one of the most banal and familiar of Hollywood domestic scenes – a husband returning home from work, greeting and kissing his patiently waiting wife. (Figure 7) But everyday actions that form the banal infrastructure of narrative, such as opening a door and entering a room, seem interminable as bodies move forward and backward in incremental stages, and photograms – instead of smoothly accumulating in the service of the illusion of movement – seem to collide. The work of the optical printer translates each movement into a potential catastrophe, a neurotic gesture revealing a profound psychic disequilibrium. Arnold describes the experience of watching another scene from this film on a computerized projector, 'At a projection speed of four frames per second the event was thrilling; every minimal movement was transformed into a small concussion.'[16] In dislocating the frame from its normalized linear trajectory, *pièce touchée* reasserts the explosive instantaneity at the heart of cinematic continuity. The recurrent frustration of the uncompleted movement here mirrors that of the instantaneous photograph. Arnold's work, in its perverse re-embodiment of the desire of Marey and

16 Martin Arnold, in Scott MacDonald, 'Sp...Sp...Spaces of Inscription: An Interview with Martin Arnold,' *Film Quarterly*, vol. 48, no. 1, Fall, 1994, p.4.

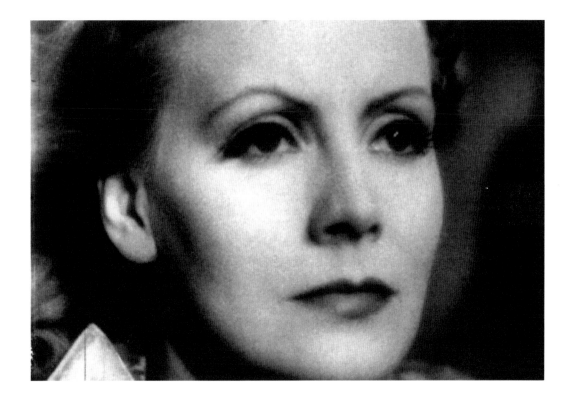

Muybridge, seems to literalize Benjamin's 'optical unconscious.' The goal here is to see differently, indeed, to see *more*. Yet, in the process of dismantling the deceptive naturalness of cinematic movement, the films reveal that movement's grounding in a spastic mechanicity, a series of violent instantaneities masquerading as flow.

In a somewhat different vein, Ute Friederike Jürss, makes use of digital compositing to produce a video installation, *You Never Know the Whole Story*, which models itself upon a series of still photographs derived from newspaper journalism. The verisimilitude the piece strives for is a form of media realism, a fidelity to newspaper photography. In a structure reminiscent of a *tableau vivant*, the figures in the video (all played by Jürss herself) assume the poses of the figures in the journalistic photos, appearing to be caught in the midst of an event, on the brink of an action, much like the subjects of instantaneous photography. Only here, the medium of video imparts a sense

Figure 6
Film still, *Queen Christina*,
Rouben Mamoulian, 1933.

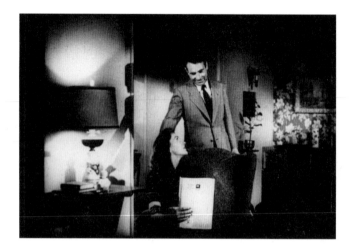

Figure 7
Still frame from Martin
Arnold's *piecè touchée*, 1989.

of presence through the slight waverings and tremblings of the figures, the
occasional blink of an eye. It is striking that the presence or absence of a
blink of the eye should be so critical to texts as diverse as *Queen Christina*,
La Jetée, and *You Never Know the Whole Story* and that it should act as the
primary signifier that we are in the presence of a time-based medium. For
the idiomatic phrase, 'in the blink of an eye', is colloquially understood as
instantaneity, immediacy. Fusing the body and temporality, that blink is the
corporeal measure of time's minimal unit. *You Never Know the Whole Story*
invokes the look of 'real time' or live broadcasting and articulates it with
the stasis of journalistic photography, which purports to present special,
exemplary moments, poses that concisely stand in for the newsworthy event.
As Ursula Frohne points out, 'This "real time" effect is evoked and even
deliberately manipulated by the superficial qualities of the images shown
here, but the promise is never delivered. For images that have the texture
of electronic broadcasting media, but do not move, are an unusual
experience for us.'[17]

17 Ursula Frohne, 'Reality Bytes:
Media Images between Fact
and Fake,' in *Ute Friederike
Jürss: You Never Know the
Whole Story*, ed. Ursula Frohne,
Dörte Zbikowski, Hatje Cantz
Verlag, Hamburg, 2000, p.30.

Why does photography find itself at the turn of the twenty-first century
the object of a sustained mimicry on the part of media that have apparently
surpassed it technically in their access to a heightened effect of the real?
Photographic instantaneity would seem to be antithetical to what we call
time-based media, which, beginning with cinema then video and television
and now digital media have the distinctive capability of representing
movement and duration. It might be productive to look more closely at the

concept of instantaneity and its meanings across the different media. In film and photography, instantaneity names the relation between the object (usually in motion) and its representation – the time lag between the event and its record shrinks so that they become, ideally, simultaneous. The event and its record take place in the same moment. Instantaneity here is a function of the production of the image or images. Yet in the context of their reception, that pinpointed temporality of the registration of the image becomes palpable as historical trace, which is why photographs and films age so visibly. This is the pressure of de Duve's time exposure, where the referent of the photo is tinged by the past tense and death. There is a sense in which instantaneity in photography and film is unreal time, because it always confounds presence and pastness (and this may be why the OED makes no mention of 'real time' in film, despite the fact that the term is widely used with reference to unedited film). There is in each case the present tense of reception – I can hold this photograph in my hands now (its tangibility readily differentiating it from the cinema). Or, in the case of film, I am the spectator of these images of movement here, now, with all the presence usually accorded to movement. On the other hand, there is also the inevitable past tense of a recording that is also a reiteration, of inscribing the traces of an event that can be circulated and witnessed far from the place and time of its original occurrence. For André Bazin, this was the latent obscenity of the film medium: although all events are singular, they happen only once, film makes them repeatable. Bazin links cinematic specificity to a scandal, that of the repeatability of the unique : 'I cannot repeat a single moment of my life, but cinema can repeat any one of these moments indefinitely before my eyes.'[18] This is particularly true, for Bazin, of death and the sexual act, each 'in its own way the absolute negation of objective time, the qualitative instant in its purest form.' The mechanical reproduction of these moments that are superbly unrepeatable constitutes a violation, an obscenity, not of a moral nature but of an ontological one.

18 André Bazin, 'Death Every Afternoon,' trans. Mark A. Cohen, *Rites of Realism: Essays on Corporeal Cinema*, ed. Ivone Margulies, Duke University Press, Durham and London, 2003, p.30.

While instantaneity in photography and film names a relation of simultaneity between the event and its recording, live television considerably transforms its purview. In live television (no longer 'real' but 'live' – a mark of the depth and intensity as well as the 'nowness' of its reality), the event, its recording, its transmission and its reception are virtually simultaneous. History is collapsed onto the present moment. The confusion between present and past in film and photography is avoided by evacuating the very category of pastness – hence the oxymoron 'telepresence'. Live television generates instantaneity as characteristic of both production and reception. Watching an event live, particularly a catastrophic event, is a qualitatively

different experience than watching it 'recorded earlier', underscoring the televisual impression that things happen 'only once'. Digital media, capable of representing all previous forms of real time, further intensifies the alliance of instantaneity with reception through the phenomenon of interactivity, in which the user, by simply pressing a key or clicking a mouse, can make something happen seemingly immediately. Benjamin's snapping of the photographer has moved from the realm of production to that of reception. The event becomes that of the user's engagement with the technology.

Yet, in all of these media of modernity and postmodernity, what is at stake is some form of temporal coincidence, of simultaneity, as the mark of the real. And although we tend to think of simultaneity as an ahistorical, abstract concept, it is in one sense produced in the nineteenth century as a function of industrialization, colonialism, and as the product of a new physics as well as social physics of time. In the 1898 essay *The Measure of Time* mentioned previously, Poincaré contests the idea of a Newtonian absolute time and instead espouses the idea of a multiplicity of times, none of which can be labeled accurate. One of the consequences of this argument is that the concept of simultaneity has no scientific grounding because we cannot 'reduce to one and the same measure facts which transpire in different worlds.'[19] To do so requires the theological hypothesis of an infinite being who could see everything and classify it all in its own time. Yet the hypothesis is self-contradictory since such a being would have to possess an imperfect recollection of the past – otherwise everything would be present to it and it could have no comprehension of time. According to Poincaré, the measurement of time is always compromised, subject to forces we can never fully account for, and we can have no direct intuition of simultaneity or of the equality of two durations. Instead, simultaneity can only be the effect of a rule governed structure, one which is seldom acknowledged. According to Peter Galison, Poincaré's speculations about simultaneity are inextricable from the extensive materialization of simultaneity in the nineteenth and early twentieth centuries: the establishment of train systems, mapping procedures, time-bearing cables, and the standardization of time.[20] With global exploration and the colonialist enterprise, synchronization of clocks became imperative; time everywhere must be the same. Hence, just as simultaneity is discredited at the scientific level, transformed into – as it were – a virtual effect, it becomes an insistent and compelling cultural desire, its lure a symptom of capitalist expansion, its fantasy materialized in new technologies of representation such as photography and film.

One could argue that this desire and this fantasy go back even further, to the advent of print technologies, but in particular to the growth of the daily

19 Henri Poincaré, op. cit., p.211.

20 Peter Galison, *Einstein's Clocks, Poincaré's Maps: Empires of Time*, W. W. Norton & Company, New York, 2003.

newspaper (which ultimately became one of the most privileged domains of instantaneous photography). According to Benedict Anderson, 'the development of print-as-commodity is the key to the generation of wholly new ideas of simultaneity'[21] that ultimately underwrite the imaginary community of the nation and the phenomenon of nationalism. With the secularization of time, a theological time of vertical simultaneity in which everything is known at once by Divine Providence is replaced by Benjamin's 'homogeneous, empty time', in which 'simultaneity is, as it were, transverse, cross-time, marked not by prefiguring and fulfillment, but by temporal coincidence, and measured by clock and calendar.'[22] This new time is incarnated, above all, in the novel and the newspaper. The novel, in its development of parallel times and its extended gloss on the term 'meanwhile', depends upon a temporality inaccessible to its characters and existing only in the mind of the reader. The logic of the newspaper's juxtaposition of the most varied and incompatible stories resides in the fact that they all happened on the same day, today (hence the rapid obsolescence of 'yesterday's newspaper'). In addition, the newspaper generates another form of simultaneity – that of its own ritualistic reading: 'each communicant is well aware that the ceremony he performs is being replicated simultaneously by thousands (or millions) of others of whose existence he is confident, yet of whose identity he has not the slightest notion.'[23] The idea of temporal simultaneity subtends that of an imagined but powerful national identity.

Time is said to be a preoccupation of modernity, of Proust, Bergson, Thomas Mann, while what characterizes postmodernity, particularly in the arguments of Fredric Jameson, is the erasure of temporality and history and the emphasis upon space. Indeed, postmodernity is said to mark the 'end of temporality' and its reduction to a present whose incoherence is a function of the loss of any past or future to which it can be opposed. This is the era of the cell phone, that 'seeming apotheosis of synchronous immediacy', when 'some new nonchronological and nontemporal pattern of immediacies comes into being.'[24] It is somewhat ironic that Jameson finds the aesthetic incarnation of this fetishism of instantaneity in a film, a product of the nineteenth century, rather than in a television show or in digital media. The film is an action movie, *Speed* (1994), which consists primarily of a series of violent or thrilling moments – 'a succession of explosive and self-sufficient present moments of violence.'[25] Jameson refers to it as 'violence porno–graphy' to suggest the well known tendency of pornography to minimize plot or narrative in favor of vignettes of sexual activity. It is this dependence upon the self-sufficient instant that makes the film symptomatic of the negation of temporality specific to late capitalism.

21 Benedict Anderson, *Imagined Communities*, Verso, London, 1991, p.37.

22 Ibid., p.24.

23 Ibid., p.35.

24 Frederic Jameson, 'The End of Temporality', *Critical Inquiry*, vol. 29, no.4, Summer 2003, pp.717, 707.

25 Ibid., p.714.

Yet, isn't this tendency to valorize violent instants reminiscent of instantaneous photography, of de Duve's snapshot with its abruptness and aggressivity (regardless of content)? Of instantaneous photography's desire for an impossible presence? Or perhaps it echoes the explosive instantaneity at the heart of filmic continuity that sometimes emerges as a formal mediation on the photogram. What Jameson sees as a distinctive trait of postmodernity – the reduction to the present and the body – can also be located in the projects of Marey and Muybridge, for whom the problem, approached by way of instantaneous photography, becomes how to theorize the instant, how to think the possibility of its representation. Both photography and film deal with the problematic and contradictory task of archiving the present – of producing the oxymoron that continues to haunt contemporary media – a historic present. It is arguable that our inclination to think of new periods (such as postmodernity) as a form of rupture, as a complete break with the past, is itself a symptom of modernity, obsessed as it was, or is, with pure presence and the annihilation of tradition. The problematic relation to time that Jameson finds so specific to postmodernity emerged much earlier in the technical and psychical pursuit of instantaneity.

What I have attempted to do here is to trace a prehistory of the concept of instantaneity that rests on the refusal to recognize it solely as the property of our alleged postmodernity. To assume that real time is only the time of the computer age is to effectively erase a history of fascination with the concept together with the very process whereby time became potentially unreal. The logics of the televisual and the digital are not so foreign to those of photography and film; and the celebrated rupture of the postmodern may be no more than a blip on the screen of a modernity that, from its beginnings, sought the assurance of a real signified by life and pursued a dream of instantaneity and a present without memory.

Stillness Becoming: Reflections on Bazin, Barthes and Photographic Stillness
Jonathan Friday

Stillness becoming alive, yet still [1]
Theodore Roethke

If one thinks of photography, as it is often tempting to do, from a perspective in which this medium's qualities are primarily identified through a contrast with cinema, then the stillness of the photographic medium is almost too trivial a matter to merit serious examination. But then the cinematic conception can exercise such an influence that it obscures other conceptions of photographic stillness, blinding us to the multifaceted nature of this quality. Long before the invention of cinema, for example, photography was associated with stillness in a way that other pictorial media were not. In the early days of the medium, before the widespread adoption of high-speed cameras and film in the 1890s, photographs were often called 'stills' in part because photographers were prone to shout "still" to alert their subjects that the shutter was about to be opened and that they were to hold their pose without moving. The stillness of these photographs is conditioned by the need of their subjects to position themselves so as to remain motionless for anywhere between twenty seconds and two minutes, imbuing the image with subtle signs of self-imposed avoidance of natural motion, such as the stiffness of posture characteristic of many early photographic portraits.

The invention of cinema, however, changed the conception of photo–graphic stillness at least as much as the invention of high-speed cameras and film. Indeed, from our position in an age in which the cinema is a mature medium, it can be hard to shake off the conceptions of photographic stillness that define this property in relation to cinematic motion and to recover what stillness might have meant before the advent of cinema – and indeed what it might mean when freed of cinematic ways of thinking about photography. It is interesting for example that it took many decades before photographers began deliberately to blur parts of the image to suggest movement. This indicates that photography was at least in part conceived of as still in the sense of being properly concerned with representing its subjects in the sort of stillness familiar from the genre of still-life painting. The stillness achieved

1 Theodore Roethke, 'The Lost Son' (1948), in *Collected Poems*, Doubleday, New York, 1966.

Figure 8
Hugh W. Diamond, *Still Life*.
Collodion print, 1860s.

by removing an object from its ordinary setting in the world and picturing it against a backdrop that isolates it from its natural context in the flow of life is another conception of photographic stillness clearly distinguishable from a stillness founded in contrast to cinematic motion. (See Figure 8) Likewise, the stillness of some early landscape photographs has more to do with the lack of any indications of life, human involvement or even indications of the actions of climate.

There is certainly more that could be said about pre-cinematic conceptions of photographic stillness, but I do not propose to provide such a history. Rather I want to draw out another dimension of stillness not defined in terms of the usual contrast with cinematic motion. We should remember in this context that 'stillness' is always a contrastive concept, one that presupposes a dynamic alternative against which the stillness is distinguished. If the notion of photographic stillness does not have its sense in contrast with cinematic motion, there must be some other dynamic dimension to underwrite its meaning. Both of the non-cinematic conceptions of stillness that I have alluded to get their sense in contrast with the movement of objects in life and experience, and both are important in the history of photography. There is, however, another non-cinematic dimension of stillness that is worthy of exploration, not least because it is closely connected to the work of two of the most significant realist photographic theorists: André Bazin and Roland Barthes. As we will see, both of them show the influence of the cinematic

conception, though both wrestle with the nature of photographic stillness in ways that point beyond cinematic conceptions of this quality.

I have repeatedly referred to the conception of photographic stillness conditioned by cinematic thought about the photograph. We need to begin by reminding ourselves of this conception. It has two main elements, one of which is perhaps only a little less obvious than the other. First, what is depicted in a photograph is not capable of movement within the picture-frame: it is a still image in contrast to cinema's capacity to depict objects in movement relative to each other and the frame enclosing them. Secondly, cinematic influences upon thought about photography have also resulted in a conception of stillness as the extractedness of an individual image from the real or implied series of images that precede or follow it. An indication of this extractedness can be found in the term 'film still', which is sometimes used to refer to a single image extracted from a strip of cinema film and printed in isolation. The analogue in ordinary photography is the selection, freezing and extraction of the exact moment in the existence of some object when focused light from the real stream of events hits the film and the photograph takes the first and most crucial step in its creation.

Few images could be said to illustrate this cinematic conception of stillness better than Cartier-Bresson's famous image of a man jumping across a puddle behind a Paris railway station. (Figure 9) Trivially the subject matter is frozen in relation to the picture frame, and the image is highly suggestive of what came before and will inevitably follow. Estelle Jussim makes this point when she observes that:

> Surely we know that in the immediate past the man executing this improbable jeté must have been hurrying to grab a taxi or catch a train, and in his immediate future there would have been a considerable wetness of the lower trousers and shoes. Past and future and present in the now.[2]

2 Estelle Jussim, The Eternal Moment, Aperture, New York, 1989, p.52.

Indeed when Cartier-Bresson turns to explaining his notion of 'the decisive moment' – of which this image is a great exemplar – he frames it within a cinematic conception of stillness. For example, he writes that

> Photography implies the recognition of a rhythm in the world of real things.... We work in unison with movement as though it were a presentiment of the way in which it unfolds... But inside movement there is one moment at which the elements in motion are held in balance. Photography must seize upon this moment and hold immobile the equilibrium of it.[3]

3 Henri Cartier-Bresson, introduction to The Decisive Moment, quoted in Estelle Jussim, The Eternal Moment, Aperture, New York, 1989, ibid., p.52.

The immobility of the subject matter, its seizure and extraction from the rhythmic movement of the world: this is the cinematic conception of photographic stillness described and embodied in a picture.

Much of the complexity of the relationship between photography and time that is so regularly observed – for example in Jussim's formulation: 'Past and future and present in the now' – arises from this extractive element in the cinematic conception of stillness. The flow of events we encounter in experience is intimately connected with an awareness of time and change over time. A crude phenomenology suggests events flow toward us from the future, through a very brief present of immediate consciousness, into a past less distinct than the future, but not much so.[4] One reason the past is less distinct is that, unlike the future, we have some of the material evidence left behind by events that were once in the present. Among the evidential remnants of once present events are photographs, and other pictorial imprints of light reflected from objects in the world, focused through an optical instrument and fixed in a material image. No one denies that photographs give us information about the past, but that does not distinguish photographs from a host of other records of events now past. But for many theorists, photographs are a unique kind of historical record because they enable spectators to make perceptual contact with, or otherwise have made present to them, objects in the historical past. Photographs, as Bazin for example would have it, preserve objects from time, by bearing their imprint and thus conveying something of their being through time but outside its effects. The idea that a picture preserves a long past temporal now of objects and people that continue to persist in that now, but through the medium of photography also exist in our temporal now, suggests that photography is a very odd mode of representation. Add in Jussim's cinematic claim that the future as much as the past is implicit in photography, and the result is a kind of picture that depicts a once present now implying both its past and future and nonetheless now and past. It is no wonder that, as Laura Mulvey has observed: 'The photograph pushed language and its articulation of time to a limit leaving the spectator sometimes with a slightly giddy feeling.'[5]

We need an example here of the kind of theorist whose treatment of photography and its stillness is conditioned by a contrast with cinematic motion, and there are few more pertinent than Bazin. For he repeatedly indicates that photography is a filmic *ersatz*, a stage in the psychological struggle to create a medium that would preserve reality in accord with the baroque ideal of animated representation. When Lumière was able to effect the technological and imaginative transformation of photography into cinema, Bazin believed this ideal was finally achieved. Writing of the charm of old family photographic albums, he observes that the images convey:

> *The disturbing presence of lives halted at a set moment of their duration, freed from their destiny; not however by the prestige of art... for photography*

4 See, for example, Keith Seddon, *Time*, Croom Helm, London, 1987, Chapter 3.

5 Laura Mulvey, 'The Index and the Uncanny' in *Time and the Image*, ed. Carolyn Gill, Manchester University Press, Manchester, 2000, p.143.

Figure 9
Henri Cartier Bresson, *Gare Saint Lazare, Paris*, 1932.

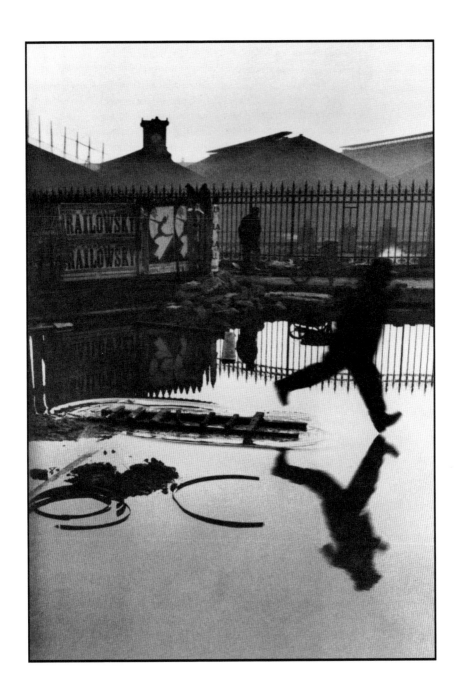

6 André Bazin, 'The Ontology
of the Photographic Image'
in *What is Cinema? Volume 1*,
Translated by Hugh Gray,
University of California
Press, Berkeley, 1967, p.14

does not create eternity, as art does, it embalms time, rescuing it simply from
its proper corruption.[6]

But immediately he makes it clear that the impulses and processes that
gave birth to photography are only truly satisfied and completed with the
invention of cinema. He writes that with this invention:

Film is no longer content to preserve the object, enshrouded as it were in an
instant . . . The film delivers baroque art from its convulsive catalepsy. Now,
for the first time, the image of things is likewise the image of their duration,
change mummified as it were.[7]

7 Ibid., pp.14-15

Bazin does of course find a source of great value in photography and is
therefore not wholly disparaging of the medium, nevertheless his position
does amount to the claim that everything photography does, cinema can do
better, because of the latter's embalming of temporal duration and animated
movement. In another essay Bazin repeats his insistence on the priority of
cinema over its photographic progenitor, writing that:

The photograph proceeds by means of the lens to the taking of a veritable
impression in light – to a mould... But photography is a feeble technique in the
sense that its instantaneousness compels it to capture time only piecemeal. The
cinema... makes a moulding of the object as it exists in time, and furthermore
makes an imprint of the duration of the object.[8]

8 André Bazin, 'Theatre
and Cinema' in *What is
Cinema? Volume 1*,
Ibid., pp.96-97

What interests me about these passages is that each indicates the way
in which photographic stillness is constructed through a contrast with
cinematic motion.

Trivially, photographs (unlike cinema) are incapable of depicting their
objects in motion, and are still in that sense. But also, photographs are
objects embalmed at an instantaneous moment in their past and extracted
from the flow of events affecting and affected by them. A moment, that is,
extracted from its destiny and the time and motion governing it. Here we
can see how the notion of photographic stillness as the extractedness of the
image leads directly to problems articulating the photograph's relationship to
time – particularly if you share Bazin's realist view of photographs as sharing

9 Ibid.

'a kind of identity' with their subject matter.[9] The photographic extraction of
being from the flow of events and the fixing of it into an image makes the
temporal connection between the now of the photograph and all subsequent
nows exceedingly complex. For the photographic preservation is of its subject
matter at a once present now, both extracted from time and persisting
through time, past and present, there and here. If by contrast we do not
conceive of the photograph as extracted, but rather as the limit or origin of a
chain of events, the relationship of the photograph to time is far less complex,
being connected simply to the time of its genesis. This is a possibility that I

will return to in due course, but if I'm right then at least part of the difficulty with articulating the relationship between photography and time can be laid at the door of the cinematic conception of photographic stillness.

There is, however, something else going on just below the surface of Bazin's discussion of photographic stillness, cinematic motion and the respective capacities of these mediums to perpetuate the being of real objects and people over time. I wouldn't like to speculate whether this something else was a conscious element of Bazin's thought, and I am not particularly concerned whether the line of thought I will pursue is actually Bazin's, but rather I will use his realist theory as a familiar backdrop against which to bring to light a dimension of photographic stillness that goes deeper than his cinematic conception, while remaining closely connected with his realist conclusions. To bring all of this out of Bazin's theory will however require a brief review of a very old philosophical problem that provides us with the primary concepts necessary for formulating an alternative conception of photographic stillness.

Much of what Bazin writes about photographic stillness and cinematic motion is very suggestive of the ancient metaphysical contrast between the categorical concepts of being and becoming, or the immutable and the mutable. Indeed, much of what is traditionally thought to be distinctive of being, in contrast to becoming, is precisely what Bazin uses to characterise photographic stillness. And moreover the flow of events, whether in the world from which the photographic still is extracted, or some portion of that flow embalmed in the strip of projected cinema film, has for Bazin the attributes distinctive of becoming. There is a very real sense in which Bazin's favouring of cinema over photography with regard to realism boils down to some perceived advantage of preserving a portion of being in the movement of its becoming.

Before exploring this further in relation to Bazin's thought, it is worth recalling the philosophical issue that gives rise to the distinction between being and becoming. Every material entity we know of is subject to a more or less apparent process of continuous change over time, with some, like rivers, managing to persist despite being in a condition of radical flux. But if rivers and everything else are always changing, what of our capacity to think of and refer to a river as having an identity over time? Indeed, given that it is a necessary condition of language and communication that we are capable of identifying ever-changing objects over time as the same thing, there must be some explanation of this unity underlying change. So when Heraclites famously remarked that 'You can never step in the same river twice', he was posing an apparent paradox: the river you step in on two different occasions

both is and is not the same river. It is, for example, the Thames on both occasions, and that means there must be some basis for our identification of it as the Thames each time we step in it. Whatever it is that underwrites the Thames' persistent identity through time is the being of the object, which is a fundamental ontological category introduced in contrast to, and defined in terms of the movement of, becoming.

The history of attempts to explain an immutable being that persists through mutable time displays a remarkable degree of inventiveness on the part of philosophers. With some degree of simplification we can divide the accounts into two sorts. First, there are those that posit an objective or real existence of some entity, substance or essence that persists and is indivisible because outside the ordinary conditions of time and space. Plato, of course, provides the paradigm instance of an objectivist about timeless being. Secondly, there are those that explain being psychologically, in terms of powers, operations, or structures of human mental and linguistic capacities. Since the eighteenth century there have been few serious attempts to formulate an objectivist account of being, but the debate between the various broadly psychological explanations is hotly contested – including whether, in addition to being, becoming should be construed psychologically or scientifically. This debate needn't concern us, however, since the phenomenon of attributing to objects an identity that persists through time is not in doubt, even though it is equally known that everything is a state of continual flux. Recognition of this phenomenon is all that is necessary of the philosophical background to being and becoming for us to return to the issue of photographic stillness.

We have seen enough of Bazin's account of photographic stillness to see that he conceives of this quality as contributing to the photograph's place within the order of being rather than becoming. The photograph enables the phenomenological being of its subject to persist through time without being subject to the mutability of becoming. Another indication of the association of the photograph with timeless being is Bazin's whole mythology of the urge to immortalise that drives our psychological responses to photographs. A further indication of this comes in his brief account of the value of photographic representation, about which he writes:

> Only the impassive lens, stripping its object of all those ways of seeing, those piled up preconceptions, that spiritual dust and grime with which my eyes have covered it, is able to present it in all its virginal purity to my attention and consequently to my love.[10]

Or to paraphrase, the photograph gives us something of its subject matter as it is in itself, outside space and time, and outside its ordinary

10 André Bazin, 'The Ontology of the Photographic Image', p.15.

appearance to us in the flux and vicissitudes of experience. Photographic representation, as Bazin regularly observes, cannot be reduced to the simple idea of resemblance as with other non-photographic pictorial media. Rather something of the perceptual essence of the subject matter is encoded in the photographic image in virtue of the imprinting nature of the process that produces it. This essence is extracted from the flow of becoming and frozen in the stillness of being, providing the spectator escape from the flow of becoming and an encounter with the world stripped of appearances, a naked and immutable reality.

Of course all this is psychologised by Bazin, in the senses that, first, it is the conclusion of a phenomenology that seeks to identify what a photograph is by careful examination of how it presents itself in the experience of human beings. Secondly, what a photograph is in experience is in large part the product of a deep unconscious need in mankind to erect defences against the passage of time, the decay and death that is its effect, and the very conditions of existence within relentless becoming. This latter sense in which Bazin's account of photographic representation is psychologised is particularly important because it indicates the degree to which the phenomenological description is an elaborate construction designed to show how photographs satisfy a longstanding, though evolving, psychological need. From the need for relief from becoming springs being, and this the imagination is able to most easily find in those pictures that are generated by the kind of processes characteristic of photography. For Bazin, therefore, the nature of the photographic medium provides the material underpinnings for an imaginative placement of photographs and their subjects within the order of being, and beyond the effects of becoming.

All of this applies to cinema as well, but with this medium there is the added dimension of motion. Cinema transfers a photochemical imprinting of some interval of becoming – of change, motion and time – into the order of being. This added dimension makes cinema the final answer to the underlying need to preserve from becoming, not mere inanimate being, but a dynamic and imaginatively animate portion of changing reality. No matter how much, however, that cinema is capable of satisfying the underlying psychological urge more fully than photography, the latter has qualities that are absent, or at least diminished in the cinema. Where photography often gains in intimacy as a result of its stillness, duration and movement in cinema are prone to smoother its subject matter with expectation. Or to put the point in a manner that Bazin never would, the cinema taints the preservation of being with the dynamism of becoming, and thereby diminishes our sense of

an encounter with timeless being as the time it takes for movement to unfold provides an opportunity for expectations to influence experience.

In an age more attuned to Nietzsche's influence than was Bazin's, we are apt to be suspicious of notions of being that reside outside time; or, what is the same thing, of notions of being defined in contrast to, rather than as a mode of, becoming. Everything that exists does so in time including those things that our psychological constitution and imagination render to under–standing and experience as existing in stillness outside time. Diagnosing the psychological need that leads us to experience the photograph as preserving the being of its subject matter is not enough. For this is a perfect instance in which to follow Nietzsche and ask whether this is a need we can overcome and dispose of; and if it is, would it be worthwhile doing so? To help us to overcome the primitive psychological need that Bazin posits, and thereby the manifestation of this need and its satisfaction in the imaginative association of the photograph and inanimate being preserved through time, we need only remember that photographs are pictorial representations that – like every other material object – travel through time and are therefore subject to inevitable change. The photographs I was familiar with in my childhood in the 1970s have changed over time; the familiar now of the earlier experiences cannot be recovered from the now comparatively old, certainly dated, images. The effects of time are palpable in these pictures, and although the speed of change may be slower than the observable motion with which we are most familiar, the subject matter of a photograph nonetheless changes, grows old, as its only possible witnesses become ever more removed from its origin, and wiser or more ignorant about its subject matter. We might put the point here in the form of a variation on Heraclites' well-known aphorism: you can never encounter the same subject matter of a photograph on two separate occasions. Photographs may change over time at a rate of nearly glacial slowness, but they like everything else are in the flow of becoming.

The passage of a photograph through time and the physical changes that it undergoes constitute a very different kind of 'movement' than that associated with the perception of motion in the cinematic image. This 'movement' of the photograph consists of changes to the photograph as a material object that stands in a certain kind of pictorial relationship with a once real object situated in historical time. Time takes its toll, affecting both the photograph-as-object and its subject matter. These effects of time on the actual photograph may have so far proved often enough to be negligible for photographs stored in ideal conditions, but pigments fade and materials decay such that time will always have a slow but inexorable effect upon them. Transforming material photographs into digital image files offers a further

dematerialised existence, but of course all photographs are fated to slip into non-existence and be forgotten at some time in the near or distant future. More importantly, what the photograph is a picture *of* changes over time, though this is not to deny the referential nature of indexical photographic representation. The referential or denotative aspect of the pictorial relationship is fixed, but the sense, or connotative aspect of the photograph changes as the meaning and significance of the real objects the photograph represents change in meaning and significance over time.

As these changes in the connotative meaning of the photograph's subject matter over time indicate, the evolution in human understanding and responses over time are an important part of the movement of the photograph. We can only understand and react to photographs from our position in the here and now, and this too changes over time, both individually and collectively. If we could stand in relation to photographs from the nineteenth century, as their original spectators did, then the effects upon photographs of their movement through historical time would certainly be minimised. But since our experience of photographs and everything else is necessarily conditioned by the background of experience, judgment, understanding and purpose we bring to the encounter with the photograph, change in these conditions will effect change in the photograph as it presents itself to us in experience. To put the point a different way; the subject matter of a photograph changes over time in tandem with changes in the background conditions, and there is no neutral position available to spectators outside the historic now from which we can identify some unchanged and authentic underlying being against which to measure the changes.

But, given these arguments, what then are we to make of the notion of photographic stillness? What possibility is there of a notion of stillness formulated in contrast to such an all-encompassing movement as that of inexorable becoming? What we need is to be able to identify some feature of the photographic medium that persists through time without the possibility of change, and here Roland Barthes provides some helpful clues. Barthes, of course, differs from Bazin in treating photography from a position in which the medium is independent of cinema, and evaluatively privileged in relation to it. Even so, in the section of *Camera Lucida*, entitled 'Stasis', there are faint indications of the cinematic conception having a grip on his thought, but here it is the cinema to which deficiency is attributed, and ultimately the stillness of photography is defined in contrast to its mingling 'with our noisiest everyday life' as 'an enigmatic point of inactuality, a strange stasis, the stasis of an *arrest*.'[11] At the same time, however, this notion of photo- graphic stillness is given a cinematic inflection by his observation that the

11 Roland Barthes, *Camera Lucida*, translated by Richard Howard, Vintage, London, 1982 p.91.

cinema has none of the completeness or totality of the photographic image. Barthes explains that:

> Because the photograph, taken in flux, is impelled, ceaselessly drawn toward other views; in the cinema, no doubt, there is a photographic referent, but this referent shifts, it does not make a claim in favour of its reality, it does not protest its former existence; it does not cling to me: it is not a spectre. Like the real world the filmic world is sustained by the presumption that, as Husserl says, 'the experience will constantly continue to flow by in the same constitutive style'; but the photograph breaks the 'constitutive style'... it is without future... Motionless, the photograph flows back from presentation to retention.[12]

12 Ibid., pp.89-90.

Whether or not this statement reveals trace elements of the cinematic conception of photographic stillness, it is one of the few places in *Camera Lucida* where the concept of stillness is brought to the fore. On the whole, Barthes is less concerned with stillness than he is with emphasising varieties of photographic motion. At the same time, two of his most familiar themes point toward an account of photographic stillness that remains below the surface of his thought, never being explicitly developed. These are the themes of the uniqueness of photographic reference – alluded to in the passage just quoted, but developed at length earlier in *Camera Lucida* – and the inscription of death within photographs. From these Barthesian materials we can construct a conception of photographic stillness not explicitly to be found in Barthes, but standing in contrast to the inexorable movement of photographs within the flow of becoming.

In a well-known passage Barthes argues for the uniqueness of photographic reference. He writes:

> Photography's Referent is not the same as the referent of other systems of representation. I call 'photographic referent' not the optionally *real* thing to which an image or sign refers but the necessarily *real* thing which has been placed before the lens, without which there would be no photograph... [I]n photography I can never deny that *the thing has been there*... And since this constraint exists only for Photography, we must consider it, by reduction, as the very essence, the noeme of photography.[13]

13 Ibid., pp.76-77.

This referential essence provides precisely the sort of immutability we need to formulate a conception of photographic stillness in contrast to the movement of becoming. The identity of the photograph's subject matter, the thing from which reflected light imprinted itself upon film, is a referential constant that cannot be changed. Time can have its effect over what human beings believe a photograph depicts, and over the connotative meaning of that subject matter, but the indexicality of photographic representation forever links the image with a particular cause, and this remains impervious

to time as long as the sign survives. From this unchanging referential relationship to its first and definitive cause, we can begin to construct a conception of photographic stillness that gains its sense through a contrast with the movement of becoming. The originating imprint of reflective light from a real object is this first and definitive cause of a photograph, remaining indexically connected to that cause throughout its existence as a picture. But there is more to this notion of photographic stillness, because it is crucial that the object a photograph depicts is its first cause, the cause that brings into existence an image that immediately begins its own journey through mutable time. The photograph, that is, depicts its own temporal limit, the moment of origination after which time begins to take its effect.

The unchanging photographic reference to its originating cause, to the temporal limit of the photograph's existence, the starting point of its becoming, provides us with a conception of photographic stillness very different to that formulated in contrast to cinematic motion. For example, as the temporal limit of its own existence, there is no sense of the extractedness from a real or implicit series of images that characterises cinematic conceptions of stillness. Rather the subject matter of a photograph is the beginning of something altogether new whilst remaining simultaneously unchangeably linked to its origins through the display of its own creation. The stillness that results is less the 'arrest' that Barthes describes, than the instant of a start, a moment of origination without a meaningful past that gives sense to the idea of it being a stop as well as a start. Finally, unlike the cinematic conception of photographic stillness as the absence of motion, the present conception of stillness posits this quality as a presence rather than an absence. Photographic stillness fills the image and displays itself as unchanging pictorial reference to its originating cause, and thus photographic stillness is not, as Bazin would have us believe, the enfeebled lack of something that cinema possesses.

Stillness, so understood, can and does enter into our experience of the photograph. To be struck by this stillness is to be struck by the unchanging persistence of the photograph's pictorial pointing to its own cause. The same uncanny sense of the past being made forcefully present that Bazin gestures toward and that Barthes explores at length has its basis in our sudden awareness of an object at the temporal limit of the photograph, preserved through time in the form of an iconic indexical reference to its own origin. In the flux of experience, photographs can strike us with this stillness, distracting us from our now and making present an unchangeable connection with the past. For Barthes this experience of stillness is one of astonishment. He writes that

Always the Photograph astonishes me, with an astonishment which endures and renews itself, inexhaustibly. Perhaps this astonishment, this persistence reaches down into the religious substance out of which I am moulded...

14 Ibid., p.82.

Photography has something to do with resurrection...[14]

Echoes of Bazin here, but in other places Barthes characterises the experience of photography's unchanging reference to reality in a manner less consistent with Bazin, such as when he observes that what we see in a photograph 'is not a memory, an imagination, a reconstitution... but reality

15 Ibid.

in a past state: at once the past and the real.'[15] These are just two of many characterisations of the experienced effects of attending to the referential stillness of photographic imagery that we can find in *Camera Lucida*. Barthes also speaks of amazement and ecstasy as qualities of the experience, but he also writes at length of how our awareness of death is both triggered by, and part of, the experience of looking at photographs. Barthes never indicates that he considers death's stalking of the photograph to be an aspect of its stillness, or one of the ways that the stillness of the referential relationship enters our experience of the photograph. And yet the connection between unchanging stillness and death is readily apparent.

Discussing an Alexander Gardner photograph of Lewis Payne, a prisoner condemned to death for his role in the plot to kill Abraham Lincoln, pictured in his prison cell, Barthes observes that a new kind of *punctum* presents itself that is distinct from the earlier account in terms of a detail of the photograph. He writes:

This new punctum, *which is no longer of form but of intensity, is Time, the lacerating emphasis of the* noeme *('that-has-been'), its pure representation... The photograph is handsome, as is [Lewis Payne]: that is the studium. But the* punctum *is: he is going to die. I read at the same time: This will be and This has been; I observe with horror an anterior future of which death is the stake. By giving me the absolute past of the pose... the photograph tells me*

16 Ibid., p.96.

death in the future.[16]

This reminder of death is to be found, Barthes argues, in every photograph in virtue of its *noeme* – its 'that-has-been' – or what I have been calling a photograph's stillness in relation to becoming. Indeed, all of this indicates a powerful way in which photographic stillness of the sort we have been exploring enters into the experience of photographs. As Barthes observes, this new *punctum*

more or less blurred beneath the abundance and disparity of contemporary photographs, is visibly legible in historical photographs: there is always a defeat of Time in them: that is dead and that is going to die. These two little

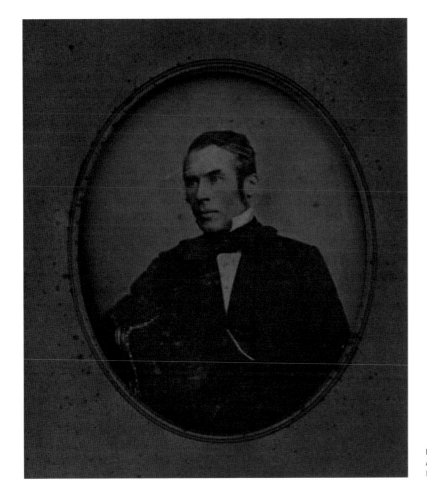

Figure 10
Anonymous portrait of a man.
Daguerreotype c.1845.

girls... how alive they are! They have their whole lives before them, but they are also dead...[17]

17 Ibid., p.96.

To experience a photograph in all its stillness, in its unchanging pictorial pointing to its original cause, is to be pricked by death, whether it is of the long dead subject, or in the future for another subject, or indeed our own death. These thoughts of death provoked by the photograph are thoughts of stillness, of a position at least partially beyond becoming; and since without

ego or experience, beyond the possibility of caring. All that survives are the visual traces that unchangingly identify what is no more or soon will be no more. Even as we are astonished by the conjunction of past and present in the photograph, we are horrified by its message of death, decay and loss. Astonishment and horror are two of the classic characterisations of the experience of the sublime, and although it is too late in this essay to pursue this thought at length, it is worth observing that there is a very great deal in Barthes that is suggestive of the experience of photography having the quality of the sublime – a quality, which, of course, is notoriously difficult to put into words. Rather than pursue this observation, I want instead to close with a brief reflection upon one final dimension of this conception of photographic stillness. Again Barthes gives us the clue.

In one of the bleakest and horror-struck passages in *Camera Lucida*, Barthes reminds us of the fate that awaits the photographs that are dear to us. He writes:

> *What is it that will be done away with, along with this photograph which yellows, fades, and will some day be thrown out, if not by me,... when I die? Not only "life" (this was alive, this posed in front of the lens), but also, sometimes – how to put it? – love. In front of the only photograph in which I find my mother and father together, this couple who I know loved each other, I realise: it is love-as-treasure which is going to disappear forever; for once I am gone, no one will any longer be able to testify to this: nothing will remain but an indifferent Nature. This is a laceration so intense, so intolerable...* [18]

18 Ibid., p.94

What happens at the death of the last person who can identify, and through that identification care about, the human subject of a photograph? (See Figure 10) This too is a kind of decay, but more powerful than the erosion of the material photograph, and typically more rapid. If there is something of resurrection in photography it is both precarious and ultimately doomed. Even the referential constant, the stillness of the photograph, is fated to pass away, but not before the subject suffers the indignity of losing his or her identity, being consigned to the nameless crowd, destined to become ever more alien while slowly disintegrating. This inevitable end is the final stillness of oblivion, and this too is inscribed in the persistent visual reference: that one day this persistence will give out, and a different stillness will follow. While the photograph hangs on, remains with us still, pointing unceasingly to its origin at the temporal limit of its existence, it displays its stillness becoming. It displays, that is, its paradox and its pleasure, its astonishment and its horror. Its stillness makes us giddy; it is a stillness that is sublime.

54 Stillness and Time

Thinking Stillness
Yve Lomax

I am almost lost for words: What can I say with respect to stillness? Yes, what can I say when it seems that for so long I have been trying to think movement; that is to say, trying to think the world as consisting of nothing but movements and processes. I want to say something; I want to find words; but, at this very moment, trying to think stillness is like banging my head against a brick wall.

How can I think stillness in a way that I have never thought before? How can I think stillness such that the movement of my thinking is not brought to a halt? (Would such a cessation be the death of me?) Now, stillness can be that warm summer's day when mind and body bathes in tranquillity; but, today, I can find no calmness in trying to think stillness and to say something with respect to these questions that are calling out for words to be found. Which is to say: I am agitated.

So, there is agitation. Yes, I can say this. But saying this makes me say that my attempt to think stillness has motion – agitation – as its starting point. I say 'starting point', but beginning with that which is in motion means that, strictly speaking, there is no starting point and things are already underway. And this is exactly how the philosopher Gilles Deleuze asks us to think as he invites us to get into thinking movement.[1]

'Look only at the movement.'

The words could be Kierkegaard's or they could be Deleuze's, but it doesn't matter. What matters is looking only at the movements. And Deleuze does look, and what he finds is an interesting coincidence: cinema appeared at the very time philosophy was trying to think motion.[2]

Movement appears in images at the same time that philosophy attempts to have movement put into thought, and in both cases it is, for Deleuze, a matter of movement ceasing to have recourse to anything beyond itself. Deleuze refuses the transcendence that comes with such recourse: 'When you invoke something transcendent you arrest movement...'[3]

Deleuze never stops attempting to put motion into thought. *How to keep thought moving?* For Deleuze, this is the real question. Now, I do not want to turn my back on this question, but it does intensify my agitation: How can I

1 See Gilles Deleuze, *Negotiations, 1972-1990*, trans. Martin Joughin, Columbia University Press, New York, 1995, p.121.

2 Ibid., p.57.

3 Ibid., p.146.

think stillness such that my thinking is not brought to a halt? And with this question there comes yet another: How can I think the 'stillness' of the so-called 'still' photographic image without my thinking becoming arrested?

I am still almost lost for words; however, I can say that for sometime it has been understood that a still photographic image never freezes the movement of time, never arrests a present moment in time. Yes, it has been understood that any such talk of freezing or arresting is born from the spatialisation of time. When the spatialisation of time occurs, the movement of time is made to continually stop at one of the numerable points that mark and divide up the 'space' of a geometric ruler or, indeed, the face of a clock. For sure, time never can be stopped but the spatialisation of time portrays time – my life-time – as measurable and open to calculation, with which comes prediction. Prediction, or, in other words, procedures through which time in its coming (call it the future) is sought to be known and neutralised – controlled – before it happens. Cutting a long story short, let me say that what the spatialisation of time offers is not only the notion of points in time that are measurable but also the presumption that the time to come can be calculated and controlled.

It was sometime ago that I first encountered the words of Jean-François Lyotard saying that what hounds and harasses human beings all the time is the miserable obsession with controlling time.[4] These words have stayed with me, and I have referred to them often. What is more, I hear the philosopher Alain Badiou saying much the same thing when he says:

4 See Jean-François Lyotard, 'Time Today', *The Inhuman: Reflections on Time*, trans. Geoffrey Bennington and Rachel Bowlby, Polity Press, Cambridge, 1991, p.73-4.

> *Our world does not favour risky commitments or risky decisions, because it is a world in which nobody has the means any more to submit their existence to the perils of chance. Existence requires more and more elaborate calculations. Life is devoted to calculating security, and this obsession with calculating security is contrary to the Mallarméan hypothesis that thought begets a throw of the dice, because in such a world there is infinitely too much risk in a throw of the dice.*[5]

5 Alain Badiou, 'Philosophy and Desire', *Infinite Thought and the Return to Philosophy*, trans. Olivier Feltham and Justin Clemens, Continuum, London and New York, 2003, p.41.

Is it almost impossible for us to side step the obsession with controlling time and calculating security? Perhaps I should put the question another way: How can we maintain an uncontrolled time? Yes, this is the question I want to shout out: How can we nourish a time that brings to us the surprise of the unexpected without which life suffocates from banality? Indeed, how can we enable chance and the unforeseen to be given a chance?

For Alain Badiou, it is a matter of constructing a time for thought that is slow and leisurely; for what marks our world is speed. As the calculation of security becomes more and more elaborate it also occurs with greater rapidity. Look at the speed with which technologies are progressed to more

quickly determine the outcome before it happens, and also look at how within our daily lives we find ourselves evermore rushing to know what is going to happen next. Yes, our world is marked by speed; 'the speed of historical change; the speed of technological change; the speed of communications; of transmissions; and even the speed with which human beings establish connections with one another.'[6] For Badiou there must be a retardation process that, in its slowing down, produces an 'interruption' within the circuits and ever increasing acceleration of the 'calculus of life determined by security'. Indeed, in the face of the injunction to speed there must be a 'revolt' that produces an interruption in which thinking can construct a time that is its own.[7] It is in this time that thinking obtains the chance to 'throw the dice' against the obsession with calculating security.

Now, it would be easy to say that Badiou's insistence upon a process of retardation brings, to our speedy world, a 'stilling'; but, if there is to be such talk, let us not forget that such a 'stilling' is a *construction* of a (uncontrolled) time for thought. And saying this makes me wonder: When hearing a cry for stillness am I hearing a plea for a time that remains uncontrolled; a time that is not spatialised and which, as such, is not subjected to measure or anything external to it?

I ask the question and wait for a response, but an answer does not arrive. However, the waiting does make me think about questioning and turn to, yet again, the words of Lyotard.

Lyotard knows only too well that procedures for controlling time are ever increasing, but he does maintain – 'let it never be forgotten' – that with the act of questioning, thinking is in a position to resist these increasing procedures: 'To think is to question everything, including thought, and question, and the process. To question requires that something happen that reason has not yet known.'[8]

To question is to have thinking receive the occurrence of that which is 'not yet' determined, and accepting this occurrence for what it is, which demands that it is not prejudged, is what, at least for Lyotard, deserves the name of thinking. In the question, thinking exposes itself to the 'not yet' determined: there is no security here and, what is more, time remains uncontrolled.

And now I find myself asking: How can a still photographic image resist procedures for controlling time? By questioning? But how are we to *see* questioning happening in this still image that is not a frozen moment of time?

I'll risk saying this: when we are open to understanding a still photographic image as an event perhaps we will see, in this event, a throwing into question of a present moment in time. Having said these words I know that I must

6 Ibid., p.51.

7 See ibid., p40, p.51.

8 'Time Today', p.74.

attempt to say more, and in saying more perhaps – who knows – I'll come to think stillness in a way that I have never thought before.

In attempting to say more let me risk saying that in every question there is a movement that throws the present tense into question. *Is* the sky blue? Let me suggest that the movement that throws the *is* into question pertains to 'the turning of time'; indeed, let me suggest that in the question time turns the present into a question. I make this suggestion but would it be too much to say that, in the question, time interrupts the present and, also, itself? Too much, perhaps; but, for now, let me say this and delve into what can be seen in and with an interruption.

Now, I could see an interruption as a rupture, but this brings to mind the image of a broken state, and seeing such an image, such a state, what becomes overlooked is the *inter* of an interruption. And what the *inter* speaks of is not a broken state but, rather, a between. In other words, an interval.

Now I am seeing an interruption as opening up an interval in time; however, it must be said that what I am seeing is not an interval that (spatially) comes between two moments in time. What I am seeing is when a present moment in time gapes open; when, that is to say, the present itself becomes an interval.

When the present is interrupted, I see time splitting in two directions at once. I see time going in the direction of that which is 'no longer' and, at the same time, I see time going in the direction of that which is 'not yet'. Indeed, with the interruption that I am seeing, what I am encountering is an interval that is composed of and created by a splitting that goes between what is 'no longer' and what is 'not yet' and which, as far as I can see, has nothing on either of its sides that would limit or terminate it. I can't say where the interval begins and ends just as I can't say how long it lasts – has the time that clocks tell stopped working?

The spatialised time of the clock-face adheres to an image of a present moment as a point that moves along a line and which, every step of the way, comes to mark one present moment that has succeeded another present moment. Here the present is a point that comes to separate before and after; but when the present moment is thrown into question and itself becomes an interval no such separation can be made. And that is to say: there is no before or after to the interval that opens as time interrupts the present; in other words, I am encountering an interval that goes on for aeons and is profoundly immeasurable. It scares me.

Yes, the interval I am seeing scares me. But wait, nothing in the present is actually taking place. Indeed, in the interval that goes between what is 'no longer' and what is 'not yet' nothing is actually happening in the present.

Now, it would be easy to rush to the conclusion that here, in this interval, time has become suspended, frozen, stopped. Yes, it would be easy to think that time has come to a standstill; but is this so? To be sure, nothing is taking place in the present, but I am not seeing, in the interval that goes between what is 'no longer' and what is 'not yet', a cessation of time. What I am seeing is the opening up of an immeasurable time. Here I am not seeing the time of Chronos, but I am seeing the time of Aion, and this time is, at least for Deleuze, the time that opens in events.[9]

For Deleuze, the agonising aspect of an event is that it is 'always and at the same time something that has just happened and something about to happen; never something that is happening.'[10] In the coming about of an event nothing takes place in the present, yet what does take place is the opening up of a vast 'empty' time, and it is such a time that I am seeing in the interval of time's interruption of both itself and the present.

Deleuze once said that he tried in all his books to discover the nature of events.[11] And what he found is that events always involve an amazing wait.[12] Indeed, in each and every event there is a wait – a *meanwhile* – in which a present moment in time does not come to pass. Deleuze does not want to miss this wait, this meanwhile. Yes, he wants to see it, even if it is unbearable, agonising; and, what is more, he wants us to see it. Perhaps it will be too much for me, but I'll test myself.

Deleuze wants us to put our seeing to the test and *see* the meanwhile of events. For sure, he wants us to see that this meanwhile, this *entre-temps*, pertains to the empty time of Aion; yet, what he wants us to see is that this time – the meanwhile – does not belong to the eternal but, rather, becoming.[13]

I have been seeing an interval – an event – in which a vast empty meanwhile opens up, and now in this interval I am seeing becoming. And what I am seeing is not a becoming that is a journey to a state of being; rather, what I am seeing is becoming in itself; that is to say, becoming in its 'pure' state. I am not sure if I really want to see this, as I fear it will be too much for me. However, even though I have my eyes shut tight, I cannot stop seeing it, cannot stop testing myself.

Seeing becoming in itself, what I see is that becoming is never what *is*. Indeed, what I am seeing is that becoming is always that which has just happened *and* that which is going to happen. Change is indeed 'on the move', yet what I am seeing is that becoming in itself is like a dance where there is a side-stepping of putting a foot down and the taking up a place in the present.

Let's say that dancing is actually happening. What *is* is the dancing that is taking place in the present; it is the dancing that is actualised or embodied on the dance-floor. But the becoming of dancing, in its 'pure' state, is what

9 See Gilles Deleuze, *The Logic of Sense*, trans. Mark Lester with Charles Stivale, ed. Constantin V. Boundas, The Athlone Press, London,1990, p.5.

10 Ibid., p.63.

11 *Negotiations*, p.141.

12 See ibid., p.160.

13 See Gilles Deleuze and Félix Guattari, *What is Philosophy?* trans. Graham Burchell and Hugh Tomlinson, Verso, London and New York, 1994, p.158.

eludes actualisation in the present. Yes, you could say that the becoming of dancing is when dancing – its next move – remains in question, as it were, 'up in the air'.

I am seeing that becoming is never what *is* and, at the same time, I am hearing Deleuze say that becomings – and events – are not part of history.[14] The living present, in which the definitive now of dancing happens, is what brings about the event of 'to dance'; however, the becoming of this event brings out a time that differs from the living present or, indeed, the succession of moments that are made to measure the day and do not sleep through the night. Yes, with every event, every becoming, there is what comes about and perishes in history; but, on the other hand, there is what escapes this historical time, which is the meanwhile that belongs to becoming in its pure state, which enjoys a virtual existence. Becoming, in its pure state, is born from history, but it is not of it.

In seeing becoming in itself, what I am seeing is that becoming never comes to rest upon a fixed point. Yes, what I am seeing is that becoming never stops where it is but always goes, in two directions at once, further. Which is to say: I am seeing unstoppable movement. Movement, nothing but movement, yet this movement has nothing whatsoever to do with a traversal of space. Rather, the movement I am seeing is the movement that comes about when the time of change is on the move and anything could happen but as yet hasn't happened. And I will risk saying that when change is on the move, and absolutely anything could happen, the movement involved is infinite. And what such infinite movement silently speaks to me of is the as yet unrepresentable, the as yet to be determined; that is to say, the time to come that is coming but as yet has not actually arrived. I say that I am seeing this infinite movement, but I have to say: it is too much for me.

In the empty meanwhile – interval – of that part of the event that escapes history, Deleuze sees the whole of time occurring.[15] Nothing is actually moving in the unhistorical time of the interval, yet the whole of time is absolutely moving. But seeing this makes me say again: it is too much for me.

The meanwhile that belongs to becoming and wherein anything could happen is like being at the edge of the world before the world *is*. It is like being at the edge of a terrifyingly ancient void. It is like hearing the silent calls of a people who do not yet exist. Intolerable? Almost. Unthinkable? Almost.

The meanwhile of the event and becoming in itself is, as far as I can see, hardly liveable, yet I hear Deleuze and Guattari saying that this event, this empty meanwhile, is pure reserve.[16] Would my thinking be going too far in saying that this pure reserve is potentiality itself? I would be the first to admit that potentiality is the hardest thing to consider; yet, now, what I cannot stop

14 See *Negotiations*, p.170-1; see also *What is Philosophy?* p.96, p.110, p.156-7.

15 See Gilles Deleuze, *Difference and Repetition*, trans. Paul Patton, The Athlone Press, London, 1994, p.89.

16 See *What is Philosophy?* p.156.

thinking is that, in relation to what is actually happening in the present, potentiality itself constitutes an empty —nothing— time. With the time of becoming nothing is taking place in the present, and now what I cannot stop thinking is that this 'nothing time' is absolute potentiality. Indeed, with the empty time of becoming, in which we are given neither this nor that, what I now cannot stop seeing is the 'abyss of potentiality'.[17]

I am seeing that becoming in its pure state never comes to rest upon a fixed point and with this I see not only the absolute movement of the time that occurs when anything could – or could not – happen (pure potentiality) but also a moment of grace where positions and oppositions don't take up a place. Indeed, in the empty meanwhile – interval – of becoming what I see is both absolute movement and a moment of grace. And saying this prompts me to think again of stillness.

In the empty meanwhile nothing happens or moves in the present and this 'nothing happens in the present' could be a way to (re) think stillness. To think stillness in this way would be, at the same time, to think the 'movement', albeit virtual, of becoming. Indeed, thinking stillness in this way does not bring my thinking to a halt; on the contrary, it invites my thinking to go with becoming in itself, which is nothing but the turning of time where chance is given a chance, which is what marks time's resistance to banality.

Nothing of the present happens in the meanwhile yet what this empty time does is to prevent becoming – and pure potentiality – from being exhausted in actualisation; indeed, it can be said that with this empty time there is a resistance to the present that keeps becoming – the emergence of a new world – from never ending. Yes, in resisting the present, what the meanwhile holds in reserve is an incalculable and irreducible 'not yet'. It doesn't hold in reserve a historical future, a prefiguration of what is to come; rather, it holds in reserve what can only be called an oceanic future.

Let me risk saying this: in the meanwhile there is a stillness with respect to anything happening or moving in the present, yet what this stillness speaks of is a resistance to the present for the benefit not of a past but of the reserve of an oceanic future. To think stillness in this way gives my thinking a moment of grace from what *is*, but the reserve that stillness speaks of here will always be too much for me to think, to bear. And it will always be too much for me because the empty time and pure reserve takes my thought to an unthinkable 'not yet'; as Deleuze and Guattari would say, it takes my thinking to the unthought within thought. This unthought will always be too much for me; however, although it is what cannot be thought it is what must be thought.[18] And it must be thought for doing so is what makes thinking have to experiment, and this is what puts thinking – and practice – to the test.

17 See Giorgio Agamben, 'Bartleby, or Contingency', *Potentialities*, Stanford University Press, Stanford, California, 1999, p.253-4.

18 See *What is Philosophy?* p.59-60.

I hear Deleuze and Guattari saying that to think is to experiment, but I also hear them saying that experimenting is always that which is 'in the process of coming about.'[19] Indeed, by experimenting thinking preserves – and produces – the uncontrolled time of becoming with which the present remains in question. Would it be too much to say that through experimenting thought gains the means to become an act of resistance to what *is*? I hope not.

In experimenting, and keeping the present in question, we expose ourselves to an unimaginable 'not yet', and doesn't this exposure make us open to having something unknown pass through us that, in effect, shows us the limits of – and makes us become strangers to – our times and ourselves? I would be the first to admit that becoming strangers to our times and ourselves can be intolerable yet, perhaps, it is what gives us the chance to diagnose what *is* intolerable in our times.

Deleuze claims that history isn't experimental. 'It's just', he says, 'the set of more or less negative preconditions that make it possible to experiment with something beyond history.'[20] To be sure, history gives experimentation 'initial conditions' but history is what one leaves behind in order that experimentation comes about. Experimentation maintains becoming in itself, it puts thinking to the test in making it go further than imagined possible and, what is more, it is what stops history from ending. Experimentation – the time of becoming – does not belong to history yet without it nothing would come about in history.[21] Indeed, the unhistorical time of becoming is what safeguards the freshness of every dawn.

And now, just as these words are to end, I see a still photographic image before me, and now I cannot stop seeing this image as an interval in which time interrupts itself and nothing of the present happens. Yes, now I cannot stop seeing this image's stillness as the amazing wait of an event wherein the present remains in question. Oh yes, now I cannot stop seeing this image's stillness as time's resistance to banality. But, perhaps, this is to see far too much. Nonetheless, what I am seeing – and thinking – is a stillness that is acting for the benefit of the 'not yet'. I don't know whether to laugh or cry. But what I do know is that here, seeing this, I am not fleeing or transcending what the photographic image gives sight to; rather, I am accepting a test and trying to go to what is within it unthinkable and perhaps, in relation to our times, intolerable.

Perhaps I should not be seeing *un entre-temps* in a still photographic image; perhaps, at least as far as Deleuze is concerned, I should be seeing it in the 'interstice' that in modern cinema sometimes opens between images (audio or visual) and which is called 'irrational' (following modern mathematics) because it produces an interval that, whilst separating or

19 Ibid., p.111.

20 *Negotiations*, p.170.

21 See *What is Philosophy?* p.112

'tracing a border', does not belong to (as the end of one or the beginning of the other) that which it separates or delimits.[22] It is not that I would prefer not to go to the cinema; rather, it is that, at this moment, I cannot look away from the still photographic image that is before me.

Time and time again, Deleuze speaks of having us become a 'seer', which is someone who sees further than they can react, that is, think.[23] He says that, whereas the media turn us into mere passive onlookers (or worse still, voyeurs), the most ordinary events cast us as visionaries; and when we become such a visionary what we accede to is a vision that unremittingly sees the time – the interval – of becoming, which is to see what is, within it, too much – agonising – to see.[24] Now, I have let myself go towards – and experiment with – such vision; however, what this means is that now I cannot stop seeing a *still* photographic image as an interval – event – in which a present moment in time remains in question; yet, what this 'experiment' has moved my thinking to do is to think stillness in such a way that demands that I ask: What contemporary image-practices are sustaining a resistance to the present?

I may have been slow in getting here, but this is the question that for me matters most: What in our contemporary image-practices is resisting the present in favour of preserving the irreducibility of that which is 'not yet' and, in so doing, maintaining a time that remains uncontrolled?

22 See Gilles Deleuze, *Cinema 2: The Time-Image*, trans. Hugh Tomlinson and Robert Galeta, The Athlone Press, London, 1989, pp.179-181.

23 See ibid., pp.169-170.

24 See *Negotiations*, p.160.

Portraits, Still Video Portraits and the Account of the Soul
Joanna Lowry

The state of our soul is one thing, the account we give of it, to ourselves and others, is another.... Our soul is a moving tableau which we depict unceasingly; we spend much time trying to render it faithfully, but it exists as a whole and all at once. The mind does not proceed one step at a time as does expression. [1]

1 Diderot, *Lettre sur les Sourds et Muets*, critical edition by Paul Hugo Meyer, *Diderot Studies VII* (1965) p.64, quoted by Michael Fried in *Absorption and Theatricality, Painting and Beholder in the Age of Diderot*, University of Chicago Press, Chicago and London, 1980. Many of the themes developed in this essay owe their inspiration to Fried's discussions about the development of concepts of spectatorship that had their origins in the eighteenth century and whose impact still resonates within the field of fine art practice today.

In this passage Diderot recognises the central difficulty implicit in the representation of what we might today call 'the subject': the tension between the time of 'the soul', as he terms it, existing in a space of duration and on-going presentness, and the intrinsic temporality of the conventions of representation or expression which always, in some sense involve a narrative and invoke a time-based sequence. What he gives voice to here is the desire that we have for an account of the soul that will in some way be transparent to its presentness, and that will provide a means by which the boundary between being and representation might be possibly breached. What is significant in his observation is the linking of this desire to a problem of time.

The problem of time has been central to discussions about the way in which photography represents reality, or, as we might say, intercepts it, disrupting our common-sense understanding of the relationship between past and present, stopping the flow of time and holding it in an uncanny stillness for years on end, revealing to us a present without a future. A preoccupation with its odd temporality has been central to the key theoretical texts about photography from Benjamin to Barthes. Significantly the discussion of the portrait has been central to many of these accounts. It seems to be the case that the representation of 'the other', of the subject or soul, is situated at some kind of limit point of visibility, a place at which the time of the subject and the time of representation are revealed as ineffably different from each other. If Levinas suggested that it was impossible to represent the face of the other, that the gaze of the other somehow presented a fissure in the field of the visible, then photography is situated on the very edge of that impossibility, the time of the other not so much represented as interrupted, and thereby revealed.

It is when we present ourselves to the camera that we become aware of the need to make ourselves into a picture and to take control of the account of our soul. Much academic interest, then, has focussed upon the notion of the pose; upon the way in which, when we are photographed, we become complicit in the discourse of photographic representation, gathering our self-hood together, performing our identity, presenting ourselves to the camera, holding ourselves steady in a mock tableau that mimics the stasis of the photograph itself. It is in the pose that we both disguise ourselves and give ourselves away, and the eloquence of the photograph is in its double-edged revelation of precisely this ambiguity. The mechanised timing of the photographic image undermines the process of self presentation: it is invariably too soon or too late. We are always aware that it is a transaction that has somehow been missed. And it always reveals something more than had been offered, but also something less. By virtue of its automatism it profoundly disrupts the skeins of attachment, meaning and interpretation through which we seek to bind ourselves to each other. It is the very fact that the still image is a product of that traumatic rupture of the hermeneutic contract between us that renders it fascinating; it produces a sign that is outside the domain of intentionality and its very lifelessness transforms us into forensic investigators of the sign. In the still image the subject in process is translated into a fixed system of signs that we, the spectators, scan for indications of some nascent interior life.

In *A Small History of Photography* Walter Benjamin contrasted the auratic presence of the sitters in the early nineteenth century photographic portraits taken by Hill-Adamson and a photograph taken of Kafka as a child of six. He is fascinated by the way in which the early subjects in the photograph gaze out of the picture, averting their gaze. The 'Newhaven Fishwife' lowers her eyes, looks modestly away from the camera; Dauthendey's wife stands next to him in the picture but 'her gaze reaches beyond him, absorbed into an ominous distance'.[2] These two poses, taken in the very early years of photography, when the genres of photographic portraiture had yet to become fixed, present to him something significant about the limitations of the technology. The image gives us the woman, but she is somehow impervious to it, and it can only indicate all those things we can never know about her, only hint at her mystery. (Figure 11) The women's refusal of the camera takes on an almost allegorical force for Benjamin. These women stand, for him, at the threshold of modernity, reminding us of a time in which the constitution of subjectivity for most people had little or no relationship to technologies of representation, to the expanded currency of the image that those technologies heralded. Most people never ever saw pictures of themselves;

2 Walter Benjamin 'A Small History of Photography' in *One Way Street and Other Writings* translated by Edmund Jephcott and Kingsley Sorter, Verso, London and New York, 1997, p.243.

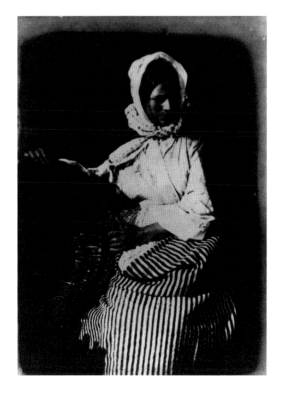

Figure 11
Hill and Adamson, *Mrs Elizabeth Johnson, Newhaven,* c. 1846.

they lived their lives outside representation: 'The human countenance had a silence about it in which the gaze rested'[3] and this, Benjamin observed, gave them a peculiar quality of self-absorption that was quickly to disappear: 'There was an aura about them, an atmospheric medium, that lent fullness and security to their gaze even as it penetrated that medium.'[4]

The auratic presence that he discerns in the image of the Newhaven Fishwife is a function, not of photography, but of its limits, of her quiet resistance to it. If aura for Benjamin was always associated with distance then it is the way in which her self-absorption creates a sense of distance between her and ourselves that seems to him to be so distinctive. This quality, which he sees as indicative of the passing of an historical era was also a product of the state of photographic technology at the time. Long exposure times meant that it was important that the sitter be photographed in a quiet secluded spot where they could concentrate on acquiring the necessary stillness demanded by the photographer:

3 Ibid., p.244.

4 Ibid., p.247.

'The expressive coherence due to the length of time the subject had to remain still' says Orlik of early photography 'is the main reason why these photographs, apart from their simplicity, resemble well drawn or painted pictures and produce a more lasting impression on the beholder than more recent photographs.' The procedure itself caused the subject to focus his life in the moment rather than hurrying past it: during the considerable period of the exposure, the subject as it were grew into the picture, in the sharpest contrast with appearance in a snapshot ...Everything about these early pictures was built to last; not only the incomparable groups in which people came together... But the very creases in peoples' clothes have an air of permanence. Just consider Schelling's coat; its immortality too rests assured; the shape it has borrowed from its wearer is not unworthy of the creases in his face.[5]

5 Ibid., p.245.

In this passage Benjamin touches upon a very particular convergence between time, technology and subjectivity. What is thrown into doubt by his reflection upon these photographs is the conventional notion of the stability of the photographic sign. The time that is figured in the image through the woman's state of plenitude and absorption is brought into being through the very slow and laborious processes of early photography. What is striking in this passage is the way in which that technology seems to have provoked an unfolding of time, causing us to inhabit, as it were, the temporality of the pose itself. It is this sense of the temporal that binds us, the readers of the image, to the subject caught on the photographic plate. The distance that Diderot remarked upon above between the lived time of the soul and the fixity of its expression in representation becomes palpable.[6] The distance between the photograph of the Newhaven Fishwife and a photograph of the young Kafka, sharing in that new complicity with the image that followed the democratisation of the image world, is, claims Benjamin, vast.

6 An interesting discussion of the relationship between the form of temporal complexity observed by Benjamin in this photograph and Deleuzian concepts of cinema can be found in Peter J. Hutchings, 'Through a Fishwife's Eye: Between Benjamin and Deleuze on the Timely Image' in *Impossible Presence: surface and screen in the photogenic era*, ed. Terry Smith, University of Chicago Press, Chicago, 2001.

This was the period of those studios, with their draperies and palm trees, their tapestries and easels, which occupied so ambiguous a place between execution and representation, between torture chamber and throne room, to which an early portrait of Kafka bears pathetic witness. There the boy stands, perhaps six years old, dressed up in a humiliatingly tight child's suit overloaded with trimming, in a sort of conservatory landscape. The background is thick with palm fronds. And as if to make these upholstered tropics even stuffier and more oppressive, the subject holds in his left hand an inordinately large broad-brimmed hat, such as Spaniards wear. He would surely be lost in this setting were it not for the immensely sad eyes, which dominate this landscape predestined for them.[7]

7 Benjamin, op.cit., p.247.

In this paragraph Benjamin draws our attention to the early history of studio portraiture with its dependence upon elaborate theatrical props and

conventions. In the midst of the paraphernalia of the display and the contrived performance of social identity he draws our attention to the self-awareness of the small boy's gaze, in which we already sense an awareness of the constraints of self-presentation. Once the threshold of photographic reproduction had been crossed we all became bound up in a currency of the image that became increasingly fundamental to the constitution of subjectivity in modern society. The difference between this small boy's pose and that of the Newhaven Fishwife is, Benjamin indicates, subtle – but absolutely significant for an understanding of the impact of technology upon the way in which we conceive of ourselves.

In drawing our attention to these two different subjects, each addressing us across the years from their separate moments in history through the medium of photographic technology, Benjamin draws our attention also to the complex variability in the ways that that technology produces both a sense of time, and of subjectivity. What is encapsulated in these two examples is the peculiar ambiguity of the photographic image, situated as it is between subject and spectator, and engaged in a dialectic between resistance, revelation and identification. After photography subjectivity is performed differently, and the correlative of this is that our sense of the presence of the other is also transformed, mediated as it is through this performance to the camera. But this sense that Benjamin was reaching for in his text, of the gulf between a secret, absorbed self, captured almost against its will by photography and the self that is constituted for photography and that is performed for it, has been central to the development of photographic portraiture. What is more pertinent to my argument here is his observation that this has something to do both with the time of being and with the alienating mechanism of the photographic apparatus – with the difference between existence and representation. Our sense of the photographic image as a fixed textual object located in the here and now, as a set of signs inscribed on the visible, begins to seem inadequate to the task of describing the problematics of this inscription of subjectivity in time through technology.

It is this issue of the relationship between time, technology and the self that is central to recent practices in photographic and time-based arts, in particular the phenomenon of the still video or film portrait, in which the subject is posed as if for a studio photograph, and filmed for anything from a few seconds to an hour or more. Recent examples of the genre include work by Bill Viola, Gillian Wearing, Sam Taylor-Wood, Rineke Dijkstra, Thomas Struth, and Fiona Tann. This type of work takes on all of the conventions of the still photograph as its framing discourse, but extends it in time, refusing the resolution of the still image and preserving the temporality of the pose.

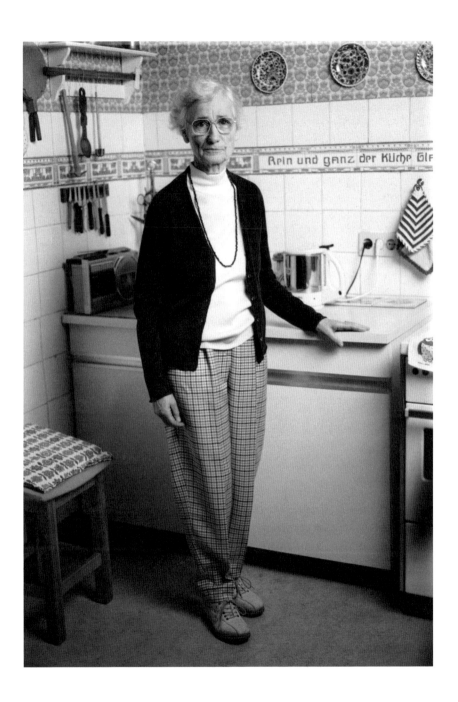

Whilst having historical precedents in experimental film work of the 1960s and in the work of performance and video artists of that period who were concerned with ideas of real time, duration and endurance, there is a strong case for situating this more recent set of experiments within discussions about photography. The adoption of a fixed camera position, the conventions of the head and shoulder portrait or group portrait, the carefully composed presentation of the subject to the camera, all indicate an attempt to delineate a space that is recognisably 'photographic'. This is a practice that seeks to use the available technology to stretch or extend the photograph to its limit, through a testing of the idea of the pose as a kind of performance.

This kind of time-based portrait, I would like to suggest, provides a peculiarly intense site for considering the triangulated relationship between subject, spectator and time, and the tension between absorption and performance that Benjamin drew attention to in *A Small History of Photography*. Perhaps it is true to say that, while Benjamin saw the distinction between the two portraits he described as being in some sense absolute and separated by historical and technological changes that were fundamental and irreversible, we might recognise the extent to which our own fascination with the portrait, photographic or filmed, continues to lie in the subject's fundamental ambivalence in relationship to the technology of representation, shifting between a performative engagement with the spectator and a self-absorbed resistance to the photographic sign. But what is significant in this type of work is how the question of the subject's presence in relationship to the spectator is changed by the framing of the encounter in time: that is by the introduction of the notion of duration. The pose here is something that takes place over time – a time that, like the still photograph, is also marked out and delimited by the operations of the technology – but nevertheless it is characterised by its ongoing presentness. In the filmed portrait we are always witness to the subject, as Benjamin put it 'growing into the picture', becoming the sign: negotiating it, withdrawing from it, resisting it, claiming it. What we see is a negotiation of the very terms of visibility itself, on a plane of the visible that has been opened up by the technological apparatuses of photography, video and film.

This process of negotiation can be seen in Fiona Tann's archival project *Countenance* (2002). Taking as her starting point *Citizens of the Twentieth Century*, August Sander's photographic survey of the German nation, begun in 1910 and first published in partial form in 1929, Tann developed a parallel archive of filmed portraits of contemporary individuals and groups in Berlin in 2002. Following the example of Sander she developed a classificatory system for her portraits based on occupation, family type, or social group. (Figure 12+13)

Her subjects were simply and artlessly filmed for around a minute at a time (and played back to us sometimes for just a few seconds), just long enough for us to have to extend the initial glance with which we assess an image into a gaze that might begin to interrogate it – and just long enough for the individuals to adapt themselves and submit to the temporal framing of the film. Standing quite still, poised against the chance and haphazard activity of their surroundings – bystanders walking past, the wind in the trees, the bustle of the street – the subjects compose themselves for the camera, gaze into it, adjust themselves, wait awhile. They are seen in the process of taking on the pose, in a kind of attentiveness to the moment that is made more significant because of the random and contingent movement around them.

These images are very knowing in their relationship to Sander's. The participants in her project were informed about his work and made aware of the relationship between the two bodies of work. His work has come, in the literature on photography, to stand for that anxiety about the social inscription of individuality within the photographic sign. As an ethnographic project *Citizens* was wedded to a positivist philosophy of description. The photographs were designed to reveal the extent to which the social position and lifestyle of the individual was engraved upon them, not only in their physiognomy but also in their expression, their stance, their clothing and their rhetoric of self-presentation to the world. The photographs were mesmerising because of the way in which they pointed to the subtlety of the pose and the camera's ability to reveal just slightly more than the subject intended. The stilled surface of the photograph provided a site for the fixing of a semiotic of the subject in the visible. It provided a mechanism for turning the subject into a text that could be read.

Tann's filmed portraits refuse that semiotic. By extending the time of the portrait by just a few seconds they expose the instability of the pose. Projected in sequence on three large screens in the gallery they disrupt the implicit dynamic of power that normally allows the spectator to look at the subject and that gives the former the advantage of time being on their side. (Figure 14) For a brief moment these figures seem to look back and to share in a kind of performed duration; they are not simply framed and distanced – their bodies reach out beyond the space of the screen and are briefly intertwined, locked in an engagement with the spectator in the lived moment.[8] The issues raised here become clearer if we look at a more extreme example of the still video portrait.

Between 1996 and 2003 Thomas Struth recorded a series of large-scale video portraits that were to be projected onto hanging screens. These were exhibited in a number of different venues, but this account is based upon

8 This description relates to the work as it was installed at Modern Art, Oxford, 2005.

Figure 14
Fiona Tann, *Countenance*, 2002.
Video projection, each screen
190 x 142 cm.

their installation in Bordeaux at the Centre for Contemporary Art in 2003. Once again there was an archival structure underpinning the work – the subjects included a number of distinct social types: an architect, a student, an art-dealer, Struth's godson, a little girl, etc. The subjects were not selected for their individuality but because, at some level, they were ordinary people – their histories were unimportant. It was their anonymity and consequently their emptiness as potential spaces for the inscription of meaning and the projection of fantasy that made them compelling. This anonymity initially impelled the spectator to consider these portraits at the level of surface, as occupying the flat dimensions of the screen. Without a sense of a particular person to whom one might begin to ascribe some meaning and identity, the faces that were presented to the spectator could only return his or her reading back onto themselves. Their anonymity refused any narrative coding

of the time of the pose. The emphasis on spectacularly large, formal and simple screens with the apparatus of projection subtly concealed, also encouraged the spectator to see these as modernist works of art, drawing attention to the elusive materiality of the surface of screen itself, reinforcing the fact that, though it offered a representational depth the screen was also an object that was absolutely without depth, absolutely thin: one could walk behind it.

The subjects sat for a whole hour in front of the camera, as still as possible, their concentration occasionally interrupted by the blink of an eye, a slight wriggle of the body or shifting of their pose. Under the imposition of the rigid terms of engagement they moved into a seeming trance-like state, alternating almost imperceptibly between a subtle self-consciousness in front of the camera and a withdrawn meditative state, flickering in between the place of being and the requirement to become a sign. At times it seemed that these people were on the brink of becoming so self-absorbed that they might slip out of visibility itself, withdraw into some other imaginary space and leave one only with the surface of the screen to gaze at. The relationship between the surface materiality of the image and the performance was absolutely fragile and thin. Here, as in Tann's piece, we see the way in which the larger cultural question of how we can know the other, how we can understand the subject, is located in terms of the relationship between technology and time. The performance of the pose becomes the over-determined site for the definition of the subject's authenticity.

If this type of portrait is about the way in which we are constituted, as subjects in a technological culture, through performance, it also raises important questions about the gaze and the significance this takes on in this context. Struth's video pieces were projected onto a series of mammoth screens suspended from the ceiling and hung, angled away from each other so that they could only be looked at one at a time. Holding their pose as still as possible for such a long period of time and staring straight into the camera lens was certainly an exercise in endurance for the subjects, one which had its own power dynamic in relationship to the mobile, shifting audience that passed through the museum halls where it was installed. The spectator felt compelled to return the gaze, to watch back, but inevitably could not meet the challenge – was out-faced, and turned to move on to the next encounter uncomfortably aware of his or her irrelevance to the subject they had left behind. Part of the discomfiture was of course related to the fact that the gaze that seemed to be directed at the spectator, was not directed at him at all, but at the camera. The very directness of the apparent form of address was in fact an illusion masking the presence of the filmic apparatus.

The camera in this work represents a blind spot in the visual field. It is the object of the spectator's gaze, but it is now absent and becomes a kind of vanishing point for a gaze that can never be met. Though we stand, as spectators, in the place it might have occupied, our own gaze can never meet the one that appears to be directed towards us.

In both these pieces of work – Tann's and Struth's – we feel as though we are engaged by the subject. Even as we look at them, they seem to be looking at us or through us, but they do not see us. Yet we also feel as though there is a sense in which, in front of the image, it is we who are positioned in the place of the visible. We are reminded of Lacan's discomfiture in his anecdote about the sardine can bobbing in the sea, reflecting the light of the sun, and not seeing him as he sits in the boat with the laughing fishermen. Now we become aware that the subjects of these works don't see us, and that the space of the visible far from being a continuous plane is in fact uneven, fissured, folded, and that this space of visibility is peculiarly complicated by the intervention of the apparatus. It is this fault-line in the visible, at the point of the illusory convergence of these two gazes – the subject's and the spectator's – that defines the difference and the distance between us.

In *The Visible and the Invisible* Merleau Ponty struggled with the development of a theory of vision that would take into account our embodied relationship to it, describing the 'chiastic' relationship between the viewer and the world, an intertwining through which the world was brought into a kind of visibility. What needed to be put into question and seen as problematic was how the viewer came to be seen as separate from the world – how the visual ever became positioned as something other, something differentiated and separate from the spectator. Stephen Melville sums up the central issue thus:

> Vision is the place where our continuity with the world conceals itself, the place where we mistake our contact for distance, imagining that seeing is a substitute for, rather than a mode of, touching – and it is this anaesthesia, this senselessness, at the heart of transparency that demands our acknowledgement and pushes our dealings with the visual beyond recognition.[9]

9 Stephen Melville, 'Division of the Gaze or Remarks on the Color and Tenor of Contemporary Theory' in *Seams: Art as a Philosophical Context*, edited by Jeremy Gilbert-Rolfe, G + B Arts, Amsterdam, 1996, p.121. Melville discusses the relationship between a Lacanian model of vision and Merleau Ponty's concept of the embodied viewer.

Recent studies theorising the history of visuality have made us more aware of its provisionality, and of the extent to which our relationship to the presumed transparency of visuality is in fact the product of complex historical conditions and cultural formations. Melville's comments draw our attention particularly to the way in which the very definition of 'the visual' is predicated upon the construction of a distance between the spectator and the world – a distance that is maintained through the work of culture and through the work of technology. Photographic technologies have provided one

key cultural mechanism for defining the place of the visual and positioning it in relationship to us. In representing the subject they also define the site of the subject's visibility, the place at which he or she can be seen. They cut through the world, interrupt it, producing difference and distance and projecting it onto the surface of the paper or the screen. They produce a differentiated space of the visible within which the subject and the spectator are made aware of their otherness and their distance from each other.

There is also a case, I suggest, for considering the way in which they produce a particular temporality of the subject. Media such as these do not 'represent' time as such; they play a significant role in producing the cultural phenomena through which we understand time. Our experiences of temporality, of duration, presence, speed, etc., in contemporary culture are increasingly a function of the technologies that support the infrastructure of our society. In the types of work discussed here we see the emergence of the production of a way of understanding the concepts of presence and duration in relation to being that is indissociable from the technologies themselves. As Mark Godfrey says in an essay on Tann's work 'new technologies produce new forms of subjectivity'.[10]

10 Mark Godfrey, 'Fiona Tann's Countenance' in *Fiona Tann: Countenance*, exhibition catalogue, Modern Art, Oxford, 2005, p.76.

The phenomenon of the absorbed, distracted subject, that Benjamin drew our attention to in his example of some of the earliest forms of photography, is significant because it reminds us of the extent to which our understanding of the subject, and of the way in which the subject is incorporated into a culture of visibility, is dependent upon the technologies of representation. The early technology of photography had a profound impact upon the way in which we learnt to read the account of the soul, and to present that account to each other. Benjamin, in his essay, noted the complex intertwining of time and performance that underpinned the photographic image; he noted the extent to which the development of photographic culture intercepted the subject and drew them into a complicity with the time of the image. This problematic is still there, although changes in technology have caused the terrain to shift. As so often is the case, and as Laura Mulvey has pointed out, as technology develops and the discourses and regimes of production that hold the very concept of 'photography' in place come under pressure, we ironically find ourselves returning to the very earliest moments in the development of the medium: the technology may have changed, but the new forms that it takes may enable us to revisit and see with new clarity, through the prism of change, the impact of the photographic upon our understanding of the self.[11]

11 Laura Mulvey, 'The index and the uncanny' in *Time and the Image*, edited by Carolyn Bailey Gill, Manchester University Press, Manchester and New York, 2000.

The technologies that have brought us the still video portrait have played a role in developing a space of the visible within which the subject can

perform themselves and move between the two registers of selfhood identified by Benjamin, resisting the textuality of the still image that might have fixed their account of themselves. They offer us a new enchantment with the provisionality and fragility of the pose, and with the alternation between absorption and performance that is central to our understanding of the self. But they also, through the very mechanisms of the recording and projection process, provide the architecture for the space and time within which the subject can be perceived in this way. They construct the discourse of visibility and distance across which we read the account of the soul.

Melancholia 2
Kaja Silverman

In this essay, I will be focusing upon James Coleman's extraordinary projection, *Background* (1991-1994). Like *Lapsus Exposure* (1992-94), *I N I T I A L S* (1993-94), and *Photograph* (1998/99), to which it is closely related, *Background* is an allegory about the formal elements out of which it is made: language and photography.[1] It also privileges 'versification' over denotation, and destabilizes the still image. Finally, in *Background,* as in the other works listed above, Coleman links the past to the present through a series of rhymes, and makes the photographic image the formal vehicle for a larger meditation upon time.

In *I N I T I A L S*, Coleman emphasizes primarily the objective dimensions of time. He does so by dramatizing the reciprocity of the relation linking temporality to photography; not only does the analogue image perdure, but time itself also has a photographic consistency. This giant photograph is not one which we can ever survey from an external vantage-point, since we are ourselves inside it. It has, however, important psychic ramifications. It renders null and void the distinction which is generally assumed to separate reality from representation, and opens the door to an entirely new theorization of human finitude.

But Coleman is finally much more concerned with the subjective than the objective dimensions of temporality. In *Lapsus Exposure*, time manifests itself primarily through the language and images which every subject inherits from the past, and within which she must make her way. We enter temporality affectively, and the vehicle of this entry is 'song'. In *Background* and *Photograph*, Coleman shapes time as much to human desire as to the transmission of language. Signification emerges from a primordial loss, to which it also always 'answers'. Affect consequently figures even more centrally in these two works. But this does not mean that there is no room in them for a more 'objective' time. For Coleman, as for Heidegger, there is finally nothing more worldly than affect. How the human subject feels at any given moment in time has dramatic consequences for other creatures and things. It determines whether or not they can appear.

<p style="text-align:center">* * *</p>

1 This essay derives from a larger study of Coleman's work. This study, which fills an exhibition catalogue, contains a chapter each on *Background*, *Lapsus Exposure*, *I N I T I A L S*, and *Photograph*. See *James Coleman*, ed. Helmut Friedel, Munich Lenbachhaus/ Hatje Cantz, 2002.

Background (See Figures 15-18) is suffused with melancholy, an affect which has often been linked to allegory: Coleman not only acknowledges this link, he also insists upon it. The most important visual representation of acedia within the Western tradition is of course Dürer's *Melancholia*. This work clusters signifiers of sorrow and contemplation – a sleeping dog, an hourglass, a setting sun, scientific instruments – around a gloomy angel, who is herself the very embodiment of black bile. A bell seems on the verge of tolling, and debris covers the ground. In a much later text – *Theses on the Philosophy of History* – Walter Benjamin also allegorizes melancholy through a dejected angel – the angel of history. Where the rest of us 'perceive a chain of events', this figure sees 'one single catastrophe which keeps piling wreckage upon wreckage and hurls it in front of his feet.'[2] And in another text, *The Origin of German Tragic Drama*, Benjamin offers a sustained discussion of the relationship between allegory and melancholy, finding the latter to be the affect specific to the former.[3]

But I do not mean to suggest that Benjamin's *Theses on the Philosophy of History* and *The Origin of German Tragic Drama* are continuous with Dürer's *Melancholia*, or that Coleman's *Background* follows directly from any of these other texts. The melancholy which concerns Benjamin is that induced by history, not black bile. He also offers a very different definition of allegory than his artistic predecessor. The tropes assembled by Dürer – like those earlier deployed by Plato and the Christian Church fathers – have a pre-given meaning, one underwritten by mimesis. Those upon which Benjamin shines his critical light have neither of these guarantees. They constitute the 'ruins' of signification – a 'petrified' landscape, in which meaning no longer resides. Allegory is also not a feature of this landscape itself, but provides – rather – a way of reading it. It represents the tragic hermeneutics through which we impose an extraneous meaning upon what once seemed to pulse with divine significance.

Although Coleman pays homage to Dürer and the medieval theory of humors by situating a black sloth at the center of the visual field of *Background*, he in no way subscribes to what E.M.W. Tillyard would call the 'Great Chain of Being.'[4] Like the author of *The Origin of German Tragic Drama*, he is concerned with the *ruins* of signification. *Background* takes place in a laboratory for the reconstruction and preservation of the skeletons of prehistoric creatures. At the same time, though, these activities are not an end in themselves. Coleman ultimately seeks not merely to 'catalogue' the 'sections' of the metaphoric sloth, but also to breathe new life into them. This project reaches its culmination in *Photograph*, which ends with the word

2 Walter Benjamin, 'Theses on the Philosophy of History', in *Illuminations*, trans. Harry Zohn, Schocken Books, New York, 1977, pp.257-58.

3 *The Origin of German Tragic Drama*, trans. John Osborne, New Left Books, London, 1977. See especially p.185.

4 See his *The Elizabethan World Picture* , Chatto & Windus, London, 1960, for an elaboration of this concept.

'quicken', but already in *Background* Coleman uses allegory as an agency for thinking beyond death.

The author of *Background, Lapsus Exposure, I N I T I A L S*, and *Photograph* might also be said to 're-motivate' allegory. He does so by basing it upon the kinds of correspondences that Baudelaire celebrates in his famous poem,[5] and Proust uses as the organizing principle of *Remembrance of Things Past*. I hasten to add that Coleman does not offer a theological or even a stable account of meaning. The metaphoric associations which interest him emerge only through the fleeting echoes and resonances which link words and visual forms to each other. It is also only via a particular listener or seer that one term can be said to reverberate within another. The temporary and subjective nature of these linkages, however, does not make them any less true. Coleman helps us to understand that it is only in finding the rhymes that are hidden within ourselves that we can complete the couplet of Being.

Figure 15
James Coleman, *Background*, 1991-94.

5 I refer, of course, to the poem 'Correspondences' which is to be found in Charles Baudelaire, *Les Fleurs du Mal/The Flowers of Evil*, trans. James McGowan, Oxford University Press, Oxford/New York, 1998.

In *Background, Lapsus Exposure*, and *Photograph*, Coleman also complicates the relationship between allegory and melancholy. He suggests that what Baudelaire calls 'correspondences' are not a throwback to a moment before the bifurcation of signifier and signified, but instead constitute a subsequent stage in the allegorical trajectory. It is only after we have ceased to believe in the immanence of meaning that we are free to form such analogies. It is also only as a result of the melancholy induced by the disintegration of the symbol that we are prompted to do so.

Coleman is in implicit dialogue with Benjamin here as well, albeit not the one who wrote *The Origin of German Tragic Drama*. In *The Arcades Project*, Benjamin links allegory not merely to the Baroque, but also to modernity in some larger sense. The latter, he writes, 'has, for its armature, the allegorical mode of vision.' This is because allegory works to dispel all illusions that proceed from the notion of a 'given order,' whether of art of life.'[6] German tragic drama achieves this goal for art by revealing the arbitrariness of the sign – by teaching us that 'any person, and object, any relationship can mean anything else.'[7] Capitalism – which is for Benjamin virtually synonymous with modernity – does the same for life by extending the principle of arbitrariness into the economic domain. The value of the commodity, capitalism's object *par excellence*, functions much as meaning does in Baroque drama; it is *extrinsic*, the result only of the relationship of the commodity with another term. 'The singular debasement of things through their signification, something characteristic of seventeenth-century allegory', finds its contemporary equivalent in 'the singular debasement of things through their price', writes the author of *The Arcades Project*.[8]

Benjamin characterizes the arbitrariness of the commodity's value as 'progressive' at one point in this latter text. However, he also dreams there and elsewhere about motivated meaning, and this dream takes the form of the 'correspondences'. In *Some Motifs in Baudelaire*, Benjamin meditates at length upon this kind of analogical signification, and its capacity to light up and exalt.[9] Although obviously deeply attached to it, he relegates it to the past – to a moment before the full flowering of consumer culture. In the Baudelaire section of *The Arcades Project*, however, Benjamin revises this chronology. He represents the correspondences as the 'antidote' to the arbitrariness of the sign – as our means for reassembling the pieces that modernity has torn asunder. He does so by quoting at length from an unidentified text by Joseph de Maistre:

> *Once can form a perfectly adequate idea of the universe by considering it under the aspect of a vast museum of natural history exposed to the shock of an earthquake. The door to the collection room is open and broken; there are no*

6 Walter Benjamin, *The Arcades Project*, trans. Howard Eiland and Kevin McLaughlin, Harvard University Press, Cambridge, Mass., 1999, p.331.

7 *The Origin of German Tragic Drama*, p.175.

8 Walter Benjamin,*The Arcades Project*, p.22.

9 See Walter Benjamin, 'On Some Motifs in Baudelaire', in *Illuminations*, pp.155-200.

more windows.... Some shells have rolled out into the hall of minerals, and a hummingbird's nest is resting on the head of a crocodile.... [But] the eye that ranges over this mighty temple of nature reestablishes without difficulty all that a fatal agency has shattered, warped, and displaced... look closely and you can recognize already the effects of a restoring hand. Some beams have been shored up, some paths cut through the rubble; and, in the general confusion, a multitude of analogues have already taken their place again and come into contact.[10]

Moreover, on the one occasion when Benjamin allows himself to meditate openly upon this linguistic second-coming, it is in emphatically subjective terms. To be human, he writes, is to name things, much as Adam did before us.[11] When we do so, we utter the words that let things Be; we complete 'God's creation'. We also produce the signifiers for which the world itself calls. Naming is, however, a strictly postlapsarian activity. What we communicate when we say the word that inducts a thing or another creature into its Being is not something already inherent within this thing or creature. It is, rather, our own 'mental being' or desire.

10 *The Arcades Project*, p.377.

11 Walter Benjamin, 'On Language as Such and on the Language of Man' in *Reflections: Essays, Aphorisms, Autobiographical Writings*, trans. Edmund Jephcott Schocken, New York, 1986, pp.319, and 317. For another elaboration of this argument, see my *World Spectators*, Stanford University Press, Stanford, 2000, pp.126-46.

* * *

Because of his commitment to the principle of epiphenomenal similitude, the author of *Background* does not hesitate to evoke melancholy through two metaphors of darkness, much as Dürer did before him: a raven, and the black skeleton of a prehistoric sloth. When the first of these metaphors is introduced into *Background*, via the voice-over, it is on the verge of dying. Rescued by two boys, it ultimately survives, but only to be carried in a black box from room to room. When the sloth is introduced into the work, through an image of three characters standing in front of it, it is practically as old as time itself. Coleman also situates it within a laboratory for the preservation and sectioning of bones. It is the primary representation in this work of 'ruination'.

But these metaphors are only one of the forms through which Coleman thematizes melancholy in *Background*. The latter begins and ends with the extinction of vision, and the sounds of a voice strangulated by the words it utters.[12] This voice, which 'belongs' to a character named 'Tom', experiences difficulty in speaking in part because of linguistic constraint: he is limited to echoing what others have said before him. He does not want this verbal legacy, we learn near the end of *Background*, but he cannot refuse it. No one speaks *ex nihilo* in the universe of James Coleman.

Tom's speech impediment also has a more local determinant: the fact that he has just re-experienced a loss which itself reenacts a more primal loss. Most of the first sequence of *Background* is given over to the verbal and

12 As Benjamin Buchloh points out in 'Memory Lessons and History Tableaux: James Coleman's Archaeology of Spectacle' in *James Coleman, Projected Images: 1972-1994*, Dia Center for the Arts, New York, 1995, p.55, the 'grain' of the voice is as important in Coleman's work as the words it utters.

Figure 16
James Coleman, *Background*,
1991-94.

13 I take the term 'aphanisis' from Jacques Lacan, who uses it to describe the effects of language upon the subject. See *The Four Fundamental Concepts of Psycho-Analysis*, trans. Alan Sheridan, Norton, New York, 1978, pp.216-229.

visual articulation of this loss. Its second and most important image shows a woman wearing a red suit standing between two men, one dressed in black and the other in jeans and a gray jacket. She is turned slightly toward the man on the right, who extends his hand to her. Although he is literally present, the man on the left seems to fall out of the field of vision. As we look, Tom identifies the woman as 'Jill', the man with the outstretched hand as 'Jo', and himself as the site of the 'fading' or 'aphanisis.'[13] He also tells us that Jill has turned toward Jo in a negative response to his own request that she come to him.

This refusal evokes the failure of another attachment – the end of the childhood love between himself and Jo. 'I hoped...it would last...f...forever...forever...Jo', Tom says at a key moment in this sequence. And although this part of *Background* marks the beginning of one relationship, as well the frustration of another, later sequences will show how hard it is to achieve or sustain a union, whether it be a marriage, a sentence, or the synchronization of sound and image.

But this is far from delimiting the uses to which Coleman puts the affect of melancholy in this work. The atmosphere of negativity which suffuses *Background* also has a crucial conceptual dimension. In it, as in *Lapsus Exposure*, *I N I T I A L S* and *Photograph*, Coleman both theorizes and reinvents still photography. He reinvents still photography by temporalizing it in a number of different ways. But his account of this form as it now exists also represents an expansion of our usual way of thinking about it, since it constitutes for him not only a technology, but also a perceptual logic, and a way of 'being'. Melancholy resides at the heart of all three because the still photograph signifies first and foremost 'mortification'.

The story which *Background* tells begins with what appears to be a nostalgic conversation between Tom and Jo about a group of photographs documenting the origin of Jo's relationship with Jill. Tom locates the latter unequivocally in the past. However, the words he utters prior to the first images are suggestive of an event taking place in the present – something which need not be feared, since it will be over in a second. This event is photographic in nature. 'In a flash...it's o.k....it's o.k.', is how his discourse begins. There is a parallel ambiguity about who is speaking at any given moment of the first sequence. A moment ago I attributed the voice-over text to Tom, but it is clear that Tom often speaks for Jo as well, not only in indirect, but also in direct discourse. In later sequences, he will do the same for other characters as well. Because of this, Tom's voice moves around spatially as well as temporally. Over the course of *Background*, it becomes less and less his

'own'. In subsequent works, Coleman will stress even more the exteriority to the subject of the words she speaks.

The term 'voice-over' also needs to be qualified. Although *Background, Lapsus Exposure, I N I T I A L S*, and *Photograph* all include non-sychronic voices, and are, indeed, based upon a technology which precludes synchronization, the relationship which they establish between word and image defies the usual categorizations. There is no 'outside' or 'above' to the space and time which Coleman's works traverse – no vantage-point from which a metacritical discourse might be marshaled. The voices in these works consequently do not speak 'over' the images to which they refer, but rather from within them.

The author of *Background* emphasizes the all-encompassing nature of the space his camera discloses by never leaving the room housing the prehistoric skeleton. Every image in this work was shot there; the apparent shifts of scene are due only to different camera set-ups. Coleman gives time an analogous circularity in *Background*. Not only does this work begin and end with Tom's voice speaking in the dark, but the past also doubles back upon the present, like a möbius strip. Shortly after the evocation of an ongoing photographic session, Tom proceeds to resituate this occurrence in the past. In the next sequence, though, he reverts to the present tense, speaking first from the perspective of a photographer coaching his subject, and then from that of the one being photographed. Nothing in the sound or image permits us to situate the photographic transaction before the conversation about the resulting images which takes place in the first sequence; rather, the two seem to be happening at the same time. Later, Jill and Jo look at the photographs which are ostensibly in the process of being shot, and Tom also situates their verbal exchange in the present. Now we are asked to think the simultaneity of three distinct moments. Thereafter, all verbal transactions transpire in the present. This implies, however, not the abolition of temporality, but rather the opening up of the 'now' to include the past and the future.

In addition to staging the production of a photograph, *Background* offers a meditation on the nature of photography. As we learn in the first sequence, a photograph is instantaneous, a 'snap'. It has no duration. It also arrests or freezes movement. Paradoxically, though, it seems to provide the permanence which human relations lack; unlike the love between Tom and Jo, it is 'forever'. In both of these ways, the photograph immortalizes what it shows. It also gives us what it depicts in the form of a 'having been'. The flash of the light bulb with which Coleman metaphorizes the production of a photo could be said to mark the happening of the present in the form of the past. It thereby undermines temporality from another direction, as well. Because the photo-

graph attests to the actuality of what it locates in the past, it constitutes a form of proof, and hence an agency of possible incrimination. Coleman underscores this last feature of photography obliquely, by having Tom say threateningly at one point, on behalf of Jo: 'I have the ph...photographs'.

<p style="text-align:center">* * *</p>

So far, Coleman's account of photography echoes that offered by other theorists of photography, such as Walter Benjamin, Roland Barthes and Christian Metz.[14] Where it goes beyond established assumptions is in its depiction of photography as a form of identity; a perceptual system; and a negation of Being. Coleman begins this part of his discourse by stressing the interpellatory nature of the photographic event.[15] A camera summons people and things to pregiven places within space and ideology. At one of the points in *Background* when Tom talks about standing in front of the camera, rather than behind it, he says portentously: 'we were...being positioned'. And at one of the moments when he seems to be on the other side of the camera, he tells Jo and Jill to 'come into...the light'.

Photography can interpellate us formally as well as spatially or ideologically. When someone reaches for a camera, most of us freeze into an anticipatory still. And even when a camera is not present, we often offer ourselves to the look of those around us in the guise of the photograph we would like to be.[16] We do so by means of the pose. The pose is one of the most recurrent elements of Coleman's work. Although its role shifts from work to work, it functions in *Background* primarily as a means of expanding the notion of the photograph to include the bodily ego. By means of the stiff and studied ways in which they hold themselves, whether they are looking at a photograph of themselves, or being photographed, the characters in this work make evident that they are playing to an internal as well as an external camera.

Craig Owens maintains in *Beyond Recognition: Representation, Power, and Culture* that posing takes place in the middle voice – that it is neither strictly active, nor strictly passive, but somewhere between these poles.[17] This is because the one who poses simultaneously displays something, and attempts to be seen – because she is both subject and object. This is an extremely helpful formulation. But in an important sequence in *Background*, Coleman suggests that posing may also include a subsequent moment – one which involves a far more radical form of objectification.

In this sequence, Jill and Jo look at the photographs of themselves which are simultaneously in the process of being shot. An elaborate flirtation

14 See Walter Benjamin, 'The Work of Art in the Age of Mechanical Reproduction' in *Illuminations*, pp.217-51; Roland Barthes, *Camera Lucida*, trans. Richard Howard, Hill and Wang, New York, 1981; and Christian Metz, 'Photography and Fetish' in Carol Squiers, ed., *The Critical Image: Essays on Contemporary Photography*, Bay Press, Seattle, 1996, pp.155-64.

15 I derive the concept of 'interpellation' from Althusser, who uses it to theorize the operations of ideology. See his 'Ideology and Ideological State Apparatuses' in *Lenin and Philosophy*, trans. Ben Brewster, Monthly Review Press, London, 1971, pp.127-86.

16 For a much fuller elaboration of this argument, see my *The Threshold of the Visible World*, Routledge, London/New York, 1996.

17 Craig Owens, ed. Scott Bryson, Barbara Kruger, Lynne Tillman, and Jane Weinstock, *Beyond Recognition: Representation, Power, and Culture*, University of California Press, Berkley, 1992, pp.214-15.

ensues, in which Jill gives herself via one of the photographs to Jo, and then coyly demands that he return her to herself. At one moment Tom says, on her behalf, 'let's pose – freeze.'[18] It is unclear whether these words signify her desire to establish an absolute oneness with the images at which she and Jo are looking, or her wish that she might achieve a similar union with a new and better one, but in either case they reflect the subordination of her bodily ego to the photograph.

But the pose signifies even more than the immobilization or objectification of the body, or its solicitation of the camera. It also implies the isolation of the body from the surrounding field of vision. This is one of the ways in which Coleman uses it in *Background*. Both because of the seeming impermeability of their bodies to their surroundings, and the contrast of their brightly-coloured clothing against the drab walls of the room in which they stand, the figures in this work seem to have been cut out of another photograph, and

Figure 17
James Coleman, *Background*, 1991-94.

18 I say 'Jill', but the case could be made that it is Jo who first gives himself through the photograph to Jill, and then demands its return – or that both characters are doing this simultaneously.

pasted into the ones we see. This has the effect of underscoring their isolation from each other, as well as their removal from time and space. Coleman dedicates a whole sequence of the installation to this topic.

The sequence in question comes near the end of *Background*. Four characters appear in it – Tom, Jill, Joe, and a red-haired woman, who also figures in several earlier sequences, and who appears to have been romantically linked with Jo before his involvement with Jill. These four figures are dressed in contrasting colours: Jill in red, the other woman in green, Joe in black, and Tom in brown. Each also stands at a significant distance from the others; faces away from them; and occupies a different plane of the image. Now deploying a third-person narrating voice, Tom says: 'One eye/I...here...the other...there...each...their own way'. Through the parsing of his sentence, he mimics the atomization he describes.

Coleman teaches us that photography encroaches as fully upon Being as it does upon identity – that it is an ontological as well as an egoic affair. In *Background*, 'camera' signifies an affectless kind of human perception, as well as a machine for the automatic production of images. It represents a kind of vision, that is, which is inimical to love. Coleman makes this point in two back-to-back sequences of *Background*. The first of these sequences immediately follows the one where Jill and Jo exchange the photographs of themselves. One of those characters says 'in images....to im-mort-alize', and the other adds 'our love', extending death from what is shown in the photograph to their feelings for each other.

In the second sequence, Coleman makes an even more overt link between photography and the arrestation of passion. He uses the word 'stoppage' to refer simultaneously to a snapshot and the relationship of Jill and Jo. 'Why are you...sad?' Jo asks Jill (or Jill asks Jo). 'I was thinking...of our... situation...I...am afraid...stoppages', she (or he) replies. Tom then says, as much on his own behalf as on that of Jill or Jo, 'I closed my eyes'. These last words also carry a double meaning – one bearing both upon the photographs at which Jill and Jo have been looking, and the role played by Tom's look in the photographic transaction. With them, Coleman characterizes photography as a blindness which is capable of afflicting the human eye, as well as a representational form that seldom conforms to our narcissistic desires.

The stoppage of love which the camera signifies has ontological ramifications. No creature or thing can be itself without the libidinal involvement of a human subject. Coleman characterizes love in visual terms because it is first and foremost a scopic affair – because it requires the 'meeting' or 'marriage' of 'tissue' and 'eyes.' Such an event does not transpire

every day. Most of the times when our eyes are literally open, they are metaphorically shut. The meeting of look and world occurs, imparting reality to the real, only when a creature or thing steps forth, requesting to be seen in a particular way, and is then apprehended both in its own specificity, and from the singularity of a particular subjectivity.[19] The look satisfies this seemingly impossible mandate by establishing correspondences between what it sees in the present, and what it has seen in the past. The more complex and profuse these correspondences are, the greater is its love.

19 For a fuller elaboration of this argument, see my *World Spectators*. Stanford University Press, 2000.

As should be evident by now, the kind of looking I have just described requires time: the time it takes for a pulsating and shimmering creature or thing to disclose enough of its formal parameters to a seer to be apprehended as something other than an 'entity', and that unique and ever-changing time which is at the heart of every subjectivity, whose temporality is not the past, the present, or the future, but the past and the future *in* the present. The still camera signifies a failure of vision for Coleman because it does not have access to this time.

In *On Some Motifs in Baudelaire*, Benjamin also contrasts photography to the kind of looking which is creative of correspondences, and makes time the fulcrum of this opposition. Whatever is looked at photographically, he tells us, seems like 'food for the hungry or drink for the thirsty' – eminently consumable. We are under the impression that we could exhaust its meaning in an instant. To embed a creature or a thing in an associative network, on the other hand, is to tap into the infinitude of human desire. It becomes that 'of which our eyes can never have their fill'.

We often look in a way that is photographic in nature because technology cannot not encroach upon the human look, and ours is a photographic age. But every technology, as Heidegger tells us, harbors a saving power.[20] If the look can pass under the influence of the still camera, then the still camera can also pass under the influence of the look; it can even become the agency whereby the Being disclosed by one pair of eyes becomes available to others as well. In a sense, these are also the moments when the analogue image most fully realizes its own potentiality. Is it not finally because of its capacity to show us what no other form can reveal – the participation in the event of the appearance of the world, as well as the look – that we find photography so endlessly fascinating and compelling?

20 Martin Heidegger, 'The Question Concerning Technology' in *The Question Concerning Technology and Other Essays*, trans. William Lovitt, Harper and Row, San Francisco, 1977, pp.25-35.

* * *

In *Background*, Coleman breaks with photography as it is conventionally practiced and lived. He does this both verbally and formally. After making

Figure 18
James Coleman, *Background*,
1991-94.

21 This is another of the
moments when it is not clear
– and not supposed to be clear
– for whom he is speaking.

Tom comment upon the interpellatory nature of photography by saying
'stand...here,' he has him add, by way of correction, 'no...not stand...dance...
around.'[21] Coleman accompanies this remark with a series of tableaux of his
characters doing just that. Through these tableaux, a crucial although almost
imperceptible transformation occurs: the still photograph mutates into what
might be called the 'stilled photograph.'

'No crime committed but...passion,' Tom says at another point in
Background, not only calling into question photography's status as evidence,
but also invoking the affect which the eye must enlist if it is to look in the
way that permits it to meet tissue. The word 'passion' refers back to an
earlier moment in *Background*, where it emerges precisely in relation to the
look. 'I could...feel seeing,' the narrator says there, on behalf of one or
perhaps more of the work's characters, underscoring the affective bases
of the truly human look.

Coleman's final rhetorical break with photography is absolute. Tom orders his companions to 'pack up...the Nikon...the latex,' as if to have done with it altogether. This command follows immediately upon the heels of the each 'eye/I' in its 'own way' meditation, making the latter an invitation to the look to assume its difficult singularity, over and against the easy automatism of the camera, as well as a description of the isolation to which photographic articulation leads.

Given that it is a temporal form, which involves actual movement along with the representation of movement, cinema might seem to provide a way out of the impasses of photography. The kind of movement which cinema shows us, however, is primarily physical in nature, and is generally used to eclipse rather than to disclose temporality. A short-hand phrase often used in discussions of early cinema – 'race to the finish' – can still be used to describe most contemporary action films; they encourage a prolepsis which is inimical to time. Coleman himself uses a variant of the phrase 'race to the finish' late in *Background*, albeit without naming cinema as such. He has Tom say that he is afraid not only of time stopped, but also of 'time...racing.' As will become increasingly clear in *Lapsus Exposure*, *I N I T I A L S* and *Photograph*, the kind of movement which really interests Coleman is perceptual, not physical, and for this he needs another set of technical coordinates.

Background, *Lapsus Exposure*, *I N I T I A L S* and *Photograph* all require for their viewing the precise lining up of three different slide projectors, and (at least in the form in which I saw these works) an audio c.d., computer programmed to proceed in tandem with the slides which have been inserted into their carousels. The projectors go on and off at planned intervals, projecting the images onto a large screen. Sometimes what is shown is a single slide, and sometimes a superimposition of two or three. At times, one slide appears mid-way through the tenure of another, and perhaps outlasts it. At other times, a slide disappears almost as soon as a second has been projected onto the screen.[22] This system has the capacity to volatilize the still photograph. It is also capable both of representing and activating the movement at the heart of vision.[23] The spectator who enters the room in which *Background*, *Lapsus Exposure*, *I N IT I A L S*, or *Photograph* is projected finds no chair to sit on, and no limits on when she may enter or leave. This spectator must decide for herself whether to stand, or sit on the floor, as well as at what distance from the screen; whether to look at the slides or the interlocking projectors which are projecting them; when to begin watching, and when to break off; and whether to stay in the same position, or move about. Although each of these freedoms might seem quite limited, together

22 For other accounts of Coleman's 'medium' see Rosalind Krauss, 'Reinventing the Medium', *Critical Inquiry*, vol. 25, no.2, pp.289-305, and 'First Lines: Introduction to *Photograph*' in *James Coleman*, Fundació Antoni Tàpies, Barcelona, 1999, pp.9-25, and Raymond Bellour, 'Les morts vivants', Centre George Pompidou, Paris, 1996, p.31. The notion of a medium has been at the heart of much of Krauss's recent work. In the first of the essays listed above, she explores the complex challenge which photography poses to this notion.

23 And as Krauss suggests in 'Reinventing the Medium', "the medium Coleman seems to be elaborating *is* just [the] paradoxical collision between stillness and movement that the static slide provokes right at the interstices of its changes" op.cit., p.97, (my emphasis).

they open the door to the experience of perceptual movement, as well as providing for a singular viewing experience.

In *Background*, Coleman uses this set-up mostly to insert what appear to be fades between images and sequences, although they are technically dissolves. These fades are all linked to the longer periods of darkness at the beginning and end of the work, and consequently serve in part as signifiers of melancholy. But they also perform an important theoretical function, and one which is potentially generative of a very different affect: they make possible the production of what Coleman calls 'polaroids...fading.'

It is the nature of a photograph to constitute a *persistent perception*, albeit of the past. Unless it is exposed to sun, or water, or some other element which erodes its material base, an analogue image of a sunflower goes on showing the same sunflower month after month, and year after year. We human beings, on the other hand, have virtually no persistence of vision. Although our conscious perceptions are often informed by unconscious memories which can last a life-time, they themselves endure only long enough to cover the line separating one film frame from the next, once a perceptual stimulus has been removed.

Earlier, I emphasized how important it is that what we see in the present be informed by what we have seen in the past, both for ourselves, and for the world; if we could not look in this way, there would be beings, but no Being. Left to its own devices, though, the unconscious would forever project the same mnemonic slide on the screen of consciousness, to the exclusion not only of other memories, but also of the perceptual present. A particular past would persist in the form of an eternal present tense. Although this is the reverse of what a camera classically does, which is to capture the present already in the form of the past, it would be just as effective in excluding time.

In order to challenge the kind of vision which immobilizes what it sees, then, it is not enough to summon memory; we must also draw upon what might be called the 'infidelity' of the perception/consciousness system. By using his three slide projectors to fade 'in' and 'out' of the analogue images he shows us, Coleman does just this. He makes it possible for one worldly form to cede to another, or to reveal another aspect of its own.

* * *

Coleman ends his allegory about photography on a melancholic note, just as he begins it. In the brief final sequence, Tom recounts the story about the black raven being carried in a glass case from room to room. The spectator who is still sitting in the room listens to this story from within a darkness

akin to night. But we are not as far as it might seem from the kind of seeing which can never have its fill. It is out of precisely such a darkness that this look will later emerge.

Although Colemanian allegory culminates in joy, it is only made possible by the melancholy precipitated by a primordial loss. The primary representative in *Background* of this loss is neither the turning away of Jill from Tom to Jo, nor Jo's earlier rejection of Tom. It is, rather, the sloth, who has paid for his entry into the discourse of paleontology with his very life. This sacrifice is one which each of us has also made, by simple virtue of using words which, rather than referring to things, refer only to other words.[24]

For the one emerging into the light for the first time after making this sacrifice, the world cannot help but seem bloodless and reduced. It has, after all, been transformed from unity and plenitude into a forest of signs.[25] We moderns are not the first to have registered the semiotic consistency of our surroundings; we are only the first to have apprehended the arbitrary relation of signifier and signified. Our predecessors also felt themselves to be inhabiting a domain of 'shadows' or representations of representations, but they could take comfort in the belief that the latter constituted a divine language, or at least one with a stable signified.

For those of us for whom God is 'dead,' it is often argued, there can no longer be any kind of meaning. The signified 'slips' beneath the signifier, or fails altogether to appear. If it comes into play at all, it is only because of linguistic convention. In *Background*, *Lapsus Exposure*, *I N I T I A L S*, and *Photograph*, Coleman duly registers the arbitrariness of the linguistic sign, but he maintains that it is only here that the real story of meaning begins. We are not consigned after the advent of the word to a far shore, like Robinson Crusoe on his island. The linguistic signifier is, rather, what opens up the possibility for a rapport between ourselves and what surrounds us.

There can be nothing more fortunate than our 'fall' into language. The melancholy generated by the loss of 'life' or 'presence' discloses the world to us, since it is in an attempt to make good our loss that we first open ourselves to it. Our *manqué-à-être* also confers upon us the capacity to name other creatures and things, and – in so doing – to complete them. When we finally stop searching for what we have sacrificed to language, and embark upon the life-long quest of symbolizing it, we begin exercising this nominative capacity. And at the moments when we do so, melancholy gives way to joy.

As should by now be clear, the English terms 'affect' and 'state of mind' do not do justice to the complexity of this last emotion. If we want to understand the kind of rapture naming affords, we must turn instead to

24 I draw here upon Jacques Lacan's account of the entry into language, which is set forth most clearly in *Four Fundamental Concepts of Psycho-Analysis*, pp.203-229.

25 Of course we never experience this unity and plenitude as such; they constitute a retroactive fantasy.

the German word 'Stimmung.' In everyday speech, 'Stimmung' generally signifies 'mood.' Etymologically, however, it means the attunement of one thing to another, and this meaning is still current in the verbal form, 'stimmen'. Let us benefit from one of the most important lessons Coleman has to teach us, and hear the echo of the past within the usage of the present. If 'Stimmung' once meant 'attunement,' and later 'mood,' it must be because certain moods constitute less a psychic state, than the ontological adjustment of one being to another. So is it, in any case, with joy.

Posing, Acting, Photography
David Campany

A gesture cannot be regarded as the expression of an individual, as his creation (because no individual is capable of creating an original gesture, belonging to nobody else), nor can it even be regarded as that person's instrument; on the contrary, it is gestures that use us as their instruments, as their bearers and incarnations.
Milan Kundera[1]

1 Milan Kundera, *Immortality*, Grove Press, New York, 1990.

... I would say that no picture could exist today without having a trace of the film still in it, at least no photograph, but that could also be true of drawings and paintings maybe.
Jeff Wall[2]

2 Jeff Wall, 'Interview/Lecture', *Transcript*, vol. 2, no.3, 1996, p.5-29.

Defining photography has always been a matter of comparison and contrast. Right from the start it has been understood through other media. Across its history, painting, literature, sculpture, theatre and cinema have offered different ways to think about what photography is. Not surprisingly different ideas have emerged. Painting puts the emphasis on questions of description and actuality; literature puts the emphasis on realism and expression; sculpture emphasises qualities of volume and flatness; theatre emphasises the performative; cinema usually emphasises aspects of time and the frame. These ways of thinking are almost unavoidable. We see them in all kinds of discussion of photography, both popular and specialist. They can be very illuminating. But they can also be artificial.

First of all, the comparing of media often lapses into 'technological determinism', stressing the mechanical facts over social use. Or more frequently, what may seem like technical thinking often turns out to be thoroughly rooted in our always social understanding of media. For example Christian Metz' brilliant essay 'Photography and Fetish' is an attempt to compare and contrast photography and film.[3] He sees that the two share a technical similarity but each has its own relation to time, framing and the experience of objecthood. But as his argument unfolds it becomes clear that what's really at stake are not the differences or similarities between film and

3 Christian Metz 'Photography and Fetish' *October*, 34, Fall 1985; reprinted in Carol Squiers, ed., *The Critical Image: essays on contemporary photography*, Bay Press, Seattle, 1990.

photography per se, but between film in its popular narrative form and the photograph as domestic snapshot. Film is not inherently narrative or popular, photography is not inherently domestic or a snapshot. Metz' opposition starts off general and technical but soon becomes a particular contrast between quite specific social uses of the still and the moving image.

Secondly, simple binary contrasts can overlook the fact that crossover between media can be much more radically hybrid. The growing convergence of image technologies and their uses may often appear to make the idea of distinctive mediums seem old fashioned to us. Technologies are overlapping and blurring while the once distinctive uses of media are being eroded producing 'infotainment', 'docudrama', 'edutainment', 'advertorials' and the like.[4] That said, such hybrid forms may also alert us in new ways to specific differences between things. For example we may grasp 'cinema' as a cultural form now scattered across many sites and technologies – television, DVD, video, the internet, mobile phones and posters, as well as actual movie theatres. But the scattering may attune us to what is particular about each encounter. In this sense the world of 'multimedia' is also a world of 'many media'. And we come to know what media are less by looking for their pure centres than their disputed boundaries.

I want to take as an instance of all of this the recurring fascination shown by photographers and artists with the depiction of narrative gesture in the still image. I have in mind the staged photograph as it has developed in the art of recent decades. It provides a useful way to think about the way hybrid practices attune us to differences and similarities.

I begin with a particularly rich binary: *acting* and *posing*. Straight away we may associate 'acting' with something unfolding or 'time based' like cinema or theatre. 'Posing' may suggest the stillness of photography or painting. A sharp reader will also be thinking of examples that complicate this: scenes of arrest such as the *tableau vivant* in theatre, or cinema's close-up of a face in pensive contemplation, or blurred movement caught but escaping a long exposure, or as we shall see, the narrative gesture performed for the still photograph. Such things could be said to be exceptions that prove the rule that acting belongs to movement and posing to stillness. But they are much too common to be mere transgressions. They are a fundamental part of how makers and viewers have come to understand images.

Before turning to recent photography let us first consider a film made over half a century ago. In one of his early comedies Federico Fellini makes a light-hearted but perceptive comment on cinematic movement and the stillness of photography. *Lo Sceicco Bianco* (*The White Sheikh*, 1952) follows the making of a *fumetto*. Fumetti were quickly produced photo-stories printed

4 The consequences of this are discussed by Victor Burgin in 'The Image in Pieces: the location of cultural experience' in Hubertus von Amelunxen, ed., *Photography After Photography* , G+B Arts, 1997.

Figure 19
Film still, *The White Sheikh*,
Federico Fellini, 1952.

on cheap paper. Read in great number by hungry film fans they were
commercial spin-offs from popular film culture. In the style of comic books,
they used sequences of staged photos to tell filmic tales with the help of
captions and speech bubbles. (Although never very popular in Britain,
fumetti were a staple of post-war popular culture in mainland Europe,
particularly Italy and France). In *The White Sheikh* we see what looks like a
regular film crew setting up on a beach. (Figure 19) They are about to shoot
a scene in which the gauche and chubby White Sheikh – a pale imitation of
the silent movie heart-throb Rudolph Valentino – slays his foe and rescues a
'damsel in distress'. Fellini shows us a frantic director preparing his ragbag
crew while marshalling his second-rate performers who can't get jobs in the
real film industry. They begin to play out the scene. Suddenly in a comic
reversal of cinematic action, the director shouts "Hold it!" The 'actors' freeze
in their postures, as if in some party game. A cameraman – we now see he
is a still photographer – excitedly takes a single shot. The actors spring back
into movement and the scene continues. Sometimes they pose themselves
as best they can, or they halt when the director yells at an instant within the
flow. Fellini cuts rapidly between the director, the actors and the stills man,
presenting it all in his carnivalesque, knockabout style. The paciness may be

5 I am thinking of the post war cinema of Michelangelo Antonioni, Straub and Huillet, Robert Bresson, Wim Wenders, and Michael Snow (and countless contemporary video artists for whom slowness seems the only possible mark of serious reflection). A full discussion of the often simplistic equation between slowness and seriousness will have to wait for another time.

why, unlike the more self-conscious films that have explored stillness (most of which are ponderously *slow* films) this one is all but forgotten.[5] Nevertheless the scene is a subtle and nuanced commentary on acting, posing, movement and stillness.

No doubt Fellini gives us an unrealistic account of how a *fumetto* would actually have been produced. He models the photo shoot too closely on filmmaking. He plays it as a losing battle of arrestedness against the juggernaut of popular cinema's momentum, as if a photographer were trying to actually photograph during the making of a moving film. In this Fellini positions photography as a poor relation of cinema. In cultural, economic and artistic terms this was so, even by 1952. The inequality was not something to be thought just at the level of the apparatus (the photograph as a primitive ancestor of film). Fellini was thinking in cultural terms too. Photography was being used to serve and mimic cinema.

Today the *fumetto* has all but vanished. The desire to possess a film in a fixed form is now satisfied by video and DVD. But photography and cinema maintain an uneven relationship. Cinema continues to make use of the still photograph for publicity (an issue I will return to later in this essay). Meanwhile photography in art has moved from the spontaneous freeze of the 'decisive moment' (by which photography was first compelled to differentiate itself from cinema in the 1920s and 30s) to the slower narrative tableau that we now see in advertising, documentary photography, fashion and photo-journalism as well as in art.

There is quite a variety of styles of acting, performance and gesture in comptemporary photography. The more dramatic follow the precedent set by Cindy Sherman and Jeff Wall, two artists who turned toward cinematics in the late 1970s. They began to expand what was then a pretty narrow repertoire of human expression and behaviour in art photographs. Technically and stylistically their pictures were highly accomplished from the start. Departing from the simple use of photography to document performance, Sherman and Wall engaged explicitly with the idea of performance *for* the image and performance *as* image. Their pictures were the result of a range of considerations – not just gesture but framing, lighting, costume, make-up, props, location and so on. The craft complex of cinema was applied to photography. This was an instance of the 'reskilling' that followed the technical reductions of photo-graphy in Conceptual Art. Since then, for one reason or another, Sherman's and Wall's imagery has tended to revolve around enacting moments of social and psychological doubt or disturbance, as we shall see. As a result there is often a deliberate gap between the uncertainty their work pictures for us and

the certainty of the images themselves – their sophisticated rhetoric, their control and assured handling of mise-en-scene.

This is perhaps most apparent in the peculiar character of the narrative photographic tableau. The tableau is an inherently artificial structure. It is a constructed form, often on the border of naturalism. It condenses, displaces and distils separate things and moments into a fixed image. It is then consumed by the viewer first as a pictorial whole then piece-by-piece as the eye and mind roam around the image, assembling meanings. In this sense the tableau exists in an idealised realm of fantasy in which everyday social laws of time and space may not wholly or clearly apply. So while it might describe the social present or past, the tableau image also belongs to the future. It always has, at least in part, a future tense. It is an imagining of the social world. Hence, the tableau photograph always has an inescapable oddness about it. A tension is created between the photograph as record or evidence which locates it in the past, and the ideal narrative organisation of the image that conjures an imaginary dimension. This tension, which can be made into an artistic virtue, is most acute around the depiction of the human figure.

Despite its regular dialogues with theatre, photography's artistic merit was discussed almost exclusively in relation to painting until the 1970s. It was only when it was taken up in relation to cinema that its theatrical condition was examined properly. At its inception cinema inherited the behavioural conventions of theatre and developed its language from there. Cinema acting came into its own with the advent of the psychologically charged close-up. Paradoxically the close-up requires the actor to act as little as possible and tends to be reserved either for moments of reaction or contemplation. This makes the close-up quite uncinematic. It comes as a pleasurable delay within a narrative film. As Laura Mulvey has pointed out, the close-up arrests time, absorbs and disperses the attention and solicits from the viewer a gaze that is much more fixing and fetishistic than narratively voyeuristic. It was also through the close-up that the 'star persona' was created. Stars are those actors that are *more* than their performances. They have a sense of 'being themselves' as much as playing their part. The phenomenon of the star is a recognition of the artifice of cinema. It accepts that there can or will be an excess beyond the part played.

Although it has become central to mainstream film culture, this excess has troubled many filmmakers. The French director Robert Bresson, for example, disliked the idea of actors and preferred non-professionals in his films. As well as avoiding close-ups he avoided the term *actor* and all its theatrical implications. (Figure 20) He preferred the idea of the *model*, a term that recalls the still photograph or the painter's studio. He had his models

Figure 20
Film still, *Pickpocket*,
Robert Bresson, 1959.

drain their performances of theatre, insisting they perform actions over and
over in rehearsal. Finally they could perform before the camera without
thought or self-consciousness. Bresson writes in his only book:

> *No actors.*
> *(no directing of actors)*
> *No parts.*
> *(no playing of parts)*
> *No staging.*
> *But the use of working models taken from life.*
> *BEING (models) instead of SEEMING (actors)* [6]

6 Robert Bresson *Notes on
the Cinematographer*, (1975),
Quartet Books, 1986, p.4.

Later he notes 'Nine-tenths of our movements obey habit and automatism.
It is anti-nature to subordinate them to will and thought.' The result was a
style of performance in which both everything and nothing looked controlled.
The 'models' perform with an inner calm and apparent stillness, even when
moving. They 'go through the motions', as we say. Unfairly described as
austere, the restraint in Bresson's films can seem unapproachable but
absorbing too.

Figure 21
Jeff Wall, *Volunteer*, 1996.

7 Wall himself describes the
image thus: '*Outburst* is a
factory scene in which
somebody – could be foreman,
could be owner, is just losing
his temper entirely. I wanted to
depict it as if it was happening
instantaneously so, for
example, the woman, who is
the object of his wrath, is
entirely startled by it. I also saw
it as a kind of explosion'.
Jeff Wall 'My Photographic
Production' in *Die Photographie
in der Zeitgenössischen Kunst*,
Edition Cantz, 1990. Extract
reprinted in David Campany,
ed., *Art and Photography*,
Phaidon, London, 2003,
pp.249-250.

8 Roger Callois 'Mimicry and
Legendary Psychasthenia',
October, 31, 1984, pp.17-32.

9 Henri Bergson, 'The Intensity
of Psychic States' in *Time and
Free Will: An Essay on the
Immediate Data of
Consciousness*, George Allen
and Unwin, London, 1910.

Jeff Wall's photograph *Volunteer* (1996) may owe a great deal to Robert
Bresson. (Figure 21) Wall hired a man to clean the floor of a set built to
resemble a community centre. He cleaned it for a month or so. Only after the
man had become unconscious and automatic in his actions was the image
made. Wall has many different methods to distil a performance or narrative
gesture into a photograph, accepting that there is no single solution to the
challenge. For *Outburst* (1986) Wall's models improvised situations between
a tyrant boss and his sweatshop workers. (Figure 22) These were recorded on
video. The tape was then reviewed and frozen in playback to discover the
gestures needed. These were then restaged for the final image. Where
Volunteer threatens to become mundane in its flattened performance *Outburst*
threatens to swamp us in dramatic excess, to burst out.[7] But in their gestural
language both may strike us as curiously automatic, deadly robotic even.

 To become automatic is to enter into blank mimicry. Roger Callois once
talked of mimicry possessing an estranging force.[8] Similarly the philosopher
Henri Bergson remarked that humans behaving like automata or robots can
be a source of unexpected or uncanny affect, even anxious humour.[9] So what
is the relation between human gestures that are automatic mimicry and the
still camera, which is itself an automatic, mimicking machine? For art, the

Figure 22
Jeff Wall, *Outburst*, 1986.

strangeness of photographed mimicry has often had a critical or analytical impulse. It has been used to distance us from the familiar. Narrative pose in photography can foreground arrestedness, setting up a space from which to rethink social conventions and stereotypes. Mass culture and daily life can be reexamined through engagingly awkward images of 'petrified unrest', as Walter Benjamin might have put it.

Excess in photography is usually thought to be a different matter from excess in cinema. In his essay 'The Third Meaning. Some notes on Eisenstein Film Stills' Roland Barthes looks for something between the two.[10] He is attracted to enigmatic, unnameable meanings he senses lurking in the details of frames from movies. These meanings are beyond the conscious control of either the actor in the image or the director. Often for Barthes they derive from those inert things that attach themselves to the flesh and blood of the living body – hair, nails, clothing and teeth.[11] These are things that belong neither to life nor to death. They are attached to the body but not strictly of it. They may express and animate but they are themselves inanimate. In the suspended frame their excess significance looms large. For Barthes it is not the acting that interests, rather it is the capacity of the extracted film frame to *intervene* in the acting, to rub it against its own intentions. The choice of stills from films by Eisenstein was deliberate and quite subversive. Famously, Eisenstein had championed a very different kind of third meaning. Putting one shot after another in a cinematic sequence could implant a controlled 'third effect' in the mind of the viewer. Much more disturbing, Barthes' third meaning resides *within* the single shot of the film. It is released by halting it, and will always escape tight semiotic control. Barthes unearths the instability lurking even within the tightly organised imagery of Russian avant garde film.

In some ways Barthes' thinking responds to ways in which photography is an inherently theatrical medium, in the sense that it theatricalizes the world. Everything is alive and unstable in the image and as Barthes rightly noted this aliveness, or polysemy, is usually contained and directed by text, context, voice over, discourse or ideology.[12] Barthes appeals to the way in which the arrestedness of the single frame poses the world, or more accurately imposes a pose on the world, making it signify in often unlikely ways. The philosopher (and photographer) Jean Baudrillard suggests that something similar is at work not just in the film frame but in every still photograph:

> 'The photo is itself, in its happier moments, an acting-out of the world, a way of grasping the world by expelling it, and without ever giving it a meaning. An abreacting of the world in its most abstruse or banal forms, an exorcism by the instant fiction of its representation...'.[13]

10 Roland Barthes 'The Third Meaning: Some notes on Eisenstein Film Stills', (1970), *Image-Music-Text*, Fontana, London, 1977.

11 Indeed it is hair, nails, teeth and clothing that return in the form of the 'punctums' in Barthes' book *Camera Lucida*.

12 There are echoes here of Walter Benjamin's notion of the 'optical unconscious' which might be brought to the surface of things when the high speed shutter or close-up lens appear to penetrate the obvious meanings of the world and reveal something deeper. Walter Benjamin 'A Small History of Photography' (1931), *One Way Street*, New Left Books, London, 1979.

13 Jean Baudrillard 'It is the object which thinks us', *Jean Baudrillard : Photographies, 1985-1998*, Hatje Cantz, 2000.

He is right, I think, that photography cannot but transform the world into a world performed or posed. This seems to be so even if it is a world of objects and surfaces. Understandably Baudrillard himself prefers objects to people in his own photographs precisely because there is then no confusion of poses. A photograph for him is performance enough without humans.

It should be said that 'film still' is quite an ambiguous term. For Barthes it refers to an actual frame extracted from the moving film – a single frame, twenty four of which conventionally make up one second of moving footage. However it also refers to still photographs, shot by a stills camera-person on the film set.[14] For these images the film actors run through things again, 'once more for stills', adjusting their performance slightly so that the scene or situation can be distilled, posed almost, into a fixed image closer to the procedure of the condensed tableau.[15] Both kinds of photographs circulate under the name 'film still' and both contribute to a film's publicity, which in turn helps form the social memory of a film. But each has its own very different relation to acting, posing, stillness and movement.

Given this ambiguity what might we make of Cindy Sherman's first major body of work, the *Untitled Film Stills*? Nearly three decades on this landmark series still has the power to fascinate. I see the title of the series playing very much on the ambiguity of the term 'film still'. Are her images modelled on the film frame or on the restaging of the scene for the still camera? Does Sherman pose or act, or act as if posing, or pose as if acting? Is she posed by the camera, or does she pose for the camera? Or is it something even more complicated? A few years after Sherman made the series the writer Craig Owens pointed out the similarity between posing for a photograph and the nature of photography: 'Still, I freeze as if anticipating the still I am about to become; mimicking its opacity, its stillness; inscribing, across the surface of my body, photography's "mortification" of the flesh'.[16] When we pose we make ourselves into a frozen image. We make ourselves into a photograph, in anticipation of being photographed. More importantly, even if we do not pose, the camera will pose us, perhaps in an unexpected way. Hence the anxiety we might have about being photographed, being posed by the camera without first being able to com-pose ourselves. Hence also the source of the great antagonism between the 'taken' and the 'made' photograph. By turns political, ethical, aesthetic and intellectual, the antagonism has fundamentally shaped debates, artistic credos and popular understandings of the medium. (It also shaped camera manufacture as it split between lightweight reportage equipment and larger format models for use in studios). While 'the taken' and 'the made' can never be totally separate, photos can still seem to flirt with the distinction. The staged photo-tableau

14 'Film still' is the translation used for Barthes' French term 'photogramme'. In English 'photogram' has another meaning - a cameraless image made by placing objects directly on to photographic paper before exposure.

15 See John Stezaker's essay elsewhere in this book.

16 Craig Owens 'Posing' (1985) in *Beyond Recognition: Representation, Power and Culture*, University of California Press, 1992, pp.201-217.

has a coyness about it in this regard. The sense of theatrical display orients the scene toward the viewer. At the same time the ignoring of the presence of the camera aspires to classical narrative cinema. Still photography always seems to carry with it a sense of frontality, a sense that the world will recognise the presence of the camera and reconcile itself to it. When it admits as much, it gives rise to 'direct address' (e.g. the passport photo, the family snap) but any photography that entertains indirectness seems to end up competing with the medium in some way, for good or bad.

Craig Owens' insight about the parallel between posing and the still photo seems straightforward enough. Yet it may not account too well for what is going on in Sherman's *Untitled Film Stills*, nor indeed for the kinds of behaviour that have evolved in the art of staged photography since the 1970s. If posing suggests consonance with the still image, Sherman inaugurated a much richer dissonance. Coming at the end of the 1970s, her performance broke with what we traditionally think of as 'performance art' photography. This was usually premised on an authentic, non-fictional, direct relation between subject and camera, in which the image was assumed to function as a transparent document outside of the performance. Sherman's camera is complicit in the performance, accepting that *it* would always be at least as responsible for posing as the human body. This, I think, has been the lasting influence of those early images.

I have always been struck by a certain reserve in Sherman's work, despite all the performance. Within the endless personae and masquerades there is a remarkable withdrawal and I think it has to do with the face. With a few notable exceptions Sherman's face remains almost neutral, very limited in its expression. All about her there is theatre, performance and communication yet her face gives little away. (Figure 23) She refuses to act or pose with the face, even when appearing to cry. Instead the face gravitates towards a mesmerising blankness, an immobility as still and automatic as the image itself. The photography poses and acts, the mise-en-scène poses and acts, but Sherman remains elusive and non-committal.[17] This blankness is not the cliché of the artistic self portrait (artists, it seems, will never smile when taking their own picture, unless it's ironic). Instead Sherman alludes to those cool stars of cinema who rarely smiled and made only minimal gestures. But Sherman's blankness for the still image is of a very different order.

The opposite of overt theatricality is often thought to be introspection or absorption. While I was thinking about this I glanced at the image on the cover of my copy of *Illuminations,* an anthology of Walter Benjamin's essays. (Figure 24) In Gisele Freund's portrait from 1939, Benjamin is thinking. Or he acts as if he is thinking. Or he is thinking that he is thinking. Or maybe we

17 Interestingly Sherman did use exaggerated faces in her *Fashion* series of the 1980s. Fashion models are often required to wear a blank, enigmatic face. Sherman mocks this from within, with a cheesy photographic grin.

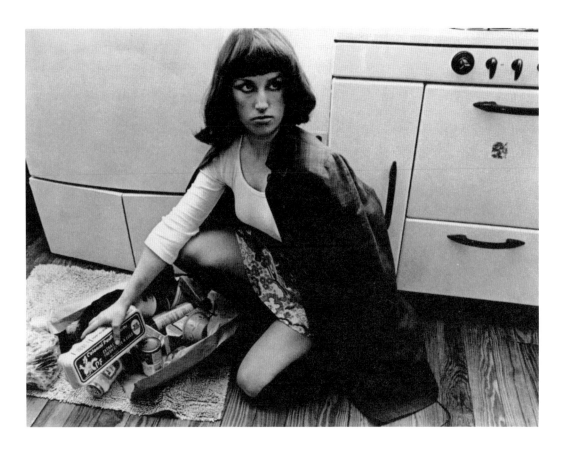

Figure 23
Cindy Sherman,
Untitled Film Still 10, 1978.

think that because he is such a serious thinker he must be thinking. Maybe that is how Benjamin thought he ought to appear. Or perhaps Freund caught him thinking. Or she caught something that looked like thinking. We are so familiar with chin stroking, reticence and spectacles as signs of the intellectual that we do not give it much thought at all.

Freund's camera is so close to Benjamin that he must surely be aware of it. There is nothing surreptitious here. He is either pretending or he is pathologically absorbed. We can relate this to Michael Fried's distinction between absorption and theatricality in painting.[18] Fried saw absorption as a mode in which people are depicted either being or doing something oblivious to the presence of the viewer. They might be mentally active – say, thinking or reading or knitting – but outwardly not much is going on. While theatricality

18 Michael Fried, *Absorption and Theatricality. Painting and the Beholder in the Age of Diderot*, University of Chicago Press, 1980.

Figure 24
Gisele Freund, *Walter Benjamin*,
c.1939, As reproduced on
the cover of Benjamin's
Illuminations, Fontana Press,
1992.

involves an explicit recognition of the presence of an audience, depictions of absorption solicit a suspension of our disbelief. We imagine we are looking at an unobserved scene. In photography the issue is slightly different since it is quite possible to take a photo of an oblivious person, usually from a distance. Any sense of theatre would stem from the photographic act, the posing of the scene *as* a scene by the camera. The 'authentic' photo of absorption at close range can only be achieved, strictly speaking, either with a hidden camera, or with the subject's familiarity or indifference. But it is easy to simulate it with the resulting image becoming a theatrical representation of absorption.

I am fairly sure about what this image of Benjamin means, but I am less sure what is, or was, really going on. This may be why it holds my interest. I sense mental movement beneath his still face and body. I sense too, a degree of melancholia in the portrait and by extension in Benjamin. Melancholia was a subject central to Benjamin's thinking and it is a disposition to which

he was himself prone.[19] Melancholia has a very particular relation to photography because it is a state that exists on the threshold of self-performance and withdrawal, between social mask and nothingness, between theatricality and absorption. It is a condition not of the melancholic's conscious making but it is experienced by them as a conscious condition. The melancholic is trapped in a kind of attenuated self-performance – alone but feeling regulated by the gaze of others, or by his or her own imaginary gaze at themself. The condition is lived from within and observed from without at the same time. Obviously melancholy can be coded in highly specific ways in photographs, and a number of women photographers of the nineteenth century refined this, such as Julia Margaret Cameron and Lady Hawarden. Less closely coded it slips into a range of moods – pensiveness, listlessness, boredom, fatigue, waiting. These are all states that seem to appeal to contemporary photographers, not least because the actors or models need not do very much. As long as they do little and the photography does a lot – in the form of 'production values' – a good result can be achieved. Narrative can still be present if entropic, while the pitfalls of hammy performance – always tempting in the face of stillness – can be avoided. (Coincidentally at the time of writing this essay, I saw an exhibition of Gregory Crewdson's series of cinematic tableaux photographs *Beneath the Roses*. At the heart of Crewdson's spectacular over-production was the same basic human gesture, a sort of exhausted standing around, slump-shouldered with the vacant face of a daydreamer. The gap betweeen inactive humans amid the grotesquely over-active photography was so extreme as to be comic. Although I'm not sure this was intentional.)

This might also be the reason why our galleries and art magazines have of late been populated with so many photographs of adolescents standing around. The adolescent embodies so many of the current paradoxes of photography: the awkward fit between being and appearance; between surface and depth; between a coherent identity and chaos; between irrationality and order; between muteness and communication; between absorption and theatricality; between stasis and narrativity; between posing and acting.

More significantly this turn towards 'slow', sedimented photography also chimes with the predominance of slowness in contemporary video art. Photography has all but given up the 'decisive moment' in order to explore what a moment is; video art has all but given up movement, the better to think what movement is. This is why just about all the current art and writing that explores stillness and movement really only considers *slowness* and movement. Worked-up tableau photos and decelerated video art partake of the same kind of exploration. But must the speedy always be sacrificed in all this?

19 On the subject of Benjamin and melancholia see Susan Sontag's introduction to Benjamin's *One Way Street*, Verso, 1985.

Need slowness be the only way? At this key point in the histories of art and media, I think it is a question worth posing. And a pose worth questioning.

The Film-Still and its Double: Reflections on the 'Found' Film-Still
John Stezaker

As an artist who has often worked with found images the latter half of the 1970s offered me an unexpected bounty in the form of 'film-stills' – a type of photographic image whose function has been to double for a single film frame in cinema publicity. (See Figures 25 and 26) I would like to emphasise though, from the outset, that my aim is not to throw light on some previously unconsidered genre of photography but rather to interrogate a mysterious opacity of those images which first attracted me when bundles of them found their way into second-hand bookshops as the result of a crisis in film distribution which resulted in the closure of the large-scale single screen cinemas and the consequent dispersal of the informal archives held there of past publicity material (often dating back several decades). This crisis in cinematic consumption also heralded the end of this microcosm of photo-ography whose chief function was to advertise the film of the week with quite copious still representations of the narrative sequence.

Originally displayed in specially designed windows on the outside of the cinema (and lit at night) or else in the foyer, these pictures were displayed in linear sequences as still versions of the cinematic narrative (without, of course, revealing the ending). They were advertisements for the current cinematic entertainment on offer and displayed alongside a smaller sample of the next week's attraction labeled 'coming soon'. Those like myself in the 1950's for whom these images were first encountered as representations of an experience from which we were prohibited, at least temporarily, will I'm sure testify to the universal sense of disappointment felt in the later consummation of these adult (x-rated) experiences. And whilst the failure of products to live up to their advertising image is a taken-for-granted rite of passage within consumerism, the failure represented by the film-still seems more acute. These images claimed to be samples of a promised cinematic entertainment but never seemed to actually appear on the screen. They evoked for me a spectral and shadowy underworld. Even when the films were in colour, the black and white stills suggested 'film noir'. The other-worldly quality of the film-still (especially the British ones) became, for me, spaces of imaginary habitation. However, this aura of the still image would be instantly

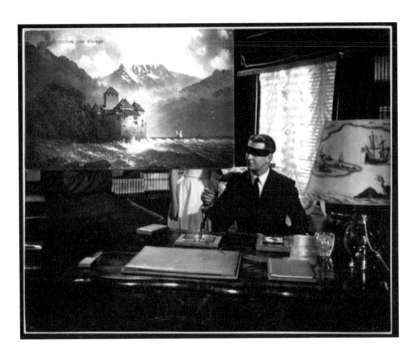

Figure 25
John Stezaker, *Blind*, 1979

dispelled by the context of the moving image (and with the everydayness of colour). Cinematic encounter with the still was invariably dissimulative.

Part of their appeal is the sense of disguise reflected in the label 'film-stills', a term that more properly belongs to the single film frame (or photogram) and with which they are sometimes confused. Otherwise they are (equally misleadingly) called 'production shots' or 'production stills', labels that refer to the pre-history of the film-still in early cinema where their function was to advertise the film to potential sponsors and for such reasons were often shot prospectively . (There exist many such 'film-stills' for scenes or sometimes entire films never shot). Besides this early history most film-stills were shot after or alongside the film itself at various levels of alignment with the vantage point of the movie camera. They were presented as 'free samples' of the cinematic feast rather than as a menu. From nearly the outset, film-stills were made by anonymous photographers working along-side the film production team. In America, where there has been some attempt to name the still photographers working in Hollywood, the 'auteurs' discovered are usually recognized for their portraiture or glamour photographs.

Figure 26
John Stezaker, *The Trial*, 1980

Their work on production stills, however, is likely to be regarded as too menial to merit any serious attention.

Despite a considerable variation in correspondence between the film-still and the cinematic moment it represents, there is a remarkable uniformity in terms of the pictorial vernacular employed. The lighting, depth of field, and lenses employed amounts to a photographic protocol at any moment in time evolving and only partly keeping up with the changing look of their cinematic counterparts. In Britain they remained in black and white long after colour had become the norm in film productions. The rigid vernacular and tonality imposed a sense of standardization (and of interchangeability) onto the cinematic scenes they represented. This unintentional sense of pictorial fixity or rigidity is mirrored in a marked quality of stillness in these representations of movement. The source of my fascination seemed to be in their failure: in what they accidentally revealed about the circumstances of their production (and that of the film's production).

Shot typically as a 'second-take' for the still camera, they are mostly photographs of still or posing actors who have then reconvened after the first cinematic take. The actors who have acted for the movie camera, pose for the

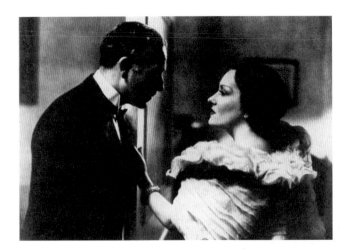

Figure 27
Film still, *Perfect Understanding*,
Cyril Gardner, 1933.

Figure 28
Theodor Van Baburen,
The Procuress, 1622.

still camera. They are predominately photographs of *tableaux vivants* which explains their rigidity and their resemblance to early photo-graphic representations of narrative where technical necessity demanded an imposition of 'stillness' on the world it represented. There is also a tendency, which film-stills share with early narrative photography, to attempt to compensate for this stillness with slight exaggerations of gesture and facial expressions. In addition to the temptation to 'overact' in posing, there is equally a tendency to compress the actions and reactions of gesture or expression into simultaneous representations for the still camera of what would be separated for the movie camera.

These estrangements of the cinematic image created by it's still 'double' became the focus of my collection and it was in trying to find an internal dramatic representation of this quality of stillness and rigidity which lead me into collecting cinematic images of blind characters or blindfolded figures. The presence of the blind character in cinema tends to be associated with stillness and a fixity of posture (especially of the head) amidst the flux of the cinematic. The blind – those excluded from the scopic regime of cinema – are represented as arrested, as being absented from the momentum of everyday life. It is also around the stilled 'absence' of the blind person that cinema seems most to celebrate its access to the bustle of life. The blind person appears stranded like an island within the flow of images and events. Within the film-still the problem is of how to draw attention to the stillness without the ambient movement. These images of the blind in film-stills are fascinating because they confront an impossibility in terms of photographic representation. But somehow the attempt, within its failure (or mysterious success), seems reminiscent of the problems of representing movement within a tradition of narrative representation that antecedes both film and photography.

Anne Hollander also seems to recognise this affinity between the film-still and the narrative art of baroque realism and Dutch genre painting. In her book *Moving Pictures* she makes a pair of pictorial juxtapositions between two film stills (one 1940s, the other 30s) and two Dutch genre painting.[1] If the photographs are production film-stills the comparison which is being made is then between two still images of posing figures. Not that this invalidates the point being made in the comparison which concerns the origins of the cinematic 'close-up', in the tradition most associated with the seventeenth century, of cutting the legs just below the hip in order to frame the scene and create a sense of proximity to it. (Figures 27 and 28) It allows, within the relatively small scale of Dutch genre painting, to give intimate access to the figures represented. Both scenes to which the viewer is given this close-up

1 Anne Hollander, *Moving Pictures*, Harvard University Press, Cambridge, Mass., & London, 1991.

intimacy are proto-cinematic images: Theodor Van Baburen's *The Procuress* is offered as a seduction scene and the source of the cinema's kiss image, whilst Georges de la Tour's *The Payment* appears as the prototype image of the criminal underworld or low-life representation to be found later in film.

Hollander illustrates the intimacy which this seventeenth century version of a 'close-up' gives by projecting a cinematic reading onto another painting, *The Calling of St Matthew* by Terbruggen:

> *We approach Terbruggen's Matthew as we approach the villain or the hero playing cards in a Western saloon, during moments when his challenger enters and moves in on him. We see what's on the table as well as on the faces; we come behind one or another shoulder and await the next move.*[2]

2 Ibid., pp.121-123.

It is worth remembering though, as Hollander pans around the scenes of narrative painting, that it is *her* movie sequence which she is creating in this 'pregnant moment'. She is the director of the cine-narrative. When the final ingredient of temporality is added to narrative and with cinema, we relinquish just that freedom to move around the image and participate in the process of narration.

However, paradoxically, in looking at a tradition in painting that Hollander sees as striving to overcome it's own essential stillness, she recognises the essentiality of stillness to highlight movement in this and other paintings of this time. The truncation of figures at the hip, in addition to bringing the viewer closer to the scene, also 'immobilizes the subject. Without legs, he is seen to be both present and still, rooted in the picture, where he must stay, having no means of escape. He is yours forever while you look at him'.[3] Hollander sees cinema as a final realisation of this intimacy with the dramatic scene that the 'close-up' in narrative painting initiates. However it is also clear that what is lost is precisely that 'forever presence' of the image with which intimacy is desired. This gulf between the perception of still and moving images is what Hollander has to brush over in this one-way representation of historical progress. In these terms there is no way of accounting for the desire of artists to make the return journey in search of the lost intimacy of the pregnant moment on the ground of the mobile image. Arguably constructed photography is making just such a return; to still narrative representation in cinematic terms. The film-still seems to stand at the cross-roads between Hollander's idea of the painter's attempt to mobilize the essentially still image and the contemporary artist's attempt to return cinematic narrative to its still terms: to hold the cinematic image 'there' – in Hollander's terms – 'forever'. Perhaps this is the desire that makes contemporary photographic artists employ the same processes and studio set-ups as cinema to arrive at still pictures. The debt of much of

3 Ibid., p.123.

this work to the production film-still is I think self-evident. The quality of frozen time is closer to the stillness of the film-still than it is to the more spectral quality of arrested motion in the photogram or film frame. For all the cinematic references in constructed photography this proximity to the cinematic seems only to enhance the quality of stillness in the images which suggests an *imposed* arrest on the world.

In a different context, in what he terms 'late photography', David Campany has noted the predilection of contemporary photographic art for images of the aftermath of events in which stillness is seen as a reflection of photography's own essential condition.[4] (Even in the context of cinema or television, such 'aftermath' images have the quality of still photographs: as suspended instants of destruction their frozen momentousness makes them feel like freeze-frames). Campany's observation is also pertinent to constructed photography in which stillness is similarly experienced as a frozen quality but in this case the relationship is with the momentousness of the cinematic image. There is a sense of return in this work to that staged quality of early photography which mainstream documentary photography sought to escape in the 'decisive moment'. Cinematic constructed photography can be seen to be a return to the scene of the production film-still and evokes a similar fascination for the stilled re-enactment of the cinematic moment. This return seems comparable to the one described by Laura Mulvey in the context of the freeze-frame: 'As the "nowness" of story-time gives way to the "then-ness" of the movie's own moment in history'.[5]

In these terms constructed photography can be seen to exploit the indexicality of the still photograph (its quality of 'having been there') to create an awareness of the constructedness of the image. I would suggest that this experience of a return in the image and consequent sense of the constructedness of the image is available ready-made in the film-still.

When one looks at a film-still one is aware first and foremost of actors enacting a role rather than of characters in the equivalent cinematic moment. And there is one image within the iconography of the film-still (as well as in cinema itself), where an indexical sense of the actors submitting to the process of simulation is experienced most ambiguously: the kiss. Virtually synonymous with cinema itself – hence its frequent appearance as a film-still in cinema's publicity – the kiss is potentially the most threatening in terms of exposing the constructedness of the image and in revealing the imposture of the filmic set-up. It is one of the cinematic images which Hollander saw as having its origins in the sub-genre of paintings of seduction and undoubtedly its prominence within cinema is for similar reasons: in the desire to represent the potential for intimacy in the picture. In publicity terms the kiss

4 David Campany, "Safety In Numbness: Some Remarks on Problems of 'Late Photography'", in *Where is the Photograph?*, ed. David Green, Photoform/Photoworks, Brighton, 2003.

5 Laura Mulvey, 'The "pensive spectator" Revisited: Time and its Passing in the Still and Moving Image', in *Where is the Photograph?*, ed. David Green, Photoform/Photoworks, Brighton, 2003, p.119.

could comparably be seen as a promise of consummation in the cinematic image. Of course, precisely because of this promise, it is also the site for experiencing the failure of the image in just these terms.

Within the cinematic narrative the kiss-image arises either as a form of narrative respite or stereotypically as an ending. It provides cinema's own occasion for stillness. Perhaps partly because of this inherent quality of stillness, the kiss seems pre-eminently transferable from the moving to the still image. But this transfer from nearly still to photographically still can often unintentionally betray the reality of the act of simulation. In order to kiss the actors and actresses must really kiss. And whilst this mimetic doubling in film acting is taken for granted in most other acts, it can become estranged in the kiss. However ubiquitous as an image it focuses the viewer on the threshold between simulation and reality and can represent a moment in which the reality of simulation can take over from a sense of the reality simulated. As an image the kiss is semiotically as ambiguous as the simulated act. It both stands for sexual union and is (usually) a part of it. It is both symbol and reality. The stilled kiss can reveal this threshold between simulation and reality to be a dangerously slippery one. (The notorious polygamy of film actors testifies to this). Despite its pervasiveness it is an image which potentially threatens the cinematic illusion and that aligned 'intimacy' with the characters which the kiss represents as cinematic consummation. Thus it threatens to expose the sacrificial underpinnings of cinematic simulation.

To compensate for the danger of a stilled contemplation of this transgressive boundary puncturing the cine-simulation, cinema often conspires to make this encounter with stillness as momentous as possible through the use of panning and rotating shots. The kiss between Madelaine (Kim Novak) and Scottie (James Stewart) in Hitchcock's *Vertigo* is precisely a vortex of these devices. Yet, clearly the act seems more difficult to negotiate for the still than the movie camera because for the former it is an actor and actress (Stewart/Novak) who are kissing for the photographer whereas for the latter it is characters (Scottie, Madelaine) caught up in the momentum of the 'scene'.

However, my collection of cinematic kiss images which includes *photo-roman* images reveals contrasting dangers in the enactment of the kiss for the still-photographer and actors. On the one hand overacting can create a predatory sense of sacrificial violence. Underacting, however, is more subversive – the posed alignment of lips punctuates the image, exposing it's artificiality. Both extremes expose the constructedness of the image and the sacrifice involved in its construction.

Figure 29
Film still, *Kiss*, Andy Warhol, 1964.

Somehow Warhol's *Kiss* manages to combine both extremes, over-simulation with the collapse of simulation. (Figure 29) In this film Warhol exploits just that sense of discomfort in confrontation with the imposed stillness of the kiss by artificially extending cinema's interlude image to unbearable duration.[6] Uniquely amongst Warhol's early 'still' films, it is an uncomfortable stillness. In *Kiss* stillness, achieved through cinematic deceleration, is felt as an imposition made gratuitously by the film set-up on behalf of a voyeuristic audience. The viewer is made to feel complicit in this imposture. Stillness (or slowness) in this context elongates the simulation temporarily beyond the point where it can remain convincing. The film then becomes the serial experience of watching the collapse of the simulation. The actors and actresses are sacrificed to this act. Isolated from the representation of characters and from narrative pretext *Kiss* represents a series of enactments of the stereotypical image designed to fail and which – in the prospect of this

6 I am grateful to Al Rees for reminding me that this impression of extreme duration amounts to little more than 3 minutes for each of the kisses making up the film.

John Stezaker The Film-Still and its Double: Reflections on the 'Found' Film-Still 121

failure – becomes a kind of sacrificial spectacle. All of Warhol's 'still' films use the slowness of real time to subvert the compression of cinematic time. But only in *Kiss* is this subversion used to challenge the voyeurism of the viewer. Perhaps this is because *Kiss* is uniquely a found cinematic image – indeed an appropriation of cinema's central image of stillness. In fact *Kiss* represents a double appropriation of cinema: firstly of the stereotypical image itself and secondly the devise most closely associated with it: the slow-motion image which *Kiss* enacts in 'real-time'.[7]

Warhol was not the first to see the idea of appropriation as a kind of stilling or temporal elongation. From Duchamp's statements about his ready-mades, as well as in the titles he gave them and their representation in associated works, it is clear that he saw them as interruptions within the momentum of everyday encounter. He refers to them as 'arrests', describing his original encounters with the ready-mades as analogous to 'snapshots'. His earlier paintings, which adapt Marey's cinematographic imagery to the representation of the temporal dimension of everyday life, suggest a metaphorical connection between these two experiences of momentum: cinema and the everyday. Within the amorphous fluidity of everyday experience, the readymade represents an arrested fixity analogous to the freeze-frame in cinema. For Duchamp a certain kind of visibility was conditional upon a disjunction from the taken for granted vectors of life and its cinematic representation. His appropriation of the Paris Metro map in 1914, which involved the removal of place names, deprived the map of its function in terms of movement but redeemed it as an image in a *Network of Stoppages*.

Through these metaphorical arrests of the fluid transparency of the everyday object or image, the invisible is made visible in just the terms in which Maurice Blanchot describes the effect of the surrealist found object, '"those outmoded objects, fragmented, unusable, almost incomprehensible, perverse" which Breton loved'.[8] Normally the utensil 'disappears into it's use',[9] it disappears into the vectors of instrumental encounter, and commodity turn-over. However in disuse the object or tool *appears* out of the ground of its disappearance in momentum. 'The category of art is linked to this possibility for objects to appear'[10] according to Blanchot, for whom this double of the object represented by the found object is a deathly suspension and fixity of the thing. The suspension of the object's double from the vectors through which it is integrated into, and disappears into, everyday life is revelatory: the object becomes its own image (self-resemblance) in this withdrawal from the world. At this moment declares Blanchot, like the corpse, the object withdraws into itself and a repressed or overlooked materiality wells up in the disused arrested object.

7 As Al Rees has pointed out to me, that though shot in real time, Warhol's *Kiss* was intended to be projected at 16 frames per second instead of 24 frames per second thereby slowing down the action.

8 Maurice Blanchot, 'Two Versions of the Imaginary', *The Space of Literature*, University of Nebraska Press, London & Lincoln, Nebraska, 1982, p.258.

9 Ibid., p.259.

10 Ibid., p.259.

But what happens in these terms when the functional object or image is designed literally to disappear into its use? This is of course the status of the film frame in relation to experience of film: 'Shot past the projectors gate, the photogram propogates itself as film only to vanish on screen'.[11]

11 Garrett Stewart, *Between Film and Screen: Modernism's Photo Synthesis*, University of Chicago Press, Chicago and London, 1999, p.5.

Disappearance into use is made absolute. Cinema can then be seen both as an intensification of the powers by which images in cultural circulation (the everyday) disappear into their use while also representing an acceleration of their physical disappearance in terms of replacement by successors. Cinema, by this analogy with the cultural turn-over of images, can be seen as 'obsolescence 24 frames per second'.

Paradoxically cinema makes this cultural blindness of overlooking (the *blazé*) perceptually absolute. Vision can never catch up with itself, trapped as it is in a process of following the perpetually fugitive image. The still image is absorbed into (disappears into) the function of perceptual deferral. In this state of blindness the immobilized gaze is fixed only on the mobile center of the image leaving the circumstantial details on the border of conscious recognition. The image as a whole, as a framed formally composed and constructed entity, disappears into cinema's double momentum of action and viewpoint.

The film-still is the main ready-made site for the return of this repressed detail and, in certain terms, for the repressed visibility of the film image to stage an appearance. By a process of cutting the temporal ties with the everyday world: linear narration, cultural circulation, historical location, the found and defunct film-still can represent a confrontation with the material circumstances of the cinematic illusion. It seems to do this by bringing the periphery of the cinematic image into an equal focus with is mobile center. There is often an excess of detail in this encounter. The still camera registers the fabric of the world which the movie camera leaves behind: the material textures of costumes, the cracks in facial make-up, the inadvertent glimpses of dusty corners of the film set. The film-still puts these details on an equal footing with the momentous centre of narrative significance in a way that *betrays* the simulations. Within this dispersed space of the film-still the viewer seeks clues to what is happening. Deduction of narrative meaning demands intellectual reflection in a sifting of essential from extraneous detail in a search for a mobile 'centre' hidden within the stillness of the photo-graphic image. Especially in the case of pre-war film-stills the compressed crowdedness of their scenes seem often to tempt their central protagonists to adopt exaggerated gestures and improbable dramatic poses to compensate for the understated evenness of the *tableaux* and to signal movement. This attempt to overcome their disappearance within the crowd of details (or

extras) through stylistic exaggeration contributes to an estrangement of the image which brings about an awareness of its constructedness within the physical circumstances of the real world.

In the found film-still fixity is doubly a condition of the visibility of the image as an interruption – both of the momentum of everyday image circulation and the momentum of cinematic experience. It represents a double displacement within the cultural vectors of image reception. I would suggest that the visibility of the image is not only the product of a technical arrest of the cinematic image but of a more complete series of estrangements and decelerations within the momentum of everyday image experience. It is difficult to conspire to create this estrangement: it has to be *found*.

In this essay I have attempted to describe what is returned or 'found' in the film-still in terms of the fugitive visibility of the cinematic image. Claims have been made for the film frame as a revelatory interruption from within the world-view of cinema. Stewart's apocalyptic disclosure of 'first things',[12] Bellour's 'recoil'[13] in the freeze-frame as a glimpse of cinema's own origin, or Mulvey's punctuation of the continuous 'now' of cinema by the 'then' of photographic indexicality[14]; each claims a return in the photogram of cinema's hidden photographic substrate. And for each it is an interruption, a murder, a stalling of the mechanism of flow. The decisive moment of photographic arrest returns as 'freeze-frame'.

The film-still as the photogram's simulation or double, I'd suggest, makes possible a return to a pre-photographic stillness, the one described by Bellour as the 'pregnant moment' of narrative painting and which he distinguishes from the 'decisive moment' of photography. The pregnant or significant moment, which Bellour adopts from Lessing, is 'the one that supposedly represents the average and acme of a dramatic action thus expressing the painting in its entirety. In a painting the meaningful instant doesn't refer to anything real, it is a fiction, a kind of image synthesis'.[15] This seems also to describe the sense of the expanded moment of the film-still.

Bellour also contrasts the way that the decisive moment is 'torn from reality'[16] and comparably Stewart describes the freeze-frame as a 'cut from action rather than hold on it'.[17] The film-still, I'd suggest, returns us to a pre-photographic pre-filmic 'hold on action' and to the inclusiveness of the pregnant moment of narrative painting. It is also the reason, I suspect, that constructed photography reflects a greater interest in the film-still than in the photogram because of its own reaction to the 'decisive moment' ethos of the documentary tradition in photography. The film-still represents a possibility within the cinematic image of a reversion to the 'pregnant

12 Garrett Stewart, op. cit., p.75.

13 Raymond Bellour 'The Pensive Spectator', *Wide Angle*, vol.9, no.1, p.6.

14 See Laura Mulvey 'Death, Twenty Four Frames Per Second', *Coil*, Issue 9/10, 2000.

15 Raymond Bellour 'The Film Stilled', *Camera Obscura*, no.24, 1991, p.107.

16 Ibid., p.108.

17 Garrett Stewart, op. cit., p.118.

moment' of an earlier pictorial tradition that in Hollander's terms is the true source of cinema's world view.

The desire for stillness as an expanded moment, rather than as an interruptive one, is described by Lessing as a stillness which allows an unfolding within the image: 'The longer we gaze, the more must our imagination add; and the more our imagination adds, the more we must believe we see.'[18] It is significant that Lessing's pregnant moment is formulated in relationship to the representation of a blind man literally caught up in a narrative within which he is unable to intervene to save himself and his sons because of his blindness. Lessing argues that rather than representing the climactic moment of the priest's death (the culminating moment in Virgil's poem) the sculptor has chosen to represent a moment of repose before the end: 'the sigh of resignation' rather than the 'open-mouthed shriek' of the end. The moment of apotheosis is left to our imagination. We contemplate it – as he does – in this stilled moment of repose before the end: 'the beholder is rather led to the conception of the extreme than actually sees it.'[19]

This creates a bond between the blind protagonist and the viewer. They are both forced to imagine the end in the absence of an image of it. As in cinematic representations of the blind there is pathos in the representation of a blind person as the still centre of visual momentousness who is himself oblivious to it all. But while in cinema this marks a separation between the viewer and the blind, in the sculpture it marks an identification between the two in the stillness of this expanded moment. Lessing's stillness is redemptive, suspending the dying figure from his fate as it saves the viewer from the literalness of the visual image of death.

Then, as now, what is at stake in the stillness of the image is the freedom of vision to mobilise itself in and beyond the image.

18 G.E. Lessing, *Laocöon*, trans. Beasley, 1853, pp.17.

19 Ibid., p.18.

Frame/d Time: A Photogrammar of the Fantastic
Garrett Stewart

To think about 'stillness and time', when considering film, is to ponder not two topics but one. Not just time embalmed, but 'change mummified', in André Bazin's deathless phrase: that's cinema for the phenomenologist.[1] Temporal transformation is preserved in all its unfolding duration. Change itself is struck off as imprint. But what is filmic time for the materialist student of the photogram, that smallest cellular unit through which photography-as film-becomes cinema? Along the serial strip of film, instead of standing still each timed image stands, till erased by succession. Since the publication of *Between Film and Screen*, which explores the projection of such serial difference as screen motion, I have found additional confirming evidence of film's tendency to disclose its photogrammatic basis at points of narrative rupture.[2] This evidence comes from a certain polarized vein of recent international filmmaking that includes, on the one hand, a European, often transnational, cinema of uncanny psychic displacement and, on the other, a Hollywood mode of virtual reality preoccupied with everything from ghosts to hallucinated alter egos to cyber-figments to digital replicants. Each, on either side of the Atlantic, is a mode of the fantastic as influentially defined by Tzvetan Todorov.[3]

Isolating the role of the photographic imprint in recent instances of the fantastic serves in part to locate the difference between the now psychological, now ontological disturbances to realilty induced, across the polarized tendencies of European and Hollywood practice, by their parting of generic ways. This is often because the moment of photography's remediation by film returns us, in quite different ways, to film's own differential basis on the celluloid strip. It is there that stillness stands disclosed, or better stands exposed, as both the constituent and the antithesis of screen movement. Motorizing the serial strip, projection elides the rapid still into the frame/d time of screen motion, so that the whisked-away module reappears in its own momentum on screen as a spectral phase of advance. All links transpire in the blinks of a mechanical eye. In a word, fantastic. Not all films of the fantasy genre take up this phenomenon as theme, of course, and least of all those concerned with distant electronic futures. But many do. And even

1 André Bazin, 'The Ontology of the Photographic Image','*What Is Cinema?*, trans. Hugh Gray, University of California Press, Berkeley, 1967, p.15.

2 Garret Stewart, *Between Film and Screen: Modernism's Photo Synthesis*, University of Chicago Press, 1999.

3 Tzvetan Todorov, *The Fantastic: A Structural Approach to a Literary Genre*, trans. Richard Howard, Cornell University Press, Ithaca, NY, 1975.

avoidance is revealing. This essay means to close in, then, on the point of intersection between photographic temporality and narrative virtuality in the impacted photomechanical crux of numerous screen narratives on both sides of the Euro-American genre divide, where desire often uncannily reanimates a fixed visual trace or, alternately, where the simulated kinetic image of living presence marks the death of the real.

It should be noted that whenever the medium-specific rudiment of filmic motion in photographic arrest is somehow called up in such fantasty films, the distancing effect may often feel residual in its very technique, a leftover from modernism's habitual way of intervening in the classic transparency of the cinematic image. Before its consolidation as a narrative system, however, cinema in its earliest years was perceived as an overt filmic machination by its first spectators. As it happens, an indirect evocation of cinema's elusive differential motion comes down to us from these same years in the late-Victorian art criticism of dance, a performance medium to which theorists of the mechanical image, Deleuze among others, have always known cinema's affinity – and to which Fernand Leger's experimental film title from 1924, *Ballet Mechanique*, pays direct testament.[4] In the slippery, self-enacting language of the Decadent critic Arthur Symonds, writing in 1898 within the first decade of cinema's absorption by cultural consciousness, the thrill of dance is that each discontinuous effect, truncated in material time, 'lasts only long enough to have been there.'[5] It is there as gone, a vanishing trace, which only attention can retain long enough to savour.

In cinema, the incremental effect, the frame itself, also lasts only 'long enough to have been there'; only long enough to have been surrendered, that is, to the next in line, assimilitated to it, shifting it as if from within, become its supplement in the oscillating slippage from split-second to split-second, moment to momentum. This is the dullest truism, perhaps, until renewed by a given screen narrative, where the filmic may obtrude with unnerving purpose from within the cinematic – often flagged by an on-screen photograph within the plot or a freeze frame on the track. Various genres have different uses for such effects. For decades in the genre of sci-fi, the evidentiary photograph marked a fixed point-of-no-return in the dystopian technology of artificial bodies and environments.[6] Several of the films taken up in this essay are the structural flip side, and the cultural aftermath, of this generic trajectory. Traditionally the photographed human body – having once been present to representation, or having been simulated as such – is deployed on screen to measure the fall from human agency to fabrication, as from organic body to cyborg in *Blade Runner* (Ridley Scott, 1982). But this particular signficance of photography grows vestigial within a fully electronic

4 It is this uninterrupted flow of poses, of course, which the motion studies of Marey and Muybridge hoped to dispell by its breakdown into sequential frames.

5 Arthur Symonds, 'The World as Ballet', in *Studies in the Seven Arts*, vol. 9 of *The Collected Works of Arthur Symonds*, 9 vols. Martin Secker, London, 1924, p.246.

6 See Garrett Stewart, 'The Photographic Regress of Science Fiction Film', in *Between Film and Screen: Modernism's Photosynthesis* University of Chicago Press, Chicago, 1999, pp.189-224.

dystopia, not to mention within a cinema increasingly enhanced–or invaded– by the digital. There are no faked or ambiguous or nostalgic photographs anywhere in the *Matrix* trilogy (the Wachowski brothers, 1999-2003). Nor does the photograph serve to anchor or contest the digital artifice of VR snuff films in a movie like *Strange Days* (Lyne, 1995). The transformation at stake is not just of genre but of medium.

Yet, though the photographic benchmark of cinematic images has increasingly lost ground with respect to the reflexive ironies of digital sci-fi, it has not disappeared. For the most part it has simply shifted genres: most obviously when it leaves behind a context in high-tech illusion for a narrative format of high-profile magic. In the *Harry Potter* films, for instance, every framed image in the land of wizardry, whether ancestral portrait or newsprint mug shot, can be found to writhe and speak within its curtailing rectangular frame–and to do so precisely as a self-referential marker of digital cinema's power to bestow such magic animation in the first place. Similar if muted effects punctuate those less strictly fantastic films, as well, where plot tends to render equiovocal either the ontology of its protagonists or the epistemology of their vision, memory, and desire. As such, the current spectrum of the unreal or imaginary runs from the blatant ghost stories and digitalized nightmares of Hollywood trends to the often elegiac uncanny of numerous European films. The present essay is a second venture on my part to account for these seemingly parallel but in fact divergent narrative tropes, this time with a more concerted look at the moment of photographic indexicality on which their plots so often turn.[7] For again and again the definitive stillness of photography, figuring the arrest of death or its overriding by desire, becomes the defining mark of these films at the emotional, and often metaphysical, turning points of their plots.

In an essay entitled 'From Presence to the Performative', David Green and Joanna Lowry return to an aspect of indexicality in Peircian semiotics that has been obscured, as the authors see it, by Roland Barthes's elegiac emphasis on the 'that-has-been' of the photographed object.[8] Peirce wanted from the indexical function a sense not just of a trace left but of its point and manner of inscription, what Green and Lowry stress as the performative index that coexists with its referential counterpart. Together, these functions delimit photography's motor as well as mortal trace, or what we might distinguish as the inscribed presence to – as well as of – the captured object, both moment of record as well as recorded moment. When commuted into film, this emphasis can help us to rethink, from the photogrammatic ground up, that current spate of fantastic narratives where point-of-view shots are anchored either by death's empty centre or by the subtracted subject of a virtual body.

7 Stewart, 'Crediting the Liminal: Text, Paratext, Metatext,',in *Limina/Film's Thresholds*, ed. Victoria Innocenti and Valentina Re, Forum, Udine, 2004, pp.51-76, where I stress in greater detail the semiotic structure of 'trick beginnings' in, among many others, some of the same films discussed below – though without the sustained emphasis placed here on the photographic dimension of their often illusory worlds. The former essay concludes with a fuller distinction between current European and Hollywood practice in these matters and its divergent cultural impact.

8 David Green and Joanna Lowry, 'From Presence to the Performative: Rethinking Photographic Indexicality' in *Where is the Photograph?*, ed. David Green, Photoform/ Photoworks, Brighton, 2003.

To clarify terms, I'll start with three divergent examples of indexical aberrations that gradually zero in on the recent film pattern I'm trying to establish, only the third of which will constitute the fantastic per se. In an 'alternate worlds' format, the frenzied sprint across town of Lola to save her boyfriend in the crime plot of Tom Tykwer's *Run Lola Run* (1999) replays itself three times in entire alternate versions, fatal and otherwise. In the process, it interrupts its three main vectors of racing action with disjunctive flash forwards to alternate lives of minor, unnamed characters whose paths Lola happens quite literally to cross. In all of these proleptic inserts, six in total, the performative indexicality of photographic record is evoked (without being in any way narratively motivated) by the overlay of shutter sounds on the track, cut by quick cut. The woman pushing a baby carriage, for example, will eventually have her child taken from her on the grounds of neglect (click) until caught stealing another (click); and the young cyclist who later gets beaten by thugs will end up having his wedding photo taken with his former nurse (click). Either that – or the woman ends up winning the lottery and finding her apotheosis in a tabloid publicity shot; or the cyclist becomes – your quick guess is as good as mine – a homeless addict last seen as if in a police photo. Jump-cut editing and soundtrack collaborate in figuring time as a series of seized stills – thereby confirming Bergson's complaint against the medium, its participation in a widespread cognitive error that life is lived not as immersed duration but as a kind of mental photo album.[9] In none of this is there a clear baseline of reality established from which a departure into fantasy can be marked. In *Run Lola Run*, time is entirely contingent, up for grabs.

Moving closer to a fantasy format in which a certified reality and its direct reversal are clearly distinguished from each other, however, is the 2003 film by Laetitia Columbani, *La folie d'amour... pas du tout*, or in English *He loves me... He loves me not*, where the radical alternatives of the proverbial petal-plucking game – installed by the film's title and its first floral shot – offer the instigating clue to a structure that will rewrite an adultery plot halfway through as the delusion of an erotomaniac. When the heroine kills herself in despair over the married lover who has deserted her, a reverse action image of the entire narrative, beginning with her strictly metaphoric rather than technological flatlining, drags her back to life to expose the fact that there has been no relationship at all, except in her stalker's imagination. Bergson's sense of the death moment as a replay of elapsed duration is here reversed within the ironic trope of life figured as an exaggerated romantic movie, but a movie now going nowhere fast – and backward at that.[10] Then, too, more than life, in the form of plot, is hereby replayed. Rehearsed as well by this turning point is the evolution of image technology. What we see amounts to

9 See a treatment of this sticking point in Bergson, as putatively overcome by arguments of Deleuze, in Stewart, *Between Film and Screen*, pp.86-7.

10 On this far limit of phenomenology, see Georges Poulet, 'Bergson: La thème de la vision panoramique des mourants et la juxtaposition', appendix to *L'espace proustien* Gallimard, Paris, 1963, pp.137-77.

the last vestige of cinema's rotary motion in the form of a VHS reel. For the heroine's second chance comes not by reverse digitial scan but by mechanical rewind – even though spooling past us faster than any filmstrip could.

In *He Loves Me . . . He Loves Me Not*, the grain of the real is so firmly established, if only in retrospect, that miscues in the first half can be confidently set right in the second. Closer yet to the model of fantastic narrative, however, and this by sustaining its ambiguity almost to the very end, is François Ozon's *Swimming Pool* (2003), which recruits the device of trick beginnings as common to the thriller plot as are trick endings. *Swimming Pool* opens behind the title with a misleading shot of blue water rippling across the entire frame. An upward pan soon reveals it to be a shot of the Thames rather than of the pool in question. The film then cuts to the Underground, where a reader notices that the woman sitting opposite her is the author whose picture is on the cover of her mystery novel. Yet here too, occular mystery and deception seem to have set in. This photographic evidence is immediately denied: 'You must have mistaken me with someone else,' says the presumed author. 'I'm not the person you think I am.' Index does not guarantee identity. A throwaway moment, one assumes – easily explained away by the author's revealed panic over her current writer's block. Throughout the rest of the film, however, we submit to an openly voyeuristic study in voyeurism, only to find out that most of the characters aren't who *we* think they are either, but erotic projections of the writer as she hallucinates herself into the world of her new murder mystery. This is a fantasy spurred in fact, at a fulcral moment of the plot, by the writer's discovering what might look at first like a photograph of the sexually voracious teenage heroine in the girl's diary. Yet this is a dated black-and-white image meant, instead, to stand in for a picture of the girl's dead mother – and former lover of the same editor the writer herself is obsessed with. The referential index of the photograph is compromised in this case by the genetic doppelganger. The 'switch' ending arrives in alternating match cuts of a real and a fantasy figure in the writer's mind's eye: the imagined sexpot Julie and her editor's actual daughter Julia, each reaching out in silhouette as if at the rear-projection of an absent mother on the distant balcony – a shot evoking the classic opening titles of Bergman's 1966 *Persona*. Shaken by this disclosure, we may be cast back to the film's trick beginning: that ontological dodge which now seems to have infiltrated the entire film from both the (destablizing) establishing shot and the subsequent photographic moment of indexical denial.

Swimming Pool is something of a renegade in the European context, closer in its contortions to recent Hollywood gimmicks. And instructive as such. Against European plots favouring preternatural accident that reroute narrative

from its expected destinations, Hollywood specializes lately in wholesale reversals, final disclosures that require the total rethinking of a deceptive narrative line. Compared to the loops or short-circuits of memory and desire in the European cinema of radical coincidence, the protagonist of the new Hollywood 'fantastic' may turn out to have been dead, or merely digital, or only, so to say, 'fantasizing' all along. The photochemical index is often the litmus test of such unreality, either lodged at the threshold of narrative or anticipated there by an associated figuration that later finds its photographic equivalent in the thick of plot. It takes awhile to see how – and why. To that end, we need a structural definition of fantasy as a genre that would encompass both tendencies of the 'irreal' I am trying to coordinate: preternatural alignments of fate in European film, with all its epistemological mystifications, over against ontological subterfuge in Hollywood, the spooky versus the literally spectral.

According to Todorov, 'the fantastic' is defined as the narrative span of undecidability during which a reader is held in suspension between incompatible explanatory options.[11] If the strange events are resolved psychologically in the end, then the fantastic is cancelled, because settled, by the uncanny (*unheimlich*). If otherworldly rules of the 'marvelous' are necessary for explanation, then fantasy is cancelled by the supernatural. Only in between, and for as long as that prolonged uncertainty can be sustained, does the genre of the fantastic persist. To give a classic example in terms that can distill Todorov's point fairly succinctly, fantasy lasts only as long as we are still wavering between preternatural and supernatural solutions, still asking whether James's ghost-seeing governess in *The Turn of the Screw* is simply obsessed or actually possessed. The European cinema of fateful coincidence gravitates to the former (or uncanny) pole in resolution. Recent Hollywood thrillers lean instead to the marvelous (or supernatural) pole, where lived reality is rewritten by the laws of virtuality or afterlife.

Yet, anticipating resolution in one direction or the other, the fantastic is clearly a genre that would have every use for the frequent undecidability of *trucage* as Christian Metz defined it.[12] This is a tampering with or 'tricking' of the image track (superimposition, lap dissolves, fades and ripples are his favoured examples) that has moved, historically, from diegesis into syntax, or in other words from manifest special effect to sheer transitional device. At the most rudimentary (syntactic) level, Metz sees *trucage* already at play when one shot makes its predecessor magically vanish. A cinematic fantasy is likely to realize this disappearing act within the plot, to lift the effect back from normalized grammar to aggravated strangeness. In *Swimming Pool*, one daughter is phantasmally displaced at the end, as in fact all along, by her

11 Tzvetan Todorov, op.cit., p.44.

12 Christian Metz, 'Trucage and the Film', trans. Françoise Meltzer, *Critical Inquiry*, Summer 1977, pp.657-75.

libidinal double. Like all laboratory manipulations according to Metz, such a syntactic device of editing is thereby returned again, as it would have seemed for film's early viewers, to an event of motivated magic or spectrality in certain narrative contexts – or at least to uncanny figuration. In the films I'll be considering, the narrative occasion for this return of technique as mysterious event is often the invasion of illusory mortal duration by a previous death – or exposed delusion.

Figure 30-31
Film stills, *The Double Life of Veronique*, Krzystof Kieslowski, 1991.

In the first link between its theme of the alter-ego and the mechanics of optical inversion, we see the heroine of Kieslowski's *Double Life of Veronique* (1991) fascinated with a glass ball's upside-down estrangement of the landscape racing by the windows of a train. (Figure 30) In this seemingly digressive optical episode, the autonomous 'sphere of vision' that turns the world upside down works to anticipate the action of the reflex camera in the next and pivotal scene. For it is there that the tourist Veronique snaps an unwitting picture of her Polish double, Weronika, a spectral transcription whose processed image goes unnoticed until much later in Paris. The heroine's last love scene, long after the death of Weronika, takes place in psychic dissociation while she is looking down her bed toward the post-humous photo from Poland, discovered in her purse for the first time by her lover: the impossible photo of herself as the other. (Figure 31)

Kieslowski's heroine is quite literally beside herself. One way in which the fantastic emerges for Todorov, and indeed as the special and intensified case of textuality all told, is that, at some triggering moment, it does indeed take 'a figurative sense literally.'[13] In *The Double Life*, a sensation like 'I'm so plagued by self-consciousness that I feel like I'm always looking on at myself,

[13] Tzvetan Todorov, op.cit., p.77.

or that someone else is' will materialize within the plot as an actual double who must eventually forego such redundant presence by dying, her difference assimilated – but never completely. Uncanny photography irrupts into Kieslowski's plot as the perfect emblem of a conscious past that is never entirely past, where instead the image is retained beyond the body as a trope for the spectator's (here the heroine's) own ambivalent psychic 'incorporation' of the imaged subject. That's the plot climax. But, yet again, we touch on a matter not only of genre but of medium.

In Todorov's view, fantasy, suspended as it is between the immanent and the unreal, the possible and the impossible, is the purest state of the literary. Such a metatextual understanding not only applies equally well to films of the fantastic but coincides with Metz's proposal that trick effects are only a special case of the cinematic illusion all told, since 'Montage itself, at the base of all cinema, is already a perpetual trucage.'[14] For Todorov, fiction is fantastic because its referents are strictly imagined. Similarly, all narrative cinema is fantastic because its presences and durations are strictly illusory. At points of rupture or resistance, however, the photograph comes forward as the special case of fantastic temporality. In its cultural function, the indexical moment of photographic record is retrograde and prospective at once, putting a seal on the past and delivering it forward to a future not its own. Todorov, in fact, admittedly lifts the paradigm for his differential definition – fantasy as the dividing line between the uncanny and the marvellous – from philosophical definitions of time present. For him the 'comparison is not gratuitous',[15] since he means to evoke the instant, the *now*, understood as the definitive yet vanishing line between the accumulated past (of received understanding) and the nebulous future (of undreamt marvels). A yet stronger claim, however, may well seem invited. It is not just the accumulated knowledge of the past that would explain away the marvellous in settling for an uncanny resolution. For the uncanny, after all, is often the spectral *return* of the past, the lifted repression of banned desire or recurrent fear. So between a haunting by the past and a daunting future of unheard-of wonders, between preternatural disturbance and supernatural epiphany, the seesaw of fantastic uncertainty negotiates its plotline across the dubious present of its presentation.

And the photograph? What is it, too, but the invisible division between a past life or space or event, arrived before the camera, and a future image that will supplement or eventually supplant its presence? The image lives off the past in order to live on into its own future. In this sense of the image's fantastic balancing act, death always encroaches from the uncanny pole of photography, immortality from the supernatural. In the discursive function of its deixis, its pointing, a photograph announces that this here was there to

14 Metz, op.cit., p.672.

15 Tzvetan Todorov, op.cit., p.42.

someone then. Thus photography inscribes the reciprocal vanishing of past and future into an objectified present transferable from taker to receiver, a present retained forever without change, a performative act of notice endlessly rehearsed as well as instantaneously preserved. What is deathlike about a human image under photochemistry is also, therefore, what is phantasmal about it.

A photograph has no memory, but is one, the material form of one. Photographed human images enact a perpetual displacement, from an absent subject to a subjectivity reconfigured by looking. The photographed person is thereby the prosthesis of a memory not belonging to it as agent, but only attached to it as object. When, moreover, such medial reverberations converge upon the doppelgänger motif of Kieslowski's *Veronique*, we recognize the simplicity of the photographic parable. An accidentally taken, processed, and subsequently unnoticed photograph of one's double, the other within, is only a general condition of psychic life spelled out in uncanny vocabulary. For in mental experience, doubleness is often *registered* without actually being recognized, psychically imprinted without being acknowledged. This is, indeed, one of the chief inferences behind the psychic trespass and sexual telepathy of so many fantastic episodes in recent European cinema.

Incorporating more obvious elements of magic realism than in Kieslowski's films, the principle of coincident plotlines and convergent fates is carried further yet in the fantastic cinema of Spanish director Julio Medem. In *The Red Squirrel* (1993), the unlikely final reunion of separated lovers is brought about through the mediation of photographic magic at the film's climax, in a shot that is literally pivotal. The hero fixes on a framed snapshot of himself with a former girlfirend, doubled by her own magnified image printed on a rock band T-shirt. Behind this image of the couple we make out in the photographic distance, as the hero does for the first time too, a further female image: the once accidental and now uncanny figure of the new lover. (Figure 32) Focused on in rapid closeup (Figures 33-34), this is a woman whose unnoticed presence in the park that day was a sheer coincidence – and premonition. Under the force of wish-fulfilment, the shot now magically *un*freezes and engulfs the hero's present space. Animated into lateral movement, the new lover and her former boyfriend first walk behind the other couple (Figure 35) and then pass in a shot/reverse shot exchange with the freestanding hero so that she may reveal the necessary clue to her present whereabouts as body rather than image (Figures 36-37). In this fantastic rescue of suture from within the two-dimensional plane of photography, a relationship previously threatened by death is submitted to the reanimation effect of desire.

Figures 32-37
Film stills, *The Red Squirrel*,
Julio Medem, 1993.

Figures 38-39
Film stills, *Lovers of the Arctic Circle*, Julio Medem, 1999.

The cinema of fantastic coincidence is even more obviously at work in Medem's next film, *Lovers of the Arctic Circle* (1999), whose opening shot of a crashed airplane in a blizzard is intercut with its front page image in the newspaper, read while crossing the street by a woman run down in the process by a passing bus. Her long-separated lover (also her stepbrother) rushes to her there, but only in time for a last fantasized embrace in the split-second of her death. The doomed nature of this reunion taps directly into the plot's incest motif, involving the first divorced (and then dead) mother for whom all the hero's previous lovers have been a failed substitute. At the film's turning point, with the hero both boy and man in the same relived space, the adult son returns home to retrieve his camera and finds his mother's corpse amid the fly-infested debris of her kitchen. In a double wrench of separation, his absolute loss is backdated to a foundational lack that is marked by a primal match-cut from this scene of adult trauma back to his former boyhood capture of the mother's living image (Figures 38-39): the taking of that very photograph which the son keeps by his bedside during his subsequent sexual

affairs. By the logic of the performative index, this photograph inscribes his mourning for himself, once present to her, as much as for her who was once there for him. When the film returns in its closing moments to the reflection of the hero in his lover's dead eye (Figure 40), followed again by the downed plane, we realize that the whole narrative may have transpired in flashback from the moment of death – and of his death as much as hers, perhaps, since he was piloting the downed plane. For in that lingeringly held image of reflected self in the death stare, what gets locked into place is the life-denying need to find your adult identity mirrored in the eye of the maternalized female other. Tom Gunning's interest in the nineteenth-century idea that a murderer's quasi-photochemical image is left as so-called 'optogramme' on the victim's eye finds a real-time but still fixed, suicidally transfixed, equivalent in this *Liebestod* variant.[16]

In its maternal overtones, the moment is almost pure Proust. Raoul Ruiz's impure version of actual Proust, *Le Temps Retrouvé* (1999), begins in the first scene with the slightest animation of family photographs in the palsied hand, and under the shaking magnifying glass, of Marcel's optically-aided revery – one after the other down through the generations, including 'Mama', until the arrival at 'et moi', his own photo as a boy (Figures 41-42). From this all but inert photographic marvel of a retrieved past, the first flashback sequence carries us to a POV shot of the young hero looking through the viewfinders of a portable stereopticon at a felled WWI cavalry horse, an image whose uncanny depth shifts into sudden cinematic motion. Optical gadgetry is here displaced from the slight parallax of paired stereo-graphic frames to the continuous animating disjunction of the serial strip, one photogram after another – and all this within the aura of the past refound as spectacle, its image trove retrieved at cinematic speed.

In recent Hollywood film, by contrast, optical tampering is more likely to be thematized as violence than as nostalgia. Though no photograph misrepresents or betrays the relation of the unnamed narrator to his violent sexual double in *Fight Club* (Fincher, 1999), it turns out that the latter, Tyler Durden, works nights as a movie projectionist. When we see him splicing porno footage into family films, frame by photographic frame, we are thereby reminded of his earlier irruption into filmic presence – even before his entrance into plot. For his own as yet unidentified image was at several points spliced into narrative by flash inserts – as if they were the extruded unconscious of the film's own structure. Against the insurgent undertext of projected filmic reality, the normally sufficient labour of seamless continuity – namely realist cinema – is the only true defence. Film keeps a lid on the fixated fetish of desire, figured here as the detached photogram or two of specular objecthood.

16 Tom Gunning, 'Tracing the Individual Body: Photography, Detectives, and Early Cinema', in *Cinema and the Invention of Modern Life*, ed. Leo Charney and Vanessa R. Schwartz, University of California Press, Berkeley, 1995, p.37.

Figure 43
Film still, *The Sixth Sense*,
M. Night Shyamalan, 1999.

Figures 44-45
Film stills, *The Others*,
Alejandro Almenabar, 2001.

Another recent film of the Hollywood fantastic, *The Sixth Sense* (Shyamalan, 1999), builds toward its delayed twist in the plot – where the hero himself is revealed as a ghost through the extrasensory perception of his young patient – by turning at one point on the fantastic ambivalence of photography. Looking at a wall of her child's photos, his mother notices for the first time that each image is streaked by a flare of light near the boy's head – almost like a reflective glare on the lens, but hovering in free space (Figure 43). A three-dimensional flaw, a ghost, an aura. By some unexplained transference, the child's extrasensory vision thus seems displaced onto photography's own alert viewer. The delayed shock of photographic recognition is even more extreme in a similar narrative twist of *The Others* (Almenabar, 2001). The infanticidal heroine dead from suicide (we discover only in the penultimate scene), who lingers on in a house she thinks haunted, comes upon a book of nineteenth century memorial photographs: the dead artificially posed as the living to preserve their souls (Figure 44). Worse, she later discovers that the three family servants she has hired have been the subjects of similar mortuary images (Figure 45). It is as if photography, in its evolved form as film, has indeed performed its supernatural magic by keeping these subservient figures in artificial animation before our own eyes as well as hers. Either as part of the protracted agony of her suicidal recognition or in the purgatory of postponed acceptance to which she is consigned, photography measures the past that will not depart, the past turned ghostly. In the process, and by extrapolation from it, filmic duration – projected as cinematic mirage – becomes an encompassing figure for the lingering time between the then and the eventual: a limbo of fantastic materializaton.

In the recent convolutions of such Hollywood filmmaking, not knowing that you are dead is only the obverse of not knowing, or failing to accept, that you have never been alive. Neo in the *Matrix* trilogy must fight back this doubt about his own existence, just in case it really is his. The spectator is asked to share his doubts. By contrast, the robot hero of *A.I. Artificial Intelligence* (Spielberg, 2001) is known all along, at least by us, to be wired rather than nerved with desire, sheathed in unchanging plastic rather than flesh. Like a free-standing photograph. He is in fact modelled, we discover halfway through, on the serial photos of the engineer's dead son (Figure 46), the most recent translated into a fixed posthumous replica engineered from the inside out. Virtual feelings in a virtual body: another version of a more pervasive digital paranoia that is backdated here to earlier anxieties about robotics and cybernetic simulation.

Life converted to images in the moment of its cancellation, and either preserved there artificially (as in *A.I. Artificial Intelligence*) or surrendered

Figure 46
Film still, *A.I., Artificial Intelligence*, Steven Spielberg, 2001.

under duress, is a familiar contemporary trope. The hero of *Vanilla Sky* (Crowe, 2001) is eventually disclosed as a post-suicidal subject who had contracted for eventual resuscitation by evolving DNA technology. When the virtual reality that has been electronically implanted in the meantime seems suddenly empty, the hero takes the 'leap of faith' into a non-programmed reality. Jumping from a skyscraper, his elapsed memories are spun past in a montaged (because deliberately metafilmic) strip of photographs and film excerpts recapitulating his own life and that of the media century. This past sweeps by so rapidly that the difference between still and moving image is reduced almost to zero – even while the whole montage closes in and down on the home-movie footage of an artificially implanted Proustian recovery where mother and son can be reunited at last (Figure 47).

This moment is prototypical. In the new ontological dystopias of Hollywood narrative, screen lives are over without having really been lived. Digital heroes, ghostly scapegoats, ectoplasmic psychopaths, robotic simulations, the suspended animation of every desire: the list lengthens, even while its remaining options would seem to be thinning out. The latest stage

Figure 47
Film still, *Vanilla Sky*, Cameron Crowe, 2001.

in Hollywood's ontological fantasy, parallel to the digital gothic of virtual agency, is a film, *Identity* (Mangold, 2003), that goes so far as to reveal all its characters as unambiguous (if long masked) projections of a psychotic central figure, an 'inner child' long ago abandoned by his mother. As each facet of a multiple personality disorder is 'folded in' – in other words, brutally murdered at the plot level – one among the splinter selves, a supposed police detective, takes forensic photographs with an off-the-rack camera as disposable as the disappearing bodies turn out to be. The images go undeveloped, perhaps because the radical apparitions of psychosis have no use for the evidentiary temporality of the fixed image in this fantastic plot. There is no time to be struck still in the present, violently or otherwise, since the entire film is merely the halluncinatory replay of past mayhem.

Figure 48
Film still, *One-Hour Photo*,
Mark Romanek, 2002.

By contrast, another recent film, also centered upon childhood trauma and its warping after-effects, turns specifically on the fantastic of photography itself: namely, its power to dissimulate one past in order to repress another, to still time and its ghosts at once. The protagonist of *One-Hour Photo* (Romanek, 2002) – reduced in the end to a dissolving trace on the frame strip, followed by a fixed but fantastized still – is a superstore clerk who has made illegal duplicates of a family's snapshots over the years and covered his walls with them, filling his underfurnished life with surrogate family pictures (Figure 48). After the police later discover he has scratched out the face of the father in every one of his hundreds of photos (Figure 49), we are led with them to suspect at the climax that he is about to take snuff pictures of the cheating husband and his mistress after cornering them *in flagrante* at

Figure 49
Film still, *One-Hour Photo*,
Mark Romanek, 2002.

knifepoint. By now, we may long ago have forgotten that the film is a flashback from police headquarters, precipitated by a question about what has provoked the photo-developer's rage.

What we are more likely yet to have forgotten is the transition from credits to opening shot: another 'trick beginning' answered to by the dénoument. As if replaying the history of still-image technology, we begin with the title sequence laterally scrolling past on the film roll, exposed credit by arrowed credit as if from inside a reflex camera. From there we jump to a digital camera in the act of piecing-out a mug shot of the protagonist. Into such a zone of secondary duplication he eventually disappears altogether, via the film's activated intertext, Michael Powell's 1960 *Peeping Tom*, where a father's continual filmed surveillance of a boy's life has turned the adult son into a voyeur and sexual psychopath. In a contemporary update of this theme, the proagonist of *One Hour Photo* turns out to have been subjected to, and objectified by, his father's explicitly pornographic photography. It is for this reason, we surmise, that all subsequent images operate as a kind of catharsis until he himself becomes reframed as a captured subject within the telltale rectangular (i.e., photographic) dimensions of the police interrogation tank (Figure 50). From there he is released only by the imagined insertion of himself into yet another (this time untaken) family snapshot that fades slowly to a final black screen. This last turn to fantasy is transacted across the revealed photogrammar of the narrative strip itself. For the transitional dissolve is so slow that the split between psychotic and avuncular personalities is manifest on screen in the form of that sheer difference,

Figures 50
Film still, *One-Hour Photo*,
Mark Romanek, 2002.

usually invisible as such, which is the secret motor not only of all shot or
scene change but of all image flow on screen. Metz's ultimate proposition –
all *montage* as *trucage* – has seldom been more eerily evoked. Furthermore, in
the break from sutured into purely hallucinatory space, the collapse of self
into its double could hardly be more sharply focused around the very logic of
'projection' in the psychoanalytic sense: the fantasy of self projected into an
illusory group image (Figure 51). *One Hour Photo* ends in what one tends to
call a wish-fulfillment fantasy, materialized by a trope of the medium itself.
The man for whom time bears always the pressure of intolerable memory is
assuaged by absolute stasis, however unreal.

More often of late, at least in Hollywood's ontological gothic, the unreality
is pervasive and entirely unwilled, imposed upon a protagonist in the form of
his or her very negation. A recent essay, wishing to recuperate a wide array of
these films in the modes of hallucinatory and digital illusion alike, to rescue
them for ethical weight, identifies their shared premise as that of a
'slipstream reality.'[17] But besides the content of such monitory fables, my
point is that both the structure of fantasy as genre and the manipulation of
screen image as medium can mark ethical parameters as well – or their
forfeit. The continuous equivocation of the real, even when it keeps viewers
on edge, can blunt their sense of consequence. In the grips of the immaterial,
nothing finally matters. If the character we took to be a hero is only an
imaginary figment or a dream double or a ghost, we leave the theatre with a
certain indifference, absolved of identification, of credence. We accede to the
unreal, which is in its own way a highly political act. In evaluating the cultural

17 See N. Katherine Hales
and Nicholas Gessler, 'The
Slipstream of Mixed Realities:
Unstable Ontologies and
Semiotic Markers' in *'The
Thirteenth Floor, Dark City,
and Mulholland Drive'*, *PMLA*,
May 2004, pp.482-499.

Film still, *One-Hour Photo*,
Mark Romanek, 2002.

valence of the fantastic, then, one must look past cinematic content to a
filmic form that may reconfigure the premise of a given plot as an axiom of
the cinematic medium itself. The filmic substrate can in this way locate the
true and deepest 'slipstream' of that virtual presence implemented by screen
mediation: the continuous mechanical analog of all fantastic illusion. And it
can be made to do so by the material ironies of the film itself. Such screen
narratives often replot their own normative condition as a fantastic deviance,
the medium reasserting itself as ontological nemesis. Photography vanishes
into its own filmic ghost as cinema: montage as apparition.

But this is partly because photography is fantastic in its own right. In
picturing that woman there, from way back then, photography is, as noted,
the moment of her transcribed past becoming my perceptual future across
the indexical insterstice of time present, time presented for capture. Duration
is cancelled within the image and displaced onto its aftermath as object. Film
then redoubles this function by giving us duration itself as visual object. It
offers, and is defined by, that continuous reanimation of the photogram that
takes the form of its relentless erasure, the mutual vanishing and eventuation
of image in the mode of motion. Stilled time is recirculated as time still: the
time of spectacle rather than its sequential registration. All cinema knows
this. Certain films find a use for showing it, rather than just depending on it.
In the present context, what comes through is a second-order recognition
that is often routed back into plot as its final undoing. Over and above the
inherent uncanniness of photography, that is, we find in cinema the fantastic
of the still image.

Examples of this recognition mobilized by plot keep coming, one after another, in Hollywood's current retoolings of the virtual. Even turning the paradigm of virtuality on end does not necessarily dislodge its strangehold on the filmic stratum of cinematic effect. In *Eternal Sunshine of the Spotless Mind* (Gondry, 2004), once again a trick beginning colludes with a twist ending (here filmically identical) even while corkscrewing round to undermine the plot's own premise. The narrative leads off, misleadingly enough, with the hero waking to a chance encounter with the woman who will become his lover – only for both of them, once the affair has gone bad, to contract with Lacuna Corporation for selective 'brain damage' to remove the 'map' (the graphically figured traces) of each other from their memories. As soon as all photographs of the former lovers have been confiscated, according to contract, along with other tangible memorabilia, their brains can then be electronically burned clean. Rather than being embalmed by photography, erotic time must here be cremated by a more advanced technology. But when that initial waking sequence is replayed in the penultimate scene, using the device of exactly repeated film footage, we realize that, the first time around, that scene had in fact been something like a proleptic flash forward to the couple's accidental second, rather than first, meeting, taking place now on the morning after the hero's electronic surgery.

Cutting through these complications, the theme of digital erasure is only a dystopian obverse of that digital fabrication explored in other recent films. In the ethics of the dystopian virtual, the real must be valorized, in this case sexually embraced, even if only after the fact. Which is why the unconscious of the couple resists their deliberate decision to forget. Electronic *trucage* dogs at their heels as they try desperately to sequester some pleasant memory beyond the reach of surveillance and effacement – with one whole *mise en scene* after another being eaten away in sequence by digital negations. Only the filmic, rather than the electronic, could finally come to their rescue, if only ambiguously. On view in the very last shot of *Eternal Sunshine* is perhaps, along with the final lap dissolve of *One Hour Photo*, the clearest divulgence of a filmic photogrammar in recent cinema. As the hero and heroine flee into the distance of a snowy landscape, a twofold loop begins, taking its slipping hold on the image plane. Such laboratory produced repetition offers a quintessential filmic disclosure from within cinema (at least from Soviet montage down to just before the era of digital imaging): an unevadable confession of the reprinted photogrammatic chain. What its overt manipulation serves to image in this case, whether as hallucination or metaphor or both, is the couple's urge to start out– and up –

Figures 52-53
Film stills, *Eternal Sunshine of the Spotless Mind*, Michel Gondry, 2004.

all over again, and then again, in their willed escape. Yet this figuring of revived desire appears in a filmic manifestation so dubious that a potential trope of renewal, at the level of cinematic rhetoric, gets thrown back into plot as more like another psychic recursion. As if violating Lacuna Corporation's first contractual stipulation to surrender all photographs, this last staggered thrust of desire seems unwilling, after all, to forego entirely the photographic index of suspended time. Instead, it holds motion itself to sheer repetition – at least until it fades to the pure white field not of snow but of projected light, unimpeded by imprint. (Figures 52-53)

This last brazen *trucage* allows the film's closing artifice of editing to resist, or at least postpone, the normal mode of filmic erasure and its fading traces. The resulting, snagged image hovers somewhere between the serial photographs that cannot finally still time and the speeding track that cannot really mummify its change in passing. In the plot-long effect of memory's overlay on duration, then, editing in *Eternal Sunshine* tacitly participates in the life-is-like-a-movie trope familiar from movies like *Vanilla Sky*, which also closed with the whiting-out (rather than blacking-out) of its home-movie footage. In this latest fable of the digital unconscious, the vicious (or mitigating) circle of the narrative's closing double loop offers a spliced succession running in place to nowhere – until the replayed grain of the snow-hazed figures fades further into the tabula rasa of the narrative's ultimate title shot, eternal only because changeless in its recurrence. Bleaching out the whole screen is a final effacing brightness that figures the 'spotless' plane of an entirely screened memory on the disappearing strip, safely invisible at last. Here, then, is a case of frame/d time stripped of all image: the photogram overexposed in every sense.

And here is where an inquiry into screen genre can penetrate and rethink the phenomenology of film's own medium – or where, in other words, the

forked paths of fantastic plotting may ultimately converge upon the temporal mystique of photographic presence. That convergence, we know, points to a process located always one level down, back, before – or between. The twist ending that rounds back on film's own plastic basis in serial imprint has become almost a new screen archetype, tapping the collective and accretive unconscious of the multi-framed strip itself. Before achieving his dream-come-true as a fantastic photograph, the sacrificial victim of *One Hour Photo* must pass, by lap dissolve, through the phantasmal abdication of his own 'real' image as a file of photograms. The frequent remediation of photography by film, even within a partly digitalized cinema, reverts at such moments from one sense of frame to the other, from screen to imprint, folding back on itself from projected rectangle to rotary increment. Here too, then, is where a narratology of mutually exclusive explanatory options (Todorov) closes upon what I would want to call a *narratography* of inscriptive intervals: attending to the simultaneous slippage and grip of imprint in the illusory play of moving images on screen. No contesting the sense that filmic succession is where the projected action is; nor that its cellular advance is regularly masked as such, photogram by photogram. That much is apparent, even if invisible. At the same time, though, and often in league with the thematic overload of foregrounded photographs, certain screen plots drop us through to a stratum of ocular response where the bared unreality of that action, that fantastic apparition, may be brought to view.

The Possessive Spectator
Laura Mulvey

As the cinematic experience is so ephemeral, it has always been difficult to hold on to its precious moments, images and most particularly, its idols. In response to this problem, the film industry produced, from the very earliest moments of fandom, a panoply of still images that could supplement the movie itself: production stills, posters, and above all, pin-ups. All these secondary images are designed to give the film fan the illusion of possession, making a bridge between the irretrievable spectacle and the individual's imagination. Otherwise, the desire to possess and hold the elusive image led to repeated viewing, a return to the cinema to watch the same film over and over again that echoes Freud's comment on children's pleasure in repetition, for instance, of play or of stories. With electronic or digital viewing, the nature of cinematic repetition compulsion changes. As the film is delayed and thus fragmented from linear narrative into favourite moments or scenes, the spectator is able to hold on to, to possess, the previously elusive image. In this delayed cinema the spectator finds a heightened relation to the human body, and particularly that of the stars. Halting the flow of film extracts the image of the star easily from its narrative surroundings for the kind of extended contemplation that had only been previously possible with film stills. From a theoretical point of view, this new stillness exaggerates the star's iconicity.

The image of a star is, in the first instance, an indexical sign like any other photographic image and an iconic sign like any other representational image. It is also an elaborate icon, with an ambivalent existence both inside and outside fictional performance. The term 'icon', in this context, goes beyond the sign of similarity in C.S. Pierce's semiotics to the symbolic processes of iconography and the iconophilia fundamental to the way Hollywood, and other mass cinemas, worked and work in their generation of star images. The cinema harnessed the human figure into the imaginary worlds of fiction, but the film industry went much further, hanging its fictions onto a highly stylized star system. Creating a star meant creating a name, sometimes literally a studio rebaptism as caricatured in *A Star is Born* (George Cuckor, 1954), but always one that could be recognised and named. The star's 'namability' introduces the third, symbolic, dimension of Pierce's trichotomy

of signs. The symbol is interpreted by the human mind and out of pre-existing cultural, rule-given, knowledge so that the instant recognisability of Amitab Bachchan and Sean Connery, for instance, or Ingrid Bergman and Nargis, would necessarily vary according to their surrounding film cultures. In this sense, the star is recognised and named within his or her spread of fandom, just as a Christian saint would be recognised and named within the spread of religious art.

When a film industry streamlines the star system, they work hard to create instantly recognizable, iconic screen actors whose highly stylized performance would be enhanced by an equally highly stylized, star focused, cinema. Star performance is, not inevitably but very often, the source of screen movement, concentrating the spectator's eye, localizing the development of the story and providing its latent energy. But the great achievement of star performance is an ability to maintain, in balance, a fundamental contradiction: the fusion of energy with a stillness of display. However energetic the star's movement might seem to be, behind it lies an intensely controlled stillness and an ability to pose for the camera. Reminiscent, figuratively, of the way that the illusion of movement is derived from still frames, so star performance depends on pose, moments of almost invisible stillness, in which the body is displayed for the spectator's visual pleasure through the mediation of the camera. In *What Price Hollywood* (George Cukor, 1932), Constance Bennett, as an aspiring actress, demonstrates the process of learning screen 'stillness'. After she fails her first screen test due to an over eager, speedy performance, she gradually internalizes the director's instructions on the stairs of her apartment building, and trains herself to walk with slow – almost slow motion – precision down the steps towards a final pose and a lazily delivered line. Female screen performance has always, quite overtly, included this kind of exhibitionist display. But the delayed cinema reveals that whilst the stillness and pose of a male star might be more masked it is nonetheless an essential attribute of his screen performance.

Roland Barthes' preference for the photograph over film lies includes his aesthetic pleasure in pose:

> *What founds the nature of Photography is the pose... looking at a photograph I inevitably include in my scrutiny the thought of that instant, however brief, in which a real thing happened to be motionless in front of the eye. I project this present photograph's immobility upon the past shot, and it is this arrest that constitutes the pose. This explains why the Photograph's noeme deteriorates when this photograph is animated and becomes cinema: in the Photograph something has posed in front of the tiny hole and has remained*

there for ever ... but in the cinema, something has passed in front of this same tiny hole: the pose is swept away and denied by the continuous series of images.[1]

1 Roland Barthes, *Camera Lucida*, Vintage, London, 1993, p.78.

The delayed cinema reveals the significance of the pose even when the 'something has passed by'. The halted frame, the arrest, discovers the moment of immobility that belongs to the frame and allows the time for contemplation that takes the image back to the brief instant that recorded the 'real thing'. As the apparatus asserts its presence and the original indexicality of its images, the pose is no longer 'swept away and denied' but may rather be enhanced by the performance of stardom. Pose allows time for the cinema to denaturalize the human body. While always remaining 'the real thing', the iconic figure of the star is always on display, a vehicle for the aesthetic attributes of cinema, a focus for light and shade, framing and camera movement. The close-up has always provided a mechanism of delay, slowing cinema down into contemplation of the human face, allowing for a moment of possession in which the image is extracted, whatever the narrative rationalisation may be, from the flow of a story. Furthermore, the close-up necessarily limits movement, not only due to the constricted space of the framing but also due to the privileged lighting with which the star's face is usually enhanced. Mary Ann Doane has pointed out that the close-up is a key figure for photogenie, the ecstatic contemplation of cinema in its uniqueness, and that the desire for the close-up has traditionally been marked by a rejection of narrative's diachronic structure in favour of the synchronic moment itself. The close-up is thus treated:

> *...as stasis, as a resistance to narrative linearity, as a vertical gateway to an almost irrecoverable depth behind the image. The discourse seems to exemplify a desire to stop the film, to grab hold of something that can be taken away, to transfer the relentless temporality of the narrative's unfolding to a more manageable temporality of contemplation.*[2]

2 Mary Ann Doane, 'The Close-up: Scale and Detail in the Cinema' *differences: a Journal of Feminist Cultural Studies* vol.14, no.3, Fall 2003.

The star's visual apotheosis is no more material than the light and shadows that enhance it and the human figure as fetish fuses with the cinema as fetish which further connects with the fusion of fetishism and aesthetics that characterises photogenie. Here the symbolic quality of film aesthetics, even 'the more manageable temporality of contemplation', leads towards its eternal, unavoidable, shadow, the psychodynamics of visual pleasure. The extraordinary significance of the human figure in cinema, the star, its iconic sexuality, raises the question of how desire and pleasure are re-configured in delayed cinema, both as stillness within the moving image and within a changed power relation of spectatorship.

In *Visual Pleasure and Narrative Cinema* I argued that the cinema, as a medium of spectacle, coded sexual difference in relation to the look while

also creating an aesthetic of extreme anthropomorphism, of fascination with the human face and human body. This coding was particularly apparent in Hollywood films, so deeply invested in the cult of the star. The female star was, I argued, streamlined as erotic spectacle while the male star's attributes of control and activity provided some compensation for his exposure as a potentially passive object of the spectator's look. The female figure's passivity and the male drive of the narrative were in tension and difficult to reconcile. As spectacular image, she tended to bring the story to a stop and capture the spectator's gaze in excess: 'The presence of woman is an indispensable element of spectacle in normal narrative film, yet her visual presence tends to work against the development of the story line, to freeze the flow of action in moments of erotic contemplation.'[3]

Watching Hollywood films delayed both reinforces and breaks down these oppositions. The narrative drive tends to weaken if the spectator is able to control its flow, to repeat and return to certain sequences while skipping others. The smooth linearity and forward movement of the story becomes jagged and uneven, undermining the male protagonist's command over the action. The process of identification, usually kept in place by the relation between plot and character, suspense and transcendence, loses its hold over the spectator. And the loss of ego and self-consciousness that has been, for so long, one of the pleasures of the movies gives way to an alert scrutiny and scanning of the screen, lying in wait, as it were, to capture a favourite or hitherto unseen detail. With the weakening of narrative and its effects, the aesthetic of the film begins to become 'feminized' with the shift in spectatorial power relations dwelling on pose, stillness, lighting and the choreography of character and camera. Or, rather, within the terms of the *Visual Pleasure and Narrative Cinema* model, the aesthetic pleasure of delayed cinema moves towards fetishistic scopophilia that, I suggested, characterized the films of Josef von Sternberg. These films, most particularly the Dietrich cycle, elevate the spectator's look over that of the male protagonist and privilege the beauty of the screen and mystery of situation over suspense, conflict or linear development. The 'fetishistic spectator' becomes more fascinated by image than plot, returning compulsively to privileged moments, investing emotion and 'visual pleasure' in any slight gesture, a particular look or exchange taking place on the screen. Above all, as these privileged moments are paused or repeated, the cinema itself finds a new visibility that renders them special, meaningful and pleasurable, once again confusing *photogenie* and fetishism.

In this reconfiguration of 'fetishistic spectatorship', the male figure is extracted from dominating the action and merges into the image. So doing,

3 Laura Mulvey, 'Visual Pleasure and Narrative Cinema', *Visual and Other Pleasures*, Macmillan, London, 1989, p.19.

he, too, stops rather than forwards the narrative, inevitably becoming an overt object of the spectator's look, against which he had hitherto been defended. Stripped of the power to organize relations between movement, action and the drive of the plot, on which the whole culture of cinema categorized by Deleuze as the 'action image' depends, the male star of a Hollywood film is exposed to the 'feminization' of the spectator's gaze. As a film's masculinity has to risk the castrating effect of delay and fragmentation, this form of spectatorship may work perversely against the grain of the film but it is also a process of discovery, a fetishistic form of textual analysis. When narrative fragments and its protagonists are transformed into still, posed, images to which movement can be restored, the rhythm of a movie changes. The supposed laws of smoothly distributed, linear cause and effect are of minor aesthetic importance compared to another kind of, more tableau orientated, rhythm. Howard Hawks pointed out that a director tends to concentrate drama and spectacle into privileged scenes so the fragmentation of narrative continuity may also be the discovery of a pattern that had been clouded by identification, action or suspense. But the human body is of the essence in 'fetishistic spectatorship'. Performance and the precision of gesture take on an enhanced value not only on the part of the great stars but of secondary and character actors as well. Movement that looks natural, even chaotic, at the normal speed of film turns out to be as carefully choreographed as a ballet and equally punctuated with pose.

In his video essay *Negative Space*, Chris Petit commented on Hollywood cinema's intrinsic ability, at its best, to produce a kind of 'silent' cinema, a system of creating meaning and emotion outside language itself. There are, he says: 'defining moments that stay in the mind long after the rest of the movie has been forgotten.' He draws, particularly, on Robert Mitchum's gesture and stance in *Out of the Past*, illustrating the way that his figure is enhanced by film noir lighting and shadow. In Don Siegel's *The Big Steal* (1949) Mitchum's first appearance illustrates both the importance of the paused moment in which the star is introduced to the camera and the importance of 'masculinizing' that moment. William Bendix leads the film through its opening sequence, during which he occasionally pauses, heavily lit in profile so that his 'tough guy' image is reflected in his shadow. As he bursts open the door to Mitchum's room, the star swings round to face the camera, frozen for an extended moment in shock, and reflected in a background mirror. This is a moment of the star on display, as exhibitionist. But the risk of feminizing the male star as spectacle is neutralised by violence, by the gun in Bendix's hand and his aggression. However, throughout the film, shots of Mitchum recur in which his movements are

similarly paused, overtly for narrative purposes but also producing a characteristic pose for the camera. Like personal *objets trouvés*, such scenes can be played and replayed, on the threshold between cinephilia and fandom. But in the process of stilling a favourite figure, transforming it into a pin-up and then reanimating it back into movement, the spectator may well find, as in the case of *The Big Steal* that the rhythm is already inscribed into the style of the film itself.

The fetishistic spectator controls the image to dissolve voyeurism and reconfigure the power relation between spectator, camera and screen, male and female. The question that then arises is whether these new practices of spectatorship have effectively erased the difficulty of sexual difference and the representation of gender in the cinema. What might the unconscious investment be in the spectator's control over the cinematic image? In *Visual Pleasure and Narrative Cinema* I suggested that, as an active instinct, voyeurism found its narrative associate in sadism. 'Sadism demands a story, depends on making something happen, forcing a change in another person, a battle of will and strength, victory/defeat, all occurring in linear time with a beginning and an end.'[4] This premise was drawn directly from Freud's equation of the active sexual instinct with masculinity and its opposite with femininity. Although it was key to his theory that the instincts were reversible, Hollywood cinema, as I understood it, by and large, inscribed the binary opposition quite literally into both narrative and the visual codes that organized the spectator's visual pleasure.

Among the many critiques of this hypothosis, an important corrective has been offered by analyses of cinema directed towards a female audience. In her study of Rudolph Valentino, Miriam Hansen analyses the ambivalence of his persona, which, on the one hand, threatened conventional masculinity, on the other, had huge commercial advantages for an industry courting an important female audience. Valentino, as well as other matinee idol type stars of the 1920s, upsets my assumptions about the gendering of visual pleasure. Hansen points out that, as a primary object of spectacle for a female audience, Valentino's persona incurs a systematic 'femininization', but she ultimately revises the unequivocal binarism of Freud's passive and active opposition. In the process, she evolves a concept of female spectatorship that is, in the first instance, specific to the Valentino anomaly, but also illuminates theoretically the visual pleasures of delayed cinema. She begins by suggesting that female vision benefits from being incomplete, in contrast to the 'goal-orientated discipline of the one-eyed masculine look.'[5] Similarly:

> *On the level of filmic enunciation, the feminine connotations of Valentino's 'to-be-looked-at-ness' destabilizes his own glance in its very origin, makes him*

4 Ibid., p.22.

5 Miriam Hansen, *Babel and Babylon: Spectatorship in American Silent Film*, Harvard University Press, Cambridge, Mass., 1991, p.278.

vulnerable to the temptations that jeopardize the sovereignty of the male subject ...The erotic appeal of Valentino's gaze, staged as a look within the look, is one of reciprocity and ambivalence rather than mastery and objectification. [6]

She goes on to analyse various points at which the Valentino movies fail to conform to either narrative or visual norms of later Hollywood, while the presence of a strong female look within the diegesis grants legitimacy to that of the female spectator. The unusual scopic attention invested in his star presence both on and off the screen is the initial source of this destablization. In the absence of narrative suspense, activity, physical movement and gesture acquire extra significance, and 'closure tends to reside in smaller units, cutting across visual and narrative registers'. [7] Finally, Hansen points out the sado-masochistic themes associated with Valentino, the 'interchangeability of the sadistic and masochistic positions within the diegesis...the vulnerability Valentino displays in his films, the traces of feminine masochism in his persona', [8] which indicate a deviance from the male subject's sexual mastery and control of pleasure.

Hansen's analysis prefigures, at many points, the spectatorship of delayed cinema, the weakening of narrative as well as transferred attention to detail and gesture and finally the importance of star-presence for a sense of oscillation between index and icon. Valentino's persona, his feminization, his association with lesbians, his possible homosexuality, his foreignness, all add to the uncertainty of both types of signs. However, in relation to sadism and masochism the picture is, perhaps, rather different. With the weakening of character identification, the spectator's vicarious control over the plot is replaced by another kind of power as the spectator gains immediate control over the image. No longer the driving force of the movie, the star succumbs to stillness and repetition. The desire for possession, only previously realized outside the film, in stills and pin-ups, can now be fulfilled not only in stillness but also in the repetition of movements, gestures, looks, actions. In the process, the illusion of life, so essential to the cinema's reality effect, weakens and the apparatus overtakes the figure's movements as they are inescapably repeated with mechanical exactitude. The human figure becomes an extension of the machine, conjuring up the pre-cinematic ghost of an automaton.

The fragmentation of narrative, the fetishization of the human figure, the privileging of certain sequences all return the question of sadism to Freud's concept of repetition compulsion. Furthermore, the psychic economy of sadism changes in the context of *Beyond the Pleasure Principle* and Freud's concept of the death instinct. As Peter Brooks demonstrates so convincingly in 'Freud's Master Plot', the death instinct, the aim to return to an inorganic, earlier state, structures the drive towards death in narrative. [9] But Freud's

6 Ibid., p.279.

7 Ibid., p.282.

8 Ibid., p.287

9 Peter Brooks, 'Freud's Master Plot' in *Reading for the Plot: Design and Intention in Narrative*, Vintage, New York, 1985.

interest in the death instinct was originally aroused by the anomalous compulsion to repeat unpleasurable experiences, thus seemingly to contradict the dominance of the pleasure principle in mental life.

Freud reconfigured his previous theories of instinct in *Beyond the Pleasure Principle* so that previous oppositions are transformed into one between the life instincts (Eros) and the death instincts. In another essay he summarizes the process:

> *The libido has the task of making the destroying instinct innocuous, and it fulfills that task by diverting that instinct to a great extent outwards... The instinct is then called a destructive instinct, the instinct for mastery, or the will to power. A portion of the instinct is placed directly in the service of the sexual function where it has an important part to play. This is sadism proper.* [10]

10 Sigmund Freud, 'The Economic Problem of Masochism' (1924) in *The Standard Edition of the Complete Psychological Works of Sigmund Freud*, volume XIX, The Hogarth Press, London, 1961, p.163.

The possessive spectator commits an act of violence against the cohesion of a story, the aesthetic integrity that holds it together and the vision of its creator. But, more specifically, the sadistic instinct is expressed through the possessive spectator's desire for mastery and will to power. In the role reversal between the look of the spectator and the diegetic look of the male protagonist, the figure that had been all powerful both on and off the screen is now subordinated to manipulation and possession. Film performance is transformed by repetition and actions begin to resemble mechanical, compulsive gestures. The cinema's mechanisms take possession of the actor or star and, as their precise, repeated gestures become those of automata, the uncanny fusion between the living and dead merges with the uncanny fusion between the organic and the inorganic, the human body and the machine.

Martin Arnold, the Viennese experimental film-maker, influenced by the work of Peter Kubelka, re-edits fragments of old Hollywood movies and, in the process, transforms the movement of celluloid figures into empty gestures with no beginning, end or purpose. In *pièce touchée*, he draws out a man's entrance into a room, in which a woman is waiting, by repeating frames in series similar to the effect of flicker films (See Figure 7). As the man enters the door over and over again, as the woman looks up from her magazine, over and over again, a couple of screen seconds are stretched out over minutes. At the same time, the rhythm of the repeated gestures begins to resemble the mechanical movements of automata. These experiments accentuate the vulnerability of old cinema and its iconic figures. Subjected to repetition to the point of absurdity, they lose the cinema's grounding in the index as well as their protective fictional worlds. Furthermore, the repeated frames that elongate each movement and gesture assert the presence of filmstrip, the individual frame in sequence that stretches towards infinity. Flicker films' repetition and variation, as in the films of Kubelka, have no

necessary limit but revolve around an abstract pattern. As Arnold combines stretched time with the manipulation of human gesture, he combines reference to the strip of celluloid with the presence of the cinema machine, the uncanny of the inorganic and the automaton.

Some years ago, I digitally re-edited a thirty second sequence of 'Two Little Girls from Little Rock', the opening number of *Gentlemen Prefer Blondes* (Howard Hawks 1953), in order to analyze the precision of Marilyn Monroe's dance movements and as a tribute to the perfection of her performance. In addition to the artificial, stylized persona, evocative of the beautiful automaton, her gestures are orchestrated around moments of pose. In this particular fragment, played to camera, she pulls up the strap of her dress in a performance of an almost sluttish disorder of dress that is completely at odds with the mechanical precision of this and each gesture. Even though the gesture was so self-consciously produced, it has, for me, something of Barthes' *punctum*, and I found myself returning over and over again to these few seconds of film. In the re-edit, I repeated the fragment three times, freezing the image at the moments when Marilyn paused between movements. In addition to her own precise and controlled performance, dance itself demands a control of the body that pushes its natural humanity to the limits also alternating between stillness and movement. The developed gesture unfolds until it finds a point of pose and then unfolds just as the delayed cinema finds such moments through repetition and return. The 30-second sequence ends as Marilyn moved forward into close-up, throwing her head back and assuming the pose and expression of the essential Marilyn pin-up photograph. This paused image seems to be almost exactly the same as the Andy Warhol 'Marilyns' that he made after her death, in his silk-screened homage to the death mask. The imaginary superimposition of the Warhol image onto the trace of the living Marilyn has a sense of deferred meaning, as though her death was already prefigured in this pose. An acute consciousness of her 'then', before her death, condenses with the image as death mask and the poignant presence of the index as the 'this was then'.

The fetishistic spectator, driven by a desire to stop, to hold and to repeat these iconic images especially as perfected in highly stylized cinema, can suddenly, unexpectedly, encounter the index. The time of the camera, its embalmed time, comes to the surface, shifting from the narrative 'now' to 'then'. The time of the camera brings with it an 'imaginary' of the filming into the mind's eye, the off-screen space of the crew and the apparatus, so that the fictional world changes into the pro-filmic event. As fictional credibility declines, as disbelief is no longer suspended, 'reality' takes over the scene affecting the iconic presence of the movie star. Due to the star's

iconic status, he or she can only be tangentially grafted onto a fictional persona. If the time of the index displaces the time of the fiction, the image of the star shifts not only between these two registers but also to include iconography constructed by the studio and any other information that might be circulating about his or her life. Out of this kind of fusion and confusion, gossip and scandal derive their fascination and become attached to the star's extra-diegetic iconography. Behind even the most achieved performance, sometimes in an unexpected flash, this extra-diegetic presence intrudes from outside the scene and off screen giving an unexpected vulnerability to a star's on-screen performance.

This kind of additional knowledge, combined with the passing of time, brings the 'shudder at the catastrophe that has already occurred' that Barthes mentions in relation to Lewis Payne, the young man photographed just before his execution. 'I read at the same time: *This will be* and *this has been*; I observe with horror an anterior future of which death is the stake.'[11] Watching James Dean, Natalie Wood and Sal Mineo, the three teenagers in *Rebel without a Cause*, that shudder then triggers another one. Knowing the deaths of all three, that were to come and that have already taken place, arouses the irrational sense of fate that Freud cites as an instance of the uncanny. Overlaid across the indexical uncanny that is derived from the photographic medium itself, in the Hollywood (or indeed, any) star system is this other uncanniness, a sense of an over-determined life, subject to an order and force outside that of the ordinary. But this kind of reverie, moving as it does away from the image, to the semi-reality of biography, anecdote and gossip, ultimately gives way to the diegetic space of the story. The star's image on the screen is inextricably woven into narrative by performance, in gesture and action. In the last resort, the star is on the screen due to the fiction alone and the iconicity of performance and performer merges back into the temporality of the story. Just as the time of the still frame coexists with that of movement, and the time of the camera's registration of the image coexists with the time of fiction, so the symbolic iconography of star is indelibly stamped onto his or her presence as a 'character' and as index. These different kinds of signification oscillate and change places with each other.

It is perhaps for this reason that scenes in which the star is translated from the iconicity of his or her extra-diegetic presence into the diegesis have particular importance. Hitchcock quite often used these moments for dramatic effect. For instance, in her first appearance in *Rear Window*, Grace Kelly poses for the camera and, turning on the electric lights one by one, creates her own *mise-en-scène* as she introduces herself ironically to James Stewart, while establishing her fictional identity for the audience. Similarly,

11 Roland Barthes, op.cit., p.96.

in *Vertigo*, Kim Novak pauses for a moment, in profile, for James Stewart to look closely at her and integrate both of them into the compulsive world of his obsession. Perhaps the most remarkable example is *Marnie*, when Tippi Hedren's face has been kept from the camera until the moment when she throws back her newly blonde, wet, hair and looks directly at the audience. These introductory shots are like re-baptisms when a star's name and image, always instantly recognizable to the audience, are replaced by another name within the order of the fiction. A kind of shifting process takes place. Roman Jacobson has pointed out that shifters, in language, combine a symbolic with an indexical sign: a word is necessarily symbolic while an index has an existential relation to the object it represents. If shifters in language are, therefore, 'indexical symbols', the screen image of a star would be an 'indexical icon' but with his or her integration into the fiction, under a new name, yet another 'symbolic' dimension opens up. The 'naming' that accompanies the star's first appearance on screen gives way to the fictional baptism but the strength of star iconography often renders this process partial and incomplete. The three forms of the sign according to Pierce merge in the star system while continually shifting in register, uncertain and unresolved. The iconic representation merges with its symbolic iconography and both shift partially the symbolic register of the fiction. However, as an indexical sign, the star is undifferentiated from his or her surroundings, all are an integral part of the photographic medium, its apparatus and its ghostly trace of reality.

In his 1946 essay 'The Intelligence of a Machine', Jean Epstein points out that the cinema's fusion of the static and the mobile, the discontinuous and the continuous seems to fly in the face of nature, 'a transformation as amazing as the generation of life from inanimate things'.[12] Human figures preserved on film embody these oppositions more completely and poignantly than any other phenomenon of representation. The cinematic illusion fuses two incompatible states of being into one, so that the mutual exclusivity of the continuous and the discontinuous, pointed out by Epstein, is literally personified in the human figure, an inorganic trace of life. To translate the stilled image into movement is to see the uncanny nature of the photograph transformed out of one emotional and aesthetic paradigm into another. The uncanny of the indexical inscription of life, as in the photograph, merges with uncanny of mechanized human movement that belongs to the long line of replicas and automata. However interwoven these phenomena may be, the index is a reminder that at the heart of the medium, these celluloid images are not replicas but are an actual, literal inscription of the figure's living movements. Furthermore, the cinema has constantly, throughout its history,

12 Jean Epstein, 'L'intelligence d'une Machine', *Ecrits sur le cinéma*, Paris, 1974, p.259.

exploited its ghostly qualities, its ability to realize irrational fears and beliefs in the most rational and material form, along similar lines to Freud's assertion that belief in the afterlife warded off fear of death. While Rossellini in *Journey to Italy*, for instance, acknowledged the long history of the popular, semi-Christian, semi-animistic, uncanny, he also demonstrated that the cinema's uncanny lay in its contradictory materialization of life and death, the organic and the inorganic. For Rossellini, the more realistic the image, the more closely it rendered the reality it recorded, the more exactly it could catch hold of the human mind's bewilderment in the face of these contradictions. It is when the struggle to reconcile and repress these contradictions fails and uncertainty overwhelms the spectator that the cinema's *punctum* can be realized. The contradiction is dramatized in the final sequence of Augusto Genina's *Prix de Beauté* (1930). While Louise Brooks watches, enraptured, as her image performs in the screen test that should make her a star, her jealous husband slips unnoticed into the back of the room and shoots her. As she dies, her filmed image continues singing on the screen, in a layered, ironic, condensation of movement and stasis, life and death and the mechanicized perfection of the screen image. Similarly, the cinema's great icons still perform and re-perform their perfect gestures after death.

Raymond Bellour, in '"...rait" signe d'utopie', makes an analysis, or psychoanalysis, of Barthes' various comments on the cinema, through his use of the conditional tense (in French marked by the suffix 'rait'). In relation to the concept of 'The Third Meaning', evolved from stills taken from *Ivan the Terrible*, Bellour argues that Barthes is unable to find a place for the cinema between reverie on its still images and writing about them. And he goes on to point out that this utopian place, inaccessible to Barthes, would ultimately be realised with the advent of new moving image technologies and 'the art of "new images"', which deeply affected spectatorship.

For Bellour, one of the great pioneers of textual analysis, this interactive transformation had always been a condition for the existence of film theory. He draws attention to what one might call the 'theoretical punctum' in Barthes' observations on the cinema. Towards the end of *Camera Lucida* Barthes describes how he was suddenly and unexpectedly affected by a scene in Fellini's *Casanova*. When he watched Casanova dance with a young automaton he found himself overwhelmed by an intense emotion aroused by details of her figure, clothes, her painted but all the same innocent face, her stiff but accessible body. He found himself beginning to think about photography because these feelings were also aroused by photographs that he loved. Bellour observes: 'The figure's incomplete, jerky movements were made from static positions so that its body became one with the movement of

the film, on which it left a kind of wound.'[13] It is as though the movement of the mechanical figure suggested that of the other, the projector, which should have remained hidden. Barthes prefaces his reflections on the automaton in *Casanova* by saying that he saw the film on the day that he had been looking at photographs of his mother that had moved him so much. Bellour sees in the description of the automaton not only the punctum associated with the 'Winter Garden' photograph of his mother as a little girl, but also with the body of the very old woman, alive but close to death. He links the relation between mother and son to the cinema itself: 'It may be that the artificial body is always too close to the mother's body.'[14]

Bellour suggests that 'a kind of wound' opened up by the automaton leads to the film's mechanism, to the 'inside' that, like the inside of the beautiful doll, needs to be disguised to maintain its credibility. The film subjected to repetition and return, when viewed on new technologies, suffers from the violence caused by extracting a fragment from the whole that, as in a body, 'wounds' its integrity. But in another metaphor, this process 'unlocks' the film fragment and opens it up to new kinds of relations and revelations. From this perspective, the automaton's staccato, mechanical movements prefigure the hovering between movement and stillness that characterizes textual analysis and Bellour's own pioneering work with film fragments. And she also acts as a figure for 'the wavering and confusion between movement and stillness' that characterize the interactive spectatorship enabled by new technologies. As it penetrates the film, this new way of looking emasculates the coherent whole of narrative structure, 'wounding' the surface. The figure of the automaton returns in a double sense, first as the site of castration anxiety, this time threatening the 'body' of the film itself, and secondly as metaphor for a fragmented, even feminized, aesthetic of cinema. With Barthes' perception of the *Casanova* automaton and with Bellour's interpretation, the Freudian uncanny of the mother's body merges with the now ageing body of film.

13 Raymond Bellour, '"...rait" signe d'utopie', in Roland Barthes après Roland Barthes, *Rue Descartes*, 34, December 2001, p.43.

14 Ibid.

Possessive, Pensive and Possessed
Victor Burgin

The cinematic heterotopia

Early in the history of cinema, André Breton and Jacques Vaché spent afternoons in Nantes visiting one movie house after another: dropping in at random on whatever film happened to be playing, staying until they had had enough of it, then leaving for the next aleatory extract. Later in the history of cinema, Raoul Ruiz went to see films set in classical antiquity with the sole desire of surprising an aircraft in the ancient heavens, in the hope he might catch 'the eternal DC6 crossing the sky during Ben Hur's final race, Cleopatra's naval battle or the banquets of *Quo Vadis*'[1] – and Roland Barthes at the cinema found himself most fascinated by 'the theater itself, the darkness, the obscure mass of other bodies, the rays of light, the entrance, the exit'.[2] Such viewing customs customise industrially produced pleasures. Breaking into and breaking up the film, they upset the set patterns that plot the established moral, political and aesthetic orders of the entertainment form of the *doxa*.[3] During the more recent history of cinema, less self-consciously resistant practices have emerged in the new demotic space that has opened between the motion picture palace and consumer video technologies. Few people outside the film industry have had the experience of 'freezing' a frame of acetate film, or of running a film in reverse – much less of cutting into the film to alter the sequence of images. The arrival of the domestic video cassette recorder, and the distribution of industrially produced films on videotape, put the material substrate of the narrative into the hands of the audience. The *order* of narrative could now be routinely countermanded. For example, control of the film by means of a VCR introduced such symptomatic freedoms as the *repetition* of a favourite sequence, or *fixation* upon an obsessional image.[4] The subsequent arrival of digital video editing on 'entry level' personal computers exponentially expanded the range of possibilities for dismantling and reconfiguring the once inviolable objects offered by narrative cinema. Moreover, even the most routine and non-resistant practice of 'zapping' through films shown on television now offers the sedentary equivalent of Breton's and Vaché's ambulatory *dérive*. Their once avant-garde invention has, in Viktor

1 Raoul Ruiz, *Poétique du Cinéma*, Paris, Dis Voir, 1995, p.58.

2 Roland Barthes, 'En sortant du cinéma', *Communications*, no.23, Paris, Seuil, 1975, p.106-7.

3 The term Barthes appropriates from Aristotle to denote 'Common Sense, Right Reason, the Norm, General Opinion'.

4 Repetition as a mode of spectatorship was established early in the history of cinema, in the 'continuous programming' that allowed spectators to remain in their seats as the programme of (typically) newsreel, 'short' and main-feature recycled. (See Annette Kuhn, *An Everyday Magic: Cinema and Cultural Memory*, London, Tauris, 2002, pp.224-5.) We may also think of typical forms of television spectatorship, with the broadcast film interrupted by such things as commercial breaks, telephone calls and visits to the kitchen.

Shklovsky's expression, 'completed its journey from poetry to prose'. The decomposition of fiction films, once subversive, is now normal.

Films are today dismantled and dislocated even without intervention by the spectator. The experience of a film was once localised in space and time, in the finite unreeling of a narrative in a particular theatre on a particular day. But with time a film became no longer simply something to be 'visited' in the way one might attend a live theatrical performance or visit a painting in a museum. Today, as I wrote in a previous book:

> ... a 'film' may be encountered through posters, 'blurbs', and other advertisements, such as trailers and television clips; it may be encountered through newspaper reviews, reference work synopses and theoretical articles (with their 'film-strip' assemblages of still images); through production photographs, frame enlargements, memorabilia, and so on. Collecting such metonymic fragments in memory, we may come to feel familiar with a film we have not actually seen. Clearly this 'film' – a heterogeneous psychical object, constructed from image scraps scattered in space and time – is a very different object from that encountered in the context of 'film studies'.[5]

5 Victor Burgin, In/Different Spaces: place and memory in visual culture, University of California Press, Berkeley and Los Angeles, 1996, pp.22-3.

The 'classic' narrative film became the sole and unique object of film studies only through the elision of the *negative* of the film, the space beyond the frame – not the 'off screen space' eloquently theorised in the past, but a space formed from all the many places of transition between cinema and other images in and of everyday life. Michel Foucault uses the term 'heterotopia' to designate places where 'several sites that are in themselves incompatible' are juxtaposed.[6] The term 'heterotopia' comes via anatomical medicine from the Greek *heteros* and *topos*, 'other' and 'place'. I am reminded of the expression *einer anderer Lokalität* by which Freud referred to the unconscious. Although Foucault explicitly applies the concept of 'heterotopia' only to real external spaces, he nevertheless arrives at his discussion of heterotopias via a reference to *utopias* – places with no physical substance other than that of representations: material signifiers, psychical reality, fantasy. What we may call the 'cinematic heterotopia' is constituted across the variously virtual spaces in which we encounter displaced pieces of films: the Internet, the media, and so on, but also the psychical space of a spectating subject that Baudelaire first identified as 'a *kaleidoscope* equipped with consciousness'.

6 Michel Foucault, 'Of Other Spaces', Diacritics, vol.16, no.1. Foucault's suggestive essay 'Des Espaces Autres' was originally given as a lecture in 1967 and he did not subsequently review it for publication. Many of the ideas in it remain undeveloped, and my own use of them here is partial.

Roland Barthes describes how one evening, 'half asleep on a banquette in a bar', he tried to enumerate all the languages in his field of hearing: 'music, conversations, the noises of chairs, of glasses, an entire stereophony of which a marketplace in Tangiers ... is the exemplary site'. He continues:

And within me too that spoke … and this speech … very much resembled the noise of the marketplace, this spacing of little voices that came to me from outside: I myself was a public place, a souk; the words passed through me, small syntagms, ends of formulae, and no sentence formed, *as if that were the very law of this language.*[7]

Eyes half closed, Barthes sees an homology between the cacophony of the bar and his involuntary thoughts, where he finds that no 'sentence' forms. When Stanley Kubrick's film *Eyes Wide Shut* (1999) was released one reviewer compared it unfavourably to its source in Arthur Schnitzler's novella *Dream Story*.[8] He observed that Schnitzler's narrative consists of a series of disconnected incidents which the writer nevertheless unifies into a meaningful whole through the continuous presence of the narrator's voice. The reviewer complained that Kubrick's retelling of the story suffers from the absence of this device, and that as a result the narrative remains disturbingly disjointed. The 'disjointedness' that the reviewer found in Kubrick's film might be seen as a structural reflection within the film of its own immediate exterior, the *mise-en-abyme* of its existential setting. A short trailer for *Eyes Wide Shut* played in cinemas for several weeks before the film was released. It showed the two principal actors embracing in front of a mirror while a pulsing rock and roll song plays on the sound track. A still from this same sequence appeared throughout the city (Paris in this instance) on posters advertising the film. For several weeks *Eyes Wide Shut* was no more than this poster and this trailer. When the film finally came to the movie theatre the short sequence was discovered embedded in it. From poster to trailer to film there was a progressive unfolding: from image, to sequence, to concatenation of sequences – as if the pattern of industrial presentation of commercial cinema were taking on the imprint of psychical structures: from the most cursorily condensed of unconscious representations to the most articulated conscious forms, as if the 'noise of the marketplace' in the most literal sense was conforming to the psychological sense of Barthes' metaphor. Opened onto its outside by the publicity system the film spills its contents into the stream of everyday life, where they join other detritus of everyday experience ('small syntagms, ends of formulae') and where no sentence forms.

The sequence-image

Barthes on the banquette compares his inner 'souk' with the noise of his immediately external surroundings. Phenomenologically, 'inner' and 'outer' form a single continuum where perceptions, memories and fantasies

7 Roland Barthes, *Le plaisir du texte*, Paris, Seuil, 1973, p.67, my translation. [*The Pleasure of the Text*, New York, Hill and Wang, 1975, p.49.]

8 Arthur Schnitzler, *Dream Story*, Penguin, London, 1999 [*Traumnovelle*, 1926].

combine. Jean Laplanche speaks of memory and fantasy as a 'time of the human subject' that the individual 'secretes' independently of historical time – the cinematic heterotopia is also heterochronic, moreover its most atomic elements are indeterminate with respect to motion. For example, here is what I believe is my earliest memory of a film:

> A dark night, someone is walking down a narrow stream. I see only feet splashing through water, and broken reflections of light from somewhere ahead, where something mysterious and dreadful waits.

The telling of the memory, of course, betrays it. Both in the sense of there being something private about the memory that demands it remain untold (secreted), and in the sense that to tell it is to misrepresent, to transform, to diminish it. Inevitably, as in the telling of a dream, it places items from a synchronous field into the diachrony of narrative. What remains most true in my account is what is most abstract: the description of a sequence of such brevity that I might almost be describing a still image. Although this 'sequence-image' is in itself sharply particular, it is in all other respects vague: uniting 'someone', 'somewhere' and 'something', without specifying who, where and what. There is nothing before, nothing after, and although the action gestures out of frame, 'somewhere ahead', it is nevertheless self-sufficient. I can recall nothing else of this film – no other sequence, no plot, no names of characters or actors, and no title. How can I be sure the memory is from a film? I just know that it is. Besides, the image is in black and white.

The memory I have just described is of a different kind from my memory of the figure of Death 'seen' by the small boy in Ingmar Bergman's film *Fanny and Alexander*, or – from the same film – my memory image of the boy's grandmother seated in a chair by a window. These examples were what first came to mind when I 'looked' in memory for a film I saw recently. They are transient and provisional images, no doubt unconsciously selected for their association with thoughts already in motion (childhood, the mother, death), but no more or less suitable for this purpose than other memories I might have recovered, and destined to be forgotten once used. The 'night and stream' memory is of a different kind. It belongs to a small permanent personal archive of images from films I believe I saw in early childhood, and which are distinguished by having a particular affect associated with them – in this present example, a kind of apprehension associated with the sense of 'something mysterious and dreadful' – and by the fact that they appear unconnected to other memories. If I search further in my memories of childhood I can bring to mind other types of images from films. What I believe to be the earliest of these are mainly generically interchangeable pictures of wartime Britain. They form a library of stereotypes which

represent what must have impressed me as a child as the single most important fact about the world around me (not least because it was offered to me as the reason for my father's absence). In addition to a small collection of enigmatic images, and a larger library of images from wartime films, I also retain other types of images from visits to the cinema in later childhood. These are neither mysterious nor generic, they tend to be associated with events in my personal history: either in direct reaction to a film, or to something that happened shortly after seeing a film. Later still, from adulthood, I can recall sequences from films that have most impressed me as examples of cinematic art, and from films seen for distraction which I expect I shall soon forget. The totality of all the films I have seen both derive from and contribute to the 'already read, already seen' stereotypical stories that may spontaneously 'explain' an image on a poster for a film I have not seen, or images of other kinds encountered by chance in the environment of the media.

So far, the examples I have given are of images recalled voluntarily, and I have not spoken of their relations to actual perceptions. But mental images derived from films are as likely to occur in the form of involuntary associations, and are often provoked by external events. For example: I am travelling by train through the French countryside *en route* from Paris to London. Earlier, as I was waiting for the train to leave the Gare du Nord, a middle-aged couple had passed down the carriage in which I was sitting. Something in the woman's face brought to mind an image from a film. The previous night, seeking distraction from work, I had switched on the television. The channel I selected was passing in cursory review some films to be broadcast in weeks to come: a title and a few seconds of footage from each. No doubt there was commentary *voix-off* but I had the mute on. A young woman, seen from behind, executes a perfect dive into a swimming pool; cut to the face of a middle-aged woman who (the edit tells me) has witnessed this. I read something like anxiety in her expression. The woman who had passed down the carriage had an anxious look. Now, as the train slices through the French countryside, I glimpse an arc of black tarmac flanked by trees on a green hillside. A white car is tracing the curve. This prompts the memory of a similar bend in a road, but now seen from the driver's seat of a car I had rented the previous summer, when I was vacationing in a house with a swimming pool. My association to the glimpse of road seen from the train is followed by my recollection of the woman who had passed me in the carriage (as if the recollection were provoked by the perception *directly*, without the relay of the film image). Although these images have different sources I must assume that they have a common *origin* – a precipitating cause – in something unconscious that has joined

them. As I recollect these associations in order to describe them it seems that they turn around the expression on the woman's face: 'something like anxiety', but *what* is 'like' anxiety. It seems that the persistence of the images is due to this enigma.

A train journey interrupted by a train of associations: a concatenation of images raises itself, as if in *bas relief*, above the instantly fading, then forgotten, desultory thoughts and impressions passing through my mind as the train passes through the countryside. The 'concatenation' does not take a linear form. It is more like a rapidly arpeggiated musical chord, the individual notes of which, although sounded successively, vibrate simultaneously. This is what led me to refer to my earliest memory of a film as a 'sequence-image' rather than an 'image sequence'. The elements that constitute the sequence-image, mainly perceptions and recollections, emerge successively but not teleologically. The order in which they appear is insignificant (as in a rebus) and they present a configuration – 'lexical, sporadic' – that is more 'object' than narrative. What distinguishes the elements of such a configuration from their evanescent neighbours is that they seem somehow more 'brilliant'.[9] In a psychoanalytic perspective this suggests that they have been attracted into the orbit of unconscious signifiers, and that it is from the displaced affect associated with the latter that the former derive their intensity. Nevertheless, for all that unconscious fantasy may have a role in its production, the sequence-image as such is neither daydream nor delusion. It is a *fact* – a transitory state of percepts of a 'present moment' seized in their association with past affects and meanings.

Image, image sequence, sequence-image

The sequence-image is a very different object from that addressed by film studies as the discipline aroused itself in the late 1960s and the 1970s, revitalised by its love affair with linguistics. Half asleep, Roland Barthes hears hybrid mutterings that form no sentence. Barthes' account of his reverie on the banquette appears in his book *Le plaisir du texte*, which was published in 1973. Ten years earlier he had been asked by the journal *Cahiers du Cinéma* whether linguistics had anything to offer the study of film. He replied that it did only if we chose 'a linguistics of the syntagm rather than a linguistics of the sign'. In Barthes' view, a linguistically informed analysis of film could not be concerned with the filmic image as such, which he considered to be pure analogy, but only with the combination of images into narrative sequences. As he expressed it: 'the distinction between film and photography is not simply a matter of degree but a radical opposition'. Such a distinction between image and image sequence has its precursor in

9 What I characterise here as 'brilliance' is a characteristic of the 'psychical intensity' of the 'screen memory'. (See the Editor's Appendix, *S.E.*III, p.66 ff. for a discussion of Freud's use of the expression 'psychical intensity', and Freud's essay 'Screen Memories' (1899), *Standard Edition*, vol.III, pp.311-12.)

Gotthold Ephraim Lessing's differentiation, in 1766, between 'arts of space' and 'arts of time'. Lessing's dichotomy underwrites the categorical separation of the still and the moving image on the basis of a supposed absolute difference between simultaneity and succession. Film studies and photography studies have developed separately largely on the basis of this assumed opposition – even while, across the same period of time, there has been increasing technological convergence between the supposedly distinct phenomena of still and moving images. It accords with common sense to assign the still image to photography theory and the moving image to film theory. But to equate movement with film and stasis with photography is to confuse the representation with its material support. A film may depict an immobile object even while the film strip itself is moving at 24 frames per second; a photograph may depict a moving object even though the photograph does not move.[10] Writing in 1971 the photographer and filmmaker Hollis Frampton envisaged an 'infinite film' that would consist of a spectrum of possibilities extending from the stasis of an image resulting from a succession of completely identical frames, to the chaos of an image produced by a succession of totally different frames.[11] Cinema, 'the movies', inhabits only part of this spectrum: that portion where movement – frame to frame, shot to shot, scene to scene – is intelligible, sentence-like. An interest in movement for its own sake may be found in early twentieth century avant-garde film and photography, and in painting under the impact of film and photography. The interest is comparatively short-lived. It is not movement as such that fascinates most people but purposive movement, movement with causes and consequences. What audiences find most interesting about characters on the screen is not their movements (albeit these may have their own, primarily erotic, interest) but their acts. Activity however is not necessarily bound to movement. Peter Wollen illustrates this point with reference to a book of photographs by André Kertèsz entitled *On Reading*.[12] Wollen observes that although all the people in the photographs are motionless they are nevertheless doing something – they are all reading. Thus, he writes: 'We can see that activity is not at all the same thing as movement.'[13]

The disjunction of activity and movement was recognised early in the history of painting. Between the sixteenth and eighteenth centuries, a body of doctrine was assembled in response to the problem of how best to depict a narrative in a painting. With only a single image at his or her disposal, it was agreed that the painter would do best to isolate the *peripeteia* – that instant in the story when all hangs in the balance. It went without question that the viewer already knew the story. The space in and between images is crossed

10 See, for example, Hollis Frampton's film *A Casing Shelved*, which consists of a static shot of a book case; and the photographs in Eadweard Muybridge's *Animal Locomotion*.

11 Hollis Frampton, 'For a Metahistory of Film: Commonplace Notes and Hypotheses' (1971), in *Circles of Confusion: Film, Photography, Video; Texts 1968 - 1980*, Visual Studies Workshop, Rochester, N.Y., 1983, p.114.

12 André Kertèsz, *On Reading*, Penguin, New York, 1971.

13 Peter Wollen, 'Fire and Ice', *Photographies*, no.4, Avril, 1984.

14 Roland Barthes, 'Introduction to the Structural Analysis of Narratives' (1966), *Image – Music – Text*, Hill and Wang, New York, 1977, p.79.

15 Roland Barthes, 'The Sequences of Actions' (1969), in *The Semiotic Challenge*, Hill and Wang, New York, 1988, p.141.

16 Ibid., p.139.

17 Norman Bryson, *Word and Image: French Painting of the Ancien Régime*, Cambridge, 1981, p.85.

with the always already *known* of stories. As Barthes writes, narrative is everywhere 'simply there, like life itself.'[14] But our ready capacity to insert image fragments into the narratives to which they may be called is not due to the mere fact that stories are everywhere. It is due to the fact that narratives, like the languages in which they are composed, are *articulated*. In his book *Morphology of the Folktale*, first published in 1928, Vladimir Propp reduces the multiplicity of fairy tales he analyses to a finite number of basic 'functions' which in combination make up the variously individual stories. In an essay of 1969 Barthes argues that these functions may in turn be decomposed into smaller units: for example, 'it is because I can spontaneously subsume various actions such as *leaving, travelling, arriving* ... under the general name *Journey*, that the sequence assumes consistency.'[15] In his book of 1970, *S/Z*, Barthes coins the expression 'proairetic sequence' for such series, taking the term *proairesis* from Aristotle who uses it to name 'the human faculty of deliberating in advance the result of an action, of *choosing*... between the two terms of an alternative the one which will be realized.'[16] The 'peripateian moment' of academic history painting might consequently be considered a 'freeze frame' from a proairetic sequence, an image from an implied narrative series. But the temporality of arrest in history painting is rarely so straightforward. For example, Norman Bryson observes that Poussin's painting *Israelites Gathering Manna in the Desert* juxtaposes within the same image 'scenes of misery from the time before the manna was found, with scenes ... from the time after its discovery'.[17] History painting routinely exhibits this characteristic attribute of the sequence-image: the folding of the diachronic into the synchronic.

Barthes' idea of proairetic codes allows us in principle to trace the lines of latent narratives underlying manifest fragments – much as an archeologist might envisage the form of an ancient dwelling, and a whole way of life associated with it, from the indications of some pottery shards. But what would it mean to see the fragmentary environment not (or not only) in terms of an 'already read' determinate content, but in such a way that the fragmentary nature of the experience is retained? In recollecting his reverie on the banquette Barthes speaks of the 'spacing' of the elements that penetrate from outside. The word he uses, *échelonnement*, may refer to either a spatial or a temporal context, what is essential is the idea of discontinuity, of absences, of gaps. The tendency of narrative is to bridge gaps, to turn discontinuities into a continuum – much as 'secondary revision', in Freud's account of the dream-work, makes a drama out of a picture-puzzle. In his reply to *Cahiers du Cinéma* Barthes drew an intransigent line between 'image' and 'image sequence' on the basis of their susceptibility to linguistic analysis.

Barthes' student Christian Metz most exhaustively demonstrated the extent to which linguistic models may be applied in the theoretical description of narrative films, and I believe that Barthes was simply wrong in asserting that linguistically derived modes of analysis cannot be applied to photographs. But Barthes on the banquette remarked a field of experience in which a different kind of object may be discerned: 'lexical' but 'sporadic' and truly 'outside linguistics'. As this object – the *sequence-image* – is neither image nor image sequence, it belongs neither to film nor photography theory as currently defined. Indeed it may be doubted whether it can ever be fully a *theoretical* object, so long as theory remains an affair of language. The early Wittgenstein famously concluded, on the last page of the *Tractatus*: 'What we cannot speak about we must pass over in silence.'[18] To which his colleague and translator Frank Ramsey added: 'What we can't say we can't say, and we can't whistle it either.' The belief that much of what cannot be said may nevertheless be whistled is foundational not only to music but to the visual arts. In *Remarks on the Philosophy of Psychology*, at the edge of the ineffable, Wittgenstein writes:

> It is as if one saw a screen with scattered colour-patches, and said: the way they are here, they are unintelligible; they only make sense when one completes them into a shape. – Whereas I want to say: Here is the whole. (If you complete it, you falsify it.)[19]

The same old story

How can that 'of which we cannot speak' speak to theories of ideology? In the film studies reformation of the late 1960s and early 1970s film was seen as, in the words of Jean-Louis Comolli and Jean Narboni, 'the product of the ideology of the economic system that produces and sells it'.[20] Much of what came after – first in film studies, then in photography studies – responded in one way or another to this initial proposition. In the intervening years, the politics that framed the premise collapsed. In more recent years, a re-engagement with film in terms of this premise and the questions deriving from it has emerged in the work of the French philosopher Bernard Stiegler. Stiegler reformulates the premise in the following terms:

> Our epoch is characterised by a takeover [prise de contrôle] of the symbolic by industrial technology, in which the aesthetic is at one and the same time the weapon and the theatre of economic war. From this there results a misery where conditioning is substituted for experience.[21]

Stiegler notes that since the second half of the twentieth century there has been an exponential growth of industries – film, television, advertising and popular music – that produce synchronised collective states of

18 Wittgenstein, *Tractatus Logico Philosophicus*, RKP, London, 1963, Statement 7, p.151.

19 Ludwig Wittgenstein, *Remarks on the Philosophy of Psychology*, vol. I, Blackwell, Oxford, 1980, Remark 257.

20 Jean-Louis Comolli and Jean Narboni, 'Cinéma/ Ideologie/Critique', cited in Francesco Casetti, *Theories of Cinema, 1945-1995*, University of Texas, Austin, 1999, p.189.

21. Bernard Stiegler, *De la misère symbolique: 1. L'époque hyperindustrielle*, Galilée, Paris, 2004, p.13.

consciousness through the agency of the *temporal object*. The 'temporal object', a concept Stiegler takes from Husserl, is one that elapses in synchrony with the consciousness that apprehends it. Husserl gives the example of a melody. For Stiegler, cinema is the paradigm of the industrial production of temporal objects, and of the consciousnesses that ensue. What most concerns Stiegler is the question of the production of a 'we' (*nous*) as a necessary sense of communality in relation to which an 'I' (*je*) may be produced and sustained. He argues that the communality produced by the global audio-visual industries to which cinema belongs results not in a 'we' (*nous*) – a collectivity of individual singularities – but in a 'one' (*on*), a homogeneous and impersonal mass who come to share an increasingly uniform common memory. For example, the person who watches the same television news channel every day at the same time comes to share the same 'event past' (*passé événementiel*) as all the other individuals who keep the same appointment with the same channel. In time, Stiegler argues: 'Your past, support of your singularity ... becomes the same past consciousness (*passé de conscience*) as the *one* (*on*) who watches.'[22] Those who watch the same television programmes at the same time become, in effect, the same person (*la même personne*) – which is to say, according to Stiegler, *no one* (*personne*).[23] Much the same point is made by Colin McCabe in defining 'normal television': 'normal television is part of that regime of the image which erases our specific being to place us as part of a normal audience.'[24]

Stiegler devotes a long chapter of his latest book to Alain Resnais' film *On Connaît la Chanson* (1997), which he sees as the mise-en-scène of 'the unhappiness in being [*mal-être*] of our epoch'.[25] His discussion turns on the fragment. The actors in this film lip-synch to popular songs much as actors do in the films of Dennis Potter, to whom Resnais pays hommage in his opening titles. The characters in Resnais' film however produce only fragments of songs. Resnais has commented: 'I'd say it's a realistic film, because that's the way it happens in our heads.' One of the film's two screenwriters, Agnès Jaoui, has said, '...we used [the fragments] like proverbs. "Every cloud has a silver lining", "Don't worry, be happy", readymade ideas, commonplaces that summarise a feeling and, at the same time, impoverish it.'[26] Asked how the songs had been chosen, the film's other screenwriter, Jean-Pierre Bacri, replied: 'We looked for very familiar songs with words that everyone can identify with, *les vraies rengaines*.' The sense of the French word *rengaine* is conveyed in the English version of the title of Resnais' film: '*Same Old Song*'. A *rengaine* is something hackneyed, threadbare, familiar and inevitable – as when one says, *C'est toujours la même rengaine* – 'It's always the same old story'. Bernard Stiegler uses this same word in describing the advent of the

22 Bernard Stiegler, *Aimer, s'aimer, nous aimer: du 11 septembre au 21 avril*, Galilée, Paris, 2003, p.53.

23 '...ces "consciences" finissent par devenir celle de la même personne – c'est-à-dire personne.' Bernard Stiegler, *De la misère symbolique: 1. L'époque hyperindustrielle*, Galilée, Paris, 2004, p.51.

24 Colin MacCabe, *Godard: a portrait of the artist at 70*, Bloomsbury, London, 2003, p.255.

25 Bernard Stiegler, *De la misère symbolique: 1. L'époque hyperindustrielle*, Galilée, Paris, 2004, p.41.

26 Catherine Wimphen, 'Entretien avec Agnès Jaoui et Jean-Pierre Bacri', http://perso.wanadoo.fr/camera-one/chanson/html/int1.htm (Jaoui's examples are: 'Après la pluie, le beau temps', 'Dans la vie faut pas s'en faire'.)

recorded song as 'the most important musical event of the 20th century'.
He writes: 'The major musical fact of the 20th century is that masses of ears
suddenly start listening to music – ceaselessly, often the same old songs (*les
mêmes rengaines*), standardised, ... produced and reproduced in immense
quantities, ... and which will often be interlaced for many hours a day with
global consciousnesses, producing a daily total of many milliards of hours
of consciousness thus "musicalised".'[27] The *rengaines* sung by the actors in
Same Old Song, songs their French audience are sure to know, conjure a
commonality that ultimately devolves upon no subject other than the subject-
in-law that is the corporation that produced it. For Stiegler, this is a source of
the very unhappiness that the characters express in song:

> '*It is the* already there of our unhappiness in being (le déja-là de notre
> mal-être) *that certain of these songs express so well, which are therefore
> (these songs that we receive so* passively*), in certain respects, at the same
> time the* cause, *the* expression, *and the possibility, if not of cure, at least
> of* appeasement.'[28]

Agnès Jaoui defines quite precisely what she means when she refers to
a song as a *rengaine*: '*Une rengaine*, it's something universal that touches the
collective unconscious and the culture of a generation, of a country, and at
the same time, for each one of us, it can evoke a moment, an event in our
life.' By 'collective unconscious' I assume that Jaoui means that which I
prefer to call the 'popular preconscious': 'those ... contents which we may
reasonably suppose can be called to mind by the majority of individuals in
a given society at a particular moment of its history: that which is "common
knowledge".'[29] Jaoui recognises the individual dimension of common
knowledge – the *rengaine* both touches the collective and *at the same time*
may evoke a personal experience. In another interview, Jaoui says that a
consensus about the choice of songs to be used in the film had been difficult
to achieve, because what a particular song meant to one member of the
writing team was not what it meant to another. The perception that the
words of a song may have both public and private meanings is commonplace,
but nevertheless absent from Stiegler's description of the ideological
determinations of 'cinema' (the audio-visual in general). Although he makes
liberal use of psychoanalytic terms in his essay on Resnais' film, he uses
neither the term preconscious nor unconscious, speaking only of
consciousness, and 'consciousnesses' (a sort of 'collective conscious'). I
believe Stiegler is both right and wrong in presenting cinema as a totalising
and potentially totalitarian machine for the production of synchronised and
uniform consciousnesses. It is no contradiction to say this if we distinguish
the political from the ideological. Stiegler is right in emphasising the extent

27 Bernard Stiegler, *De la
misère symbolique: 1. L'époque
hyperindustrielle*, Galilée,
Paris, 2004, pp.52-3.

28 Ibid., p.69.

29 Victor Burgin, 'Seeing
Sense', *Artforum*, February,
1980; reprinted in *The End
of Art Theory: Criticism and
Postmodernity*, Macmillan,
Houndmills, Basingstoke,
and London, 1986.

30 Colin MacCabe, *Godard: a portrait of the artist at 70*, Bloomsbury, London, 2003 p.301.

31 Ibid., p.302.

32 My remarks here are in response to what, at the time of writing, is Stiegler's most recent book: *De la misère symbolique: 1. L'époque hyperindustrielle*, Galilée, Paris, 2004. In a more recent conference paper Stiegler has given some indication of the engagement with Freud's work that we may expect from his next book. My impression is that this engagement is with Freud the neuroscientist rather than with Freud the psychoanalyst. Nevertheless Stiegler's attention to the technological exploitation of desire by global marketing remains exemplary.

33 See Laura Mulvey's essay elsewhere in this book.

34. Laura Mulvey, 'The pensive spectator revisited: time and its passing in the still and moving image', in David Green (ed.), *Where is the Photograph?*, Photoworks/Photoforum, Brighton, 2003.

to which industrially produced commodities have occupied not only real space but psychical space. At least one aspect of this – the issue of copyright – is clearly political. As Colin MacCabe has written: 'in a world in which we are entertained from cradle to grave whether we like it or not, the ability to rework image and dialogue, light and sound, may be the key to both psychic and political health.' [30] The same technology that has constructed the audio-visual machine has put the means of reconfiguring its products into the hands of the audience. But when 'two thirds of global copyrights are in the hands of six corporations' [31] the technological capacity to rework one's memories into the material symbolic form of individual testament and testimony is severely constrained. We rarely own the memories we are sold. Stiegler is wrong, however, to ignore the fact that whatever the audio-visual machine produces is destined to be broken up by associative processes that are only minimally conscious. [32] Consciousnesses may be synchronised in a shared moment of viewing, but the film *we* saw is never the film *I* remember.

Resnais' musical fiction film is set in present day Paris, apart from a brief opening scene, which takes place in 1944 towards the end of the German occupation of the city, and which represents an historical event. General von Scholtitz receives by telephone a direct order from Hitler to destroy Paris. He sets down the receiver, and with a look of shocked gravity on his portly face ventriloquizes in perfect lip-synch the voice of Josephine Baker singing 'J'ai deux amours'. The effect is simultaneously comic and uncanny, clearly played for laughs and yet utterly chilling. Throughout the light comedy that ensues the singing voices that issue from the mouths of Resnais' characters are indifferent to the gender, race and age of their host bodies – in unequivocal demonstration that we are witnessing the possession of a subject by its object, here in the commodity form of the popular song. I began by talking about the various ways in which a film may be broken up, and its fragments dispersed thoughout the environment in which we conduct out daily lives. Where subjective agency is involved in this, the subject corresponds to what Laura Mulvey has called the *possessive spectator*. [33] I then went on to describe some of the ways in which memory and fantasy may weave these fragments into more or less involuntary, insistent and enigmatic reveries. The subject position here may be assimilated to what Mulvey, after Raymond Bellour, has called the *pensive spectator*. [34] Bernard Stiegler's essay about Alain Resnais' film tells me that the fragment that haunts me may come to usurp the place of my former singularity. To the 'possessive spectator' and the 'pensive spectator' we must now add the category of the *possessed spectator*.

Notes on Contributors

Victor Burgin is Millard Professor of Fine Art at Goldsmiths College, University of London, and Professor Emeritus of History of Consciousness at the University of California, Santa Cruz. Burgin's books include such theoretical works as *The Remembered Film* (2004), *In/Different Spaces* (1996), *The End of Art Theory* (1986), and *Thinking Photography* (1982), and such monographs of his visual work as *Relocating* (Arnolfini, 2001), *Victor Burgin* (Fundacio Antoni Tàpies, 2001), *Shadowed* (Architectural Association, 2000), *Some Cities* (Reaktion, 1996) and *Between* (ICA, 1986).

David Campany is an artist, writer and Reader in Photography at the University of Westminster. His current work includes a photographic collaboration with Polly Braden; a book, *Photography and Film*, to be published by Reaktion in 2007; and a treatise on the lens, the shutter and the light sensitive surface. He has published essays on conceptual art, reproduction, industrial photography, film stills, amateurism and painting. He is the author of *Art and Photography* (Phaidon Press, 2003).

Mary Ann Doane is Professor of Modern Culture and Media at Brown University, USA. She is the author of *The Emergence of Cinematic Time: Modernity, Contingency, the Archive* (2002), *Femmes Fatales: Feminism, Film Theory, Psychoanalysis* (1991), and *The Desire to Desire: The Woman's Film of the 1940s* (1987). In addition, she has published a wide range of articles on feminist film theory, sound in the cinema, psychoanalytic theory, television, and sexual and racial difference in film.

Jonathan Friday is the author of *The Aesthetics of Photography* (2002) and has written on various philosophical aspects of photography for a number of academic periodicals including the *British Journal of Aesthetics* and the *Journal of Aesthetics and Art Criticism*. He was previously Lecturer in Philosophy at the University of Aberdeen but now heads the History and Philosophy of Art department at the University of Kent.

David Green is Senior Lecturer in the History and Theory of Art at the University of Brighton. He is the editor and contributor to *History Painting Reassessed* (Manchester University Press, 2000) and *Where is the Photograph?* (Photoworks/Photoforum, 2003). He has written widely on various aspects of photography and contemporary art including most recently essays for the exhibition catalogues of *David Claerbout* (Lenbachhaus Munich, 2004), *Visible Time: The Work of David Claerbout* (Photoworks, 2004) and *Laurent Montaron* (Centre d'art contemporain de-Noisy-le-Sec, Paris, 2005).

Yve Lomax is a visual artist and writer who lives in London. She is author of *Writing the Image; An Adventure with Art and Theory* (I.B.Tauris, London and New York, 2000) and *Sounding the Event: Escapades in dialogue and matters of art, nature and time* (I.B.Tauris, London and New York, 2005). She is currently the Research Tutor for Photography and Fine Art at the Royal College of Art.

Joanna Lowry is Reader in Visual Theory and Media Arts at the University College for the Creative Arts at Canterbury, Epsom, Farnham, Maidstone and Rochester. She has written widely on contemporary photographic and moving image practices. Selected essays include writing on Douglas Gordon in *Performing the Body, Performing the Text* (1999), Jeff Wall in *Whatever Happened to History Painting* (2000), Ori Gersht in *Afterglow* (2002), David Claerbout in *Visible Time: The work of David Claerbout* (2004) and Conceptual Art and photography in *Where is the Photograph?* (2003).

Kaja Silverman is Professor of Rhetoric and Film at the University of California, Berkeley, USA. Her primary object of study is the field of vision, which she approaches from a psychoanalytic and phenomenological point of view. Among the monographs she has published are *World Spectators* (2000) and *The Threshold of the Visible World* (1996). Although her earlier work focused upon cinema, her recent research has extended into the areas of photography and time based-art and she has written a number of major essays on the work of the artists James Coleman, Jeff Wall, Alan Sekula, and Eija-Liisa Ahtila.

John Stezaker is Senior Tutor in Critical and Historical Studies at the Royal College of Art. He is an artist who lives and works in London. His work has recently been seen at the Munich Kunstverein and The Approach Gallery, London. In January 2006, he held a one-person show in 'White Columns', New York and at the same time showed work in the Tate Triennial.

Garrett Stewart is James O. Freedman Professor of Letters at the University of Iowa, USA. In addition to his work in the field of literature he has published widely on various aspects of cinema and other visual media. He is the author of *Between Film and Screen: Modernism's Photo Synthesis* (1999) and of *The Look of Reading: Book, Painting, Text* to be published by the University of Chicago Press in 2006.

Laura Mulvey is Professor of Film and Media Studies at Birkbeck College, London. She is the author of *Visual and Other Pleasures* (1989), *Citizen Kane* (1992) and *Fetishism and Curiosity* (1996). In addition to her numerous writings on the cinema and film theory, she has also co-directed six films with Peter Wollen and her last film, co-directed with Mark Lewis, was *Disgraced Monuments* (1994). Her latest book entitled *Death 24 x a second: Stillness and the Moving Image* was published by Reaktion Books in 2005.

List of Illustrations

Figure 20
Film still, *Pickpocket*, Robert Bresson, 1959.

Figure 21
Jeff Wall, *Volunteer*, 1996. Courtesy of the artist.

Figure 22
Jeff Wall, *Outburst*, 1986. Courtesy of the artist.

Figure 23
Cindy Sherman, *Untitled Film Still 10*, 1978.
Courtesy Metro Pictures, New York.

Figure 24
Gisele Freund, *Walter Benjamin*, c. 1939, Gisele
Freund/The John Hillelson Agency. As
reproduced on the cover of Benjamin's
Illuminations, Fontana Press, 1992.

Figure 25
John Stezaker, *Blind*, 1979.
Courtesy the artist and Approach Gallery, London.

Figure 26
John Stezaker, *The Trial*, 1980.
Courtesy the artist and Approach Gallery, London.

Figure 27
Film still, *Perfect Understanding*, Cyril Gardner, 1933.

Figure 28
Theodor Van Baburen, *The Procuress*, 1622. Oil on
canvas, 101.6 x 107.6 cm. Museum of Fine Arts,
Boston. M. Theresa B. Hopkins Fund 50.2721.
Photograph © 2005 Museum of Fine Arts, Boston.

Figure 29
Film still, *Kiss*, Andy Warhol, 1964. © 2005
The Andy Warhol Museum, Pittsburgh, PA, a
museum of Carnegie Institute. All rights reserved.

Figure 30-31
Film stills, *The Double Life of Veronique*, Krzystof
Kieslowski, 1991.

Figures 32-37
Film stills, *The Red Squirrel*, Julio Mendem, 1993.

Figures 38-40
Film stills, *Lovers of the Arctic Circle*, Julio Medem,
1999.

Figures 41-42
Film stills, *Le Temps Retrouvé*, Raoul Ruiz 1999.

Figure 43
Film still, *The Sixth Sense*,
M. Night Shyamalan, 1999.

Figures 44–5
Film stills, *The Others*,
Alejandro Almenabar, 2001.

Figure 46
Film still, *A.I., Artificial Intelligence*,
Steven Spielberg, 2001.

Figure 47
Film still, *Vanilla Sky*, Cameron Crowe, 2001.

Figures 48–51
Film stills, *One-Hour Photo*,
Mark Romanek, 2002.

Figures 52–53
Film stills, *Eternal Sunshine of the Spotless Mind*,
Michel Gondry, 2004.